PERSPECTIVES:
ANGLES ON AFRICAN ART

PERSPECTIVES:
ANGLES ON AFRICAN ART

by

James Baldwin
Romare Bearden
Ekpo Eyo
Nancy Graves
Ivan Karp
Lela Kouakou
Iba N'Diaye
David Rockefeller
William Rubin
Robert Farris Thompson

Interviewed by Michael John Weber
Introduction by Susan Vogel

The Center for African Art, New York
and Harry N. Abrams Inc.

For incomparable Charlie,
tie collector, opera lover,
and the fastest eye in town—
who has made life more fun for the past ten years

Perspectives: Angles on African Art is published in conjunction with an exhibition of the same title organized by The Center for African Art and shown at: The Virginia Museum of Fine Arts and The Birmingham Museum of Art. The exhibition has been made possible by a grant from Philip Morris Companies Inc.

Design: Linda Florio
Typography: David E. Seham Associates, Inc.

Printed in Japan.

ACKNOWLEDGEMENTS

The Center for African Art has been fortunate in its friends. We have had unstinting cooperation and assistance of all sorts from many people as we assembled this book and exhibition. We are grateful to all of them for their efforts on our behalf.

The essential task of interviewing the cocurators and editing their remarks was accomplished by Michael John Weber with finesse and taste. Michael also handled the return of all the texts to the cocurators and the revisions that followed the initial interviews. Polly Nooter wrote most of the checklist entries and oversaw preliminary loan arrangements with her usual cool efficiency. Norman Skougstad assumed registrar responsibilities for the exhibition itself, and also assisted in the final stages of the catalogue including some writing of checklist entries. Jeanne Mullin created the index, helped with copy editing and proofreading, sometimes under hair-raising time pressures. Discussions with Ivan Karp, John Picton, Kenneth Prewitt, Norman Skougstad, and Enid Schildkrout were stimulating and helpful in the writing of the introduction. The elegant design of the catalogue is the work of Linda Florio who performed miracles in no time at all. Jerry Thompson's sensitive photographs enhance our understanding of the works of art and our insights into the people in his portraits. The interviews with Lela Kouakou and Iba N'Diaye were conducted abroad by Susan and Jerome Vogel who received considerable help from Yao Koffi Celestin, Judith Timyan, Francine N'Diaye, Catherine de Clippel, and Michael Bastos.

The French transcripts of both interviews were ably translated into English by Alisa Lagamma. Putting our work into the computer and retrieving it was ably performed by Pamela Bash and Carri Cohen. Viewing and photography of objects in New York area collections were aided by Robert Rubin, Denyse Ginzberg, and Thomas Wheelock.

Loans from museums and collections were graciously facilitated by friends and colleagues: Kate Ezra, William Fagaly, Roberto Fainello, Jacques Hautelet, Michael Kan, Joseph Knopfelmacher, Christine Mullen Kreamer, Frederick Lamp, Louise Lincoln, Ellen Napiura, Pamela McClusky, Doran Ross, Christopher Roy, Tom Seligman, Ann Spencer, Richard Woodward, and William Wright.

Above all we are grateful to the lenders who generously parted with their fine objects for this exhibition, and to the cocurators who willingly shared their personal feelings and insights about African art with us and with the public.

The Board of Directors and I are proud to collaborate with Philip Morris Companies Inc. on this exhibition, and express our deep appreciation for their support of the exhibition.

S.V.

THE CENTER FOR AFRICAN ART

The Center for African Art was founded in 1982 to increase the understanding and appreciation of African art. To that end it has presented a variety of exhibitions to the public which explored facets of the art itself. None have examined how we deal with it. For the first time, *Perspectives: Angles on African Art* looks closely at some of the ways African art may be regarded, and thereby invites the public to look at African art anew. We feel that ancient stereotypes about Africa should no longer cloud perceptions, and that appreciation can lead to understanding.

SPONSOR'S STATEMENT

Recalling his first response to African art in 1907, Pablo Picasso remarked, "At that moment, I realized what painting was all about." It has only been in recent years, however, that the innate power of African art has been fully appreciated for its own sake, and within new and illuminating contexts.

Through the multitude of insights contained in *Perspectives*, the many meanings of African art are explored in the service of that realization. This exhibition focuses on the continuing dialogue between the works themselves and the various perspectives from which they are viewed— anthropological, religious, cultural, political, historical, personal and aesthetic.

Philip Morris supports the innovative approach taken by the Center for African Art and *Perspectives*. It is a Philip Morris tradition to provide a unique cultural showcase for art that might otherwise be denied an audience and to encourage the ongoing expression of multiplicity of points of view.

We are proud to be corporate sponsors of *Perspectives* and hope you enjoy the exhibition.

Hamish Maxwell
Chairman and Chief Executive Officer
Philip Morris Companies Inc.

TABLE OF CONTENTS

INTRODUCTION

The Museum [of Primitive Art] would be the first to grant the paradoxical nostalgia implied by [anthropologists]: the best setting for any art, they seem to suggest, is the total context of its own culture. (And were one to insist upon it, how little of the world's art could be known at all!) Failing this, works of art must be shown accompanied by the artificial props of maps and photographs and texts, aids to understanding, and so to appreciation as well. But a museum of art also believes the reverse to be true—appreciation is one path to understanding.[1]

Robert Goldwater

Perspectives grew out of an awareness that people had come to look at African art in vastly different and sometimes contradictory ways, were seeking in it answers to a variety of questions, needs, and aspirations. It seemed that interest, discussion, and debate had recently quickened and, like prisms, had clarified a spectrum of outlooks on African art: as a national patrimony; as a personal heritage; as objects in an art collection; as part of the study of art history and anthropology; as an influence on twentieth century art; as material for artists to draw on in different ways; and as it always has been, the expression of religious and political beliefs.

All but the last of these are quite extraneous to the original creation of African art. For reasons related to Western culture at this juncture in history, Africa's ancient art and culture are interesting, relevant, and useful in a variety of ways that have almost nothing to do with Africa itself. In part because of the universal themes that are its domain—birth, survival, regeneration, and death—and partly because of the urgent eloquence of its forms, African art provokes strong emotional reactions—for better and for worse. Historically, Africa itself has occupied a vivid, secluded place in the imagination of the West, where it has been the object of fantasies essential to our sense of who *we* are. The time has come to accept what Africa really is, to surrender at last the nightmare-dream of dark otherness, and to look at African art the way

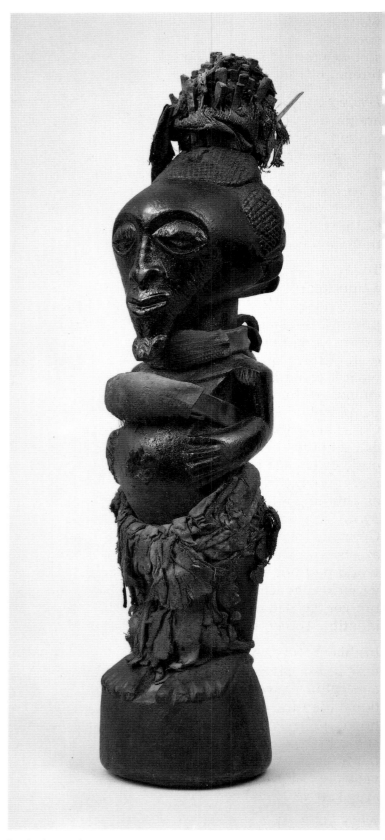

Power figure, Songye, Zaire. Wood metal and other materials, 14 in. Drs. Daniel and Marian Malcolm collection, selected by the author.

we look at all art. If Africa stands alone in any respect, it is in having created great sculptural forms so original that they are unlike any others in human history. All the rest is familiar.

Perspectives presents the views of individuals who are far from the old stereotypes about Africa as obscure and unknowable—who have made African art part of their intellectual and aesthetic lives. That their views were never imagined by traditional African artists no more invalidates them than current views of Egyptian tomb furnishings or Gothic cathedrals are invalidated by distance from the intentions of their original makers.

Today's perspectives on African art barely existed a hundred years ago. African art outside of Africa was then regarded not as art, but as the curious product of distant peoples interesting, perhaps, for extrinsic reasons, though little considered for its own intrinsic qualities. It was discussed mainly for what it could reveal about the origins of human culture, or for the insights it might offer about peoples that Europe was seeking to convert to Christianity (hence an interest in idols and fetishes), dominate militarily (an early interest in weapons), or engage in profitable trade (an interest in ivory, gold, and crafts). It was certainly not seen as anything most art collectors would want to own; art historians (with the exception of a few Germans) never thought about it; the European artists who were to bring it to the attention of the world had not seen it; and Afro-Americans, while very close genealogically to their African roots had not yet focused on that aspect of their cultural identity. Today, of course, all this has changed.

In this century, Africans themselves have acquired new perspectives on their artistic traditions. Art and culture have become important symbols of national identity, expressions of a sense of nationhood in the world community. And of course art still serves its ancient purposes in Africa. Of all the outlooks expressed in this book, only the views of Lela Kouakou, Baule artist and diviner, are likely to have been heard a hundred years ago.

After identifying ten perspectives, we sought ten individuals to serve as cocurators who would, we thought, each articulate one. The people we chose,

however, proved to have a breadth of intellect and a largeness of interest that so far exceeded the narrow definitions we had picked for them, that the categories have all but vanished in the interviews.

As a working procedure, the cocurators each chose ten objects from about one hundred photographs of African art as varied in type and origin, and as high in quality, as we could manage.
After each selection was made, ten new photographs were added to the pool. Thus no two cocurators saw the same group of objects. We strove to maintain a constant level of unusual objects in the pool, so those who saw the photographs late in the process were not more limited in their possible choices than those who had come before. In the case of the Baule artist, a man familiar only with the art of his own people, only Baule objects were placed in the pool of photographs.[2]

The choices made by the cocurators are more easily understood if one can see what they did not choose. Mindful of the admonitions of my colleagues who stress the equal validity of African art forms we might designate as decorative arts, I put into the pool of photos a number of fine nonfigurative items such as textiles, vessels, a hammock and other artifacts. On the whole they excited little interest. Only one object completely lacking in representational features was chosen: a bronze vessel (page 134), selected by art collector David Rockefeller. Interestingly, even the Baule artist, Kouakou Kouame, passed over the less figurative objects presented to him which included a splendid drum with relief carvings on it, and two hats, one carved of wood, the other with wooden decorations, both covered with gold leaf. Though in a traditional Baule context crafts and craftspeople are respected, crafts are acknowledged to be less interesting and less prestigious than sculpture, including nonritual sculpture. This judgment, incidentally, parallels the value system of our own culture.

The market value of the works of art seems to have had almost no influence on the selections made by our cocurators. While they chose some objects highly prized by dealers and collectors, they also repeatedly passed over others. I showed the pool of photos to several avid African

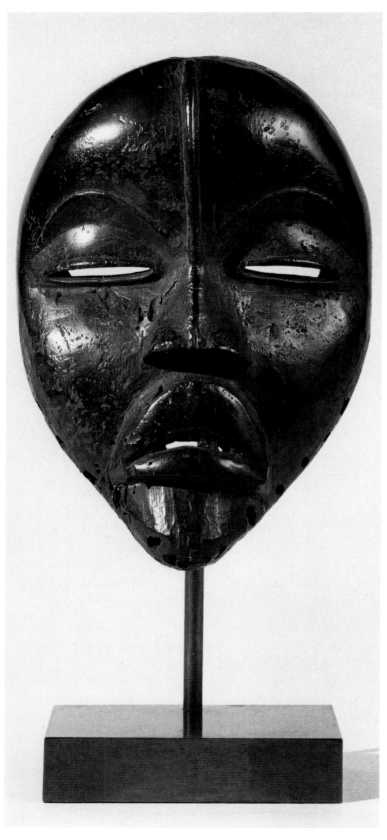

Mask, Dan, Ivory Coast. Wood, 8½ in. Marc and Denyse Ginzberg collection, selected by many collectors.

art collectors whose choices were in substantial agreement with each other, and differed somewhat from those of the cocurators. One favorite of the collectors was a famous Dan mask of great subtlety and understatement whose severe expression may have put off less experienced observers. Another was a small but powerful Bembe figure known to the circle of collectors who may have been partially swayed by what they knew of its purchase history, but which nevertheless is so superb a piece of sculpture, that I cannot explain its having been overlooked by all nine of the cocurators who saw it. Several pieces that are personal favorites of mine, illustrated here, were not selected by any of the cocurators.

The works of art each cocurator selected speak of an attitude, an approach, as clearly as his or her words. Particularly in the case of those whose comments are shortest, the viewer must look hard at the choices that have been made and the kind of statement the works themselves represent. As we expected, each group of objects selected by an individual shows a consistency which reflects the cocurator's personal tastes and predilections. Writer James Baldwin is clearly drawn to sculptures that have a narrative quality, that show more than one figure, often in interaction—a rare feature in African art. William Rubin of the Museum of Modern Art has selected sculptures that are planar, geometric, non-naturalistic—close to the aesthetic that influenced modern artists. All of the artists, Romare Bearden, Nancy Graves, Iba N'Diaye, and Lela Kouakou are interested in how the African artists solved particular formal or sometimes technical problems. To some extent, all measure these sculptures against their own work, and vice versa. Robert Thompson, the art historian, is drawn to objects from the areas he has researched because he is not only seduced by the forms, but is fascinated by meanings he can read in the sculptures.

Despite their individuality and distinctness, the cocurators are all concerned with the dichotomy between appreciation and understanding, form and meaning; between what David Rockefeller calls the artistic sense, and the scholarly one. Though this is not a question we raised in the in-

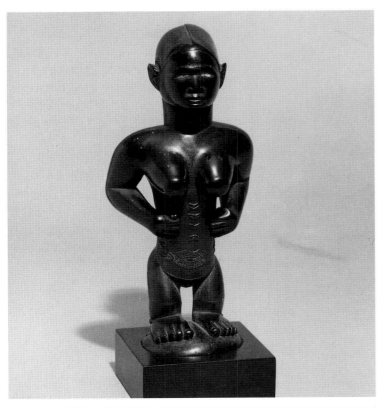

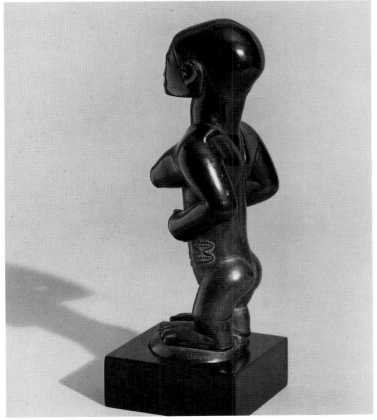

Female figure, Bembe, Zaire. Wood, porcelain, 6¼ in. Marc and Denyse Ginzberg collection, selected by many collectors.

terviews, it is an issue mentioned by nearly everyone. Ivan Karp, anthropologist, puts it most clearly: "I'm really torn between the arguments that are made for universal aesthetic criteria and the idea that we can only truly appreciate something from the point of view of the people for whom it was originally made—that aesthetics are 'culture bound.'" This question is fundamental to the consideration of all nonwestern art: how do we legitimately understand or appreciate art from a culture we do not thoroughly know?

The artist cocurators are the least preoccupied by the cultural context of the objects which they confidently approach as pure sculptural form. Nancy Graves says "The art is here for us to appreciate intuitively. One may get more information about it which enhances it, but its strength is here for anyone to see." An extreme of this position is taken by Iba N'Diaye, who makes no reference to meaning in his commentaries, and describes drawing objects as the way he learned to see them. Romare Bearden feels that information can even inhibit perception: "I had to put the books down and just look at how I felt about it. The books get in the way sometimes." For James Baldwin, the only way to understanding lies through direct experience. "You want to find out?" he asks, "Go and expose yourself. You can't find out through a middleman anyway." He denies that the distinction even exists. "There's this curious dichotomy in the West about form and content. The form *is* the content." In this he echoes the African sculptor and diviner, Lela Kouakou, who recognizes no distinction between the two.

William Rubin argues that the distinction is theoretical since neither an understanding of the cultural context nor a personal appreciation is possible as a pure experience. "The choices are not between a total contextual reconstruction—which is a mythic pursuit—and a pure aesthetic response, whatever that is. We don't respond to art objects with one particular set of responses that are isolatable as aesthetic. We respond to them with our total humanity."

Robert Thompson deals with form and content simultaneously. "What draws me into the study of

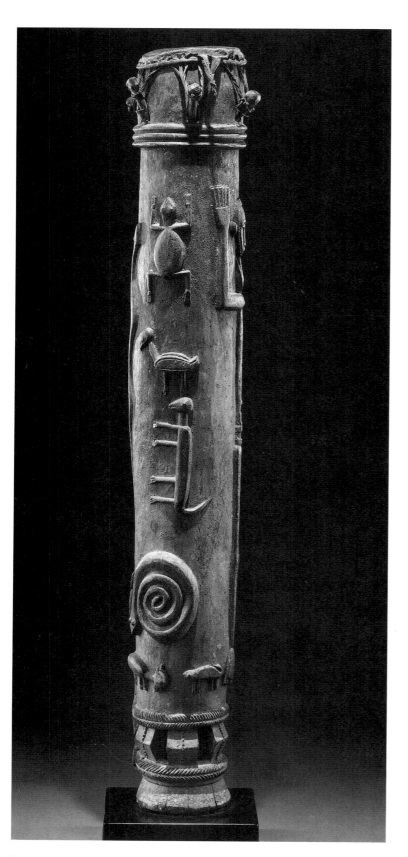

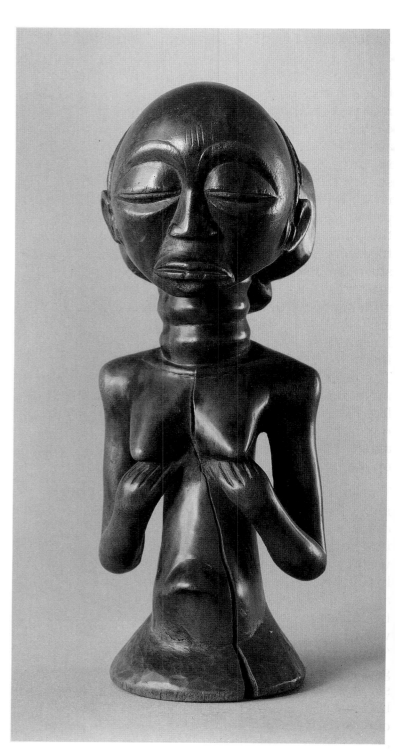

Half figure, Hemba, Zaire. Wood, 9 in. The Metropolitan Museum of Art, The Michael C. Rockefeller Memorial Collection, selected by the author.

Drum, Baule, Ivory Coast. Wood, leather, 50½ in. The Detroit Institute of Arts collection.

African traditional art is meaning, more than anything else. Aesthetics are equally important. I started with aesthetic studies. I will end with them. But attractive to me at this point in my career is African iconology.'' Ekpo Eyo remarks that each response completes the other: ''Appreciating a work of art must be at two levels: the level of instant aesthetic impulse and the level of understanding the context. However, if one is not familiar with context, one has to rely on aesthetic impulse. I don't think one is more important than the other. They are complementary.'' He goes further to suggest that an intermingling of scholarship and emotional aesthetic response leads to understanding when he speaks of his personal experience with archaeological objects: ''The more I looked at them, the more I studied them, the more I appreciated their beauty over and above the information about their context. They were beautiful! The more I described them and handled them, the more emotionally attached to them I became. It's like having a baby: you look at the baby all the time, and you begin to discover many things about it which you could not see at first. My eyes opened.''

The statements of Lela Kouakou, who lives immersed in the very context of African art, stand in dramatic contrast to the others in this regard. His understanding of the character and meaning of the works is so complete that, like other members of his culture, he entwines content and form inseparably. His deep feelings about these objects spring from his intense faith, and intermingle reactions to what he sees with reactions to what he knows. ''This is the Dye sacred mask,'' he says. ''The Dye god is a dance of rejoicing for us men. So when I see the mask, my heart is filled with joy. I like it because of the horns and the eyes. The horns curve nicely, and I like the placement of the eyes and ears. In addition, it executes very interesting and graceful dance steps.''

In its original African context, works of art have multiple meanings, often layers of significance which are different for different people. An individual's grade in initiation, for example, his or her right to know secret information, as well as factors such as age, sex, family or other affiliation determine understanding of works of art. Most works have a superficial meaning that is known to everyone. For masks this is often a simple moral lesson, and the sheer entertainment value that virtually all mask performances have, even the most sacred. Deeper levels of meaning, often based on complex and overlapping symbolic systems, are known only to the most thoughtful individuals. The knowledgeable are often elders because only they have experienced all the elements of the culture, some of which are rarely seen.

Similarly, as it has voyaged forth into the wider world, African art has acquired multiple meanings never intended by its makers. To cite my own field experience, a certain Baule mask in the collection of the Musee de l'Homme is of capital importance to me as an art historian because it was one of the earliest to be documented and published. I also see it in terms of the opposition between the village and the wilderness that is at the core of Baule philosophy. For young people in the Baule village where I lived, masks of its type were simply the most stunning of the mask series that appeared in a day long celebration; for Lela Kouakou its type is beautiful of form and dramatic in performance (see p.158); for Alany Kouadio Soule, an elder I knew, it represented the supreme product of Baule civilization, a moral and physical ideal that contrasted with the images of slaves and foreigners that precede it in the dance. For most people living in the Ivory Coast it is a symbol of modernity and advancing technology because it is the logo of Energie Electrique de Cote d'Ivoire, the national electric power company. There are, of course, myriad examples of similar radical, unplanned shifts in the meanings of works of art, most of them not African.

There is every evidence that in Africa for centuries art forms have moved from one ethnic group to another without retaining their original meanings. Thus a masquerade whose main significance was the exposition of clan histories and relationships was adopted by a neighboring people who, having no clans, altered it slightly, and attributed to it a new meaning relevant to hierarchies which

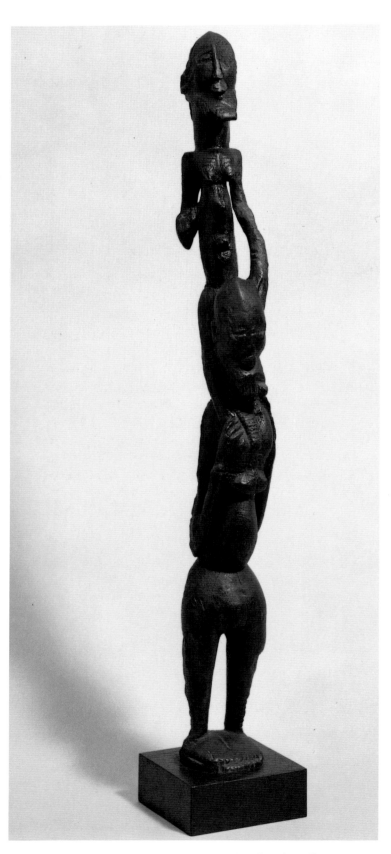

Double figure, Dogon, Mali. Wood, 22 in. Gordon Douglas collection, selected by the author.

are their preoccupation. They insist that their version of the masquerade is identical to the original. The originators of the masquerade consider the new version preposterous and ignorant (sentiments the artists who made the works in this book might feel if they ever knew the comments it contains).

Western culture has appropriated African art and attributed to it meanings that reflect our own preoccupations. Though this process is analogous to the transfer of the masquerade mentioned above, there are important differences. We have acquired not a version, but the original works themselves. We are aware that the meanings we give to these visitors in our homes and museums are not those that inspired their creators.

Many Westerners feel too sharply their ignorance of the original context of African art and are too ready to let it blind them to its visible qualities. They are less daunted by the impossibility of seeing *any* work of art with the eyes of the original audience —much less those of the artist. The cultural context of the world's art, particularly that large segment of the world's art which is religious in inspiration, is remote from the contemporary museum going public. If nothing else, the aura of faith with which it was regarded by its intended audience, a central part of their apprehension of the work, is missing for most of us. We can be insiders only in our own culture and our own time.

Now that African art has generally been accepted as art, we face the alternative errors of assuming that we understand it, or that we can never understand it. On the one hand, the increasing presence of African figures and masks in fashionable interiors and in museum halls lends these objects a spurious familiarity. As their forms become familiar (aided by a superficial resemblance to the art of our own century), African sculpture runs the risk of becoming banal without ever having been understood on its own terms. On the other hand, to insist on the obscurity of the cultural context of African art is to push it again outside the realm of the world's art.

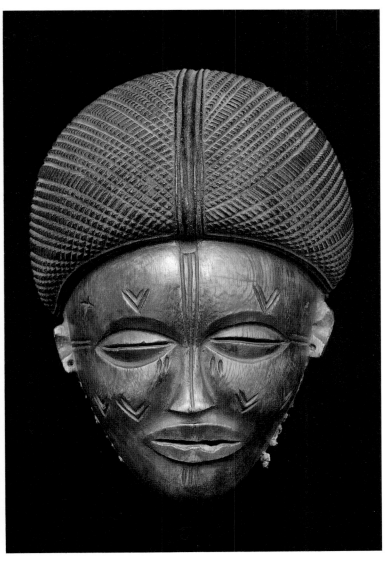

Mask, Ovimbundu, Angola. Wood, 12¼ in. Beatrice Riese collection, selected by the author.

The debate over the *Primitivism* exhibition[3]contained numerous assertions to the effect that we Westerners could perhaps never understand this art, that it belongs to a realm of magic and strange rituals so far from anything we have ever encountered as to be unknowable. But this itself is an interpretation of African art, albeit a reading based on an ancient stereotype. It belongs to a vision of Africa precious to the Western psyche—Africa as other, as obscure. Africa's existence as something so different from us that we may have to redefine humanity or civilization to include it is an idea ever refuted, but like the Hydra, ever reappearing.

I do not deny Africa's uniqueness, the variety and difference of its civilizations—far from it. But I would assert that its uniqueness lies above all in the genius of the artists who created forms the like of which had never before been seen.

Part of the very definition of art is the object's ability to transcend its own cultural moment, to speak to us across time and space. We can no longer deny that ability to African art. The texts in this book attest to that ability, and to the many voices heard in African art today. None can be called right or wrong. None can be called complete.

Susan Vogel

1. *Aspects of Primitive Art* by Robert Redfield, Melville J. Herskovits, and Gordon F. Ekholm, The Museum of Primitive Art, 1959, pp. 8–9.

2. Showing him the same assortment of photos the others saw would have been interesting, but confusing in terms of the reactions we sought here. Field aesthetics studies, my own and others, have shown that African informants will criticize sculptures from other ethnic groups in terms of their own traditional criteria, often assuming that such works are simply inept carvings of their own aesthetic tradition.

3. Primitivism and Twentieth Century Art, organized by William Rubin and Kirk Varnedoe at the Museum of Modern Art, 1984; discussed in many periodicals including: Thomas McEvilley in *Artforum* November 1984, February, and May 1985; Arthur Danto in *The Nation* December 1984.

CHECKLIST

All objects date from 19th-20th centuries unless otherwise noted.

Page 37
Double Bowl
Luba-Shankadi, Zaire
Wood L. 14½ in.
Mr. and Mrs. Joseph M. Goldenberg Collection

A bowl figure was part of the insignia of all Luba rulers and may represent the ruler's first wife who served as the locus for his protecting spirit.

Page 38
Double Figure
Chamba, Nigeria
Wood and pigment H. 21 in.
Robert and Nancy Nooter Collection

This male/female couple sharing a single pair of legs is attributed to neighbors of the Mumuye, the Chamba, who inhabit a region just south of the Benue River.

Page 39
Figure
Northern Nigeria
Wood H. 12 in.
Robert and Nancy Nooter Collection

The sagital crest relates this cubistic figure to the art of Northern Nigeria, though its active pose and dynamism distinguish it from much African art which portrays a static, timeless ideal.

Page 40
Female Figure
Bongo, Sudan
Wood H. 73 in.
Francesco Pelizzi Collection

At the death of a high-status individual, the Bongo construct a stone mound where they place an ensemble of wooden figures both abstract and naturalistic—to honor the family of the deceased.

Page 41
Male Figure
Tiv, Nigeria
Wood H. 65 in.
Francesco Pelizzi Collection

Male figures mounted on posts are commonly found from the Tiv area east and are often related to funerary contexts.

Page 42
Mask
Dan, Liberia
Wood H. 10 in.
Private Collection

Dan masks embody powerful spirits who instruct and lend guidance to humankind during communal crises (war, famine) or celebrations (initiation, entertainment); this mask represents a gentle spirit whose responsibility may have been to collect food from villagers for boys secluded in the initiation camp.

Page 43
Female Figure
Dogon, Mali, possibly 14–17th century
Wood H. 75 in.
Leloup Inc.

This hermaphrodite with its raised arms and miniature figures flanking the navel seems to represent one of the Dogon founding ancestors, and upholds a fundamental Dogon belief that all human beings at birth possess both male and female characteristics. Stylistic similarities suggest that it may be contemporary with archaeological finds from Djenne dating from the 12th to the 17th centuries.

Page 44
Stool
Dogon, Mali, date unknown
Wood H. 14½ in.
Francesco Pelizzi Collection

A religious object, this stool symbolizes the earthly and supernatural realms mediated by the eight mythical ancestors who introduced the arts of civilization - agriculture, weaving, and divination to the Dogon people.

Page 46
Standing Female Figure
Bamana, Mali
Wood, metal, beads, leather H. 20⅜ in.
The Detroit Institute of Arts,
Bequest of Robert H. Tannahill

Called *nyeleni* ("pretty little one" or "little ornament"), this figure was used in public dance performances by members of the Jo initiation society to advertise their new adult status and their desire for marriage.

Page 47
Oshe Shango Dance Staff
Yoruba, Nigeria
Wood and metal H. 19 in.
Robert and Nancy Nooter Collection

Staffs topped by a symbolic axe are carried by devotees of the God of Lightning Shango, at annual festivals to honor this important deity in the Yoruba pantheon.

Page 53
Mask
Makonde, Mozambique
Wood, wax, human hair H. 10½ in.
Private Collection

Makonde helmet masks with facial scars and filed teeth are worn at the coming-out ceremonies of young initiates which celebrate their hard-earned membership into adulthood.

Page 54
Mask
Aduma, Gabon
Wood H. 14½ in.
Lawrence Gussman Collection

Although they traditionally functioned in initation rites, today Aduma masks with their geometric quadrants of color are used primarily for entertainment.

Page 55
Reliquary Guardian
Mahongwe, Gabon
Wood and brass H. 23 in.
Lawrence Gussman Collection

Highly abstract figures covered with brass and copper sheeting are made to surmount the relics of important deceased persons and form part of an ancestral cult that extends throughout Gabon.

Page 56
Female Figure
Dogon, Mali
Wood H. 22 in.
Private Collection

The coiffure, incised ornaments, and gesture of hands on abdomen allude to fertility, and suggest that this female figure—attributed to the Master of Ogol—may have been carved for an altar dedicated to the souls of deceased pregnant women.

Page 57
Reliquary Guardian
Fang, Gabon
Wood and tacks H. 15 in.
Drs. Daniel and Marian Malcolm
Collection

Fang figures are made for a family cult known as *bieri,* which honors ancestral spirits and protects the remains of the dead from forces of ill-will.

Page 58
Figure
Bembe, Zaire
Wood and cloth H. 19½ in.
Museum of Cultural History, University of California, Los Angeles

This figure belongs to a southern Zairian style complex called the "pre-Bembe hunters," who honored heroic ancestors and anonymous founders of lineages and chiefdoms through figure sculpture.

Page 59
Mask
Pende, Zaire
Wood, paint and fiber H. 13 in.
Gustave and Franyo Schindler Collection

Pende face masks represent about twenty different social types, such as "the diviner," "the executioner," "the chief," and "epileptic," and appear in theatrical skits following circumcision rites.

Page 60
Mask
Grebo, Liberia
Wood H. 21 in.
Mr. and Mrs. Saul Stanoff Collection

Flat facial planes with protruding cylindrical eyes represent the most geometric tendency in the art of the Grebo, a Kru-speaking people inhabiting the dense primeval forest of southwestern Ivory Coast.

Page 63
Musical Instrument
Zande, Zaire
Wood, skin L. 25 in.
Alan L. Lieberman Collection

Such harps were used by itinerant musicians among the Zande and neighboring groups, and may also have served as status symbols for certain highly born individuals.

Page 62
Female Figure
Mfute, Cameroon
Wood H. 25 in.
Private Collection

Far from random, the forms of this figure represent a very studied reinvention of the human body and reflect the extraordinary variety of forms in this region of northwestern Cameroon where many small social groups coexist.

Page 69
Mask
Mbagani, Zaire
Wood and paint H. 15 in.
Gustave and Franyo Schindler Collection

Mbagani masks appear at circumcision and initiation rites, and share many characteristics with the art styles of their neighbors, the Luluwa and Lwalwa.

Page 70
Female Figure
Luba-Shankadi, Zaire
Wood H. 15½ in.
Udo Horstmann Collection

This sculpture displays the bold angularity and cascading coiffure typical of the Shankadi style.

Page 71
Female Figure
Senufo, Ivory Coast
Wood H. 47½ in.
Rolin Gallery Collection

Men wearing fiber masks carry figures like this one during funeral rites, swinging them from side to side and rhythmically striking the ground in time with horns and drums of the funeral orchestra.

Page 72
Female Figure
Bamana, Mali
Wood H. 19½ in.
Cecilia and Irwin Smiley Collection

This figure depicts ideal qualities of young marriageable Bamana women—slender torso, swelling abdomen, full buttocks, and large firm breasts—and represents the kind of woman its initiated male owner sought to marry.

Page 73
Door
Ishan, Nigeria
Wood H. 52 in.
Shango Galleries

Doors carved from a single piece of wood turn on the protruding pegs which were inserted into sockets in the doorframe. The designs in low relief may have indicated a special function for the room to which the door led.

Page 74
Mother and Child
Dogon, Mali
Wood H. 18 in.
The Graham Collection

Figures with raised arms and encrusted surfaces found in caves situated high above present-day Dogon villages are attributed by some scholars to the Tellem, previous inhabitants of the Bandiagara escarpment.

Page 75
Rhythm Pounder
Senufo, Ivory Coast
Wood H. 39 in.
Private Collection

Large standing figures with heavy bases were held by the arms and pounded on the ground to mark the rhythm of Senufo funeral processions.

Page 76
Male Figure
Kusu, Zaire
Wood H. 32 in.
Jay and Clayre Haft Collection

The Kusu and their southern Hemba neighbors share a tradition of large figures honoring important lineage ancestors who assure the well-being of the living.

Page 77
Bowl
Yoruba, Nigeria
Wood H. 11¾ in.
The Newark Museum Collection

The cup surmounting this mounted warrior once held the sixteen palm nuts used in Yoruba divination by an Ifa priest to determine the causes and cures for his clients' misfortune.

Page 78
Ikenga Figure
Igbo, Nigeria
Wood H. 30½ in.
Mrs. Marjorie L. Lewis Collection

Ambitious Igbo men establish shrines called Ikenga to celebrate their success in warfare and title-taking. The masculine forms and powerful horns bespeak strength, status, and aggression.

Page 85
Society Emblem
Ejagham, Nigeria
Raffia, animal skulls, caning, wood and rope
H. 48 in.
New Orleans Museum of Art, Gift of Jeanne Nathan and Robert Tannen in honor of William A. Fagaly

This accumulative composition once adorned a meeting house of the men's Ekpe association where it served as an emblem of a particular senior grade.

Page 86
Pipe Bowl
Yaka, Zaire
Wood, iron and beads H. 3 in.
Marc and Denyse Ginzberg Collection

Elaborate pipes with human imagery reflect the high status of their owners and the value accorded tobacco, which is smoked both for pleasure and for ritual purposes throughout Africa.

Page 87
Female Figure
Kongo, Zaire
Ivory H. 3 in.
Drs. Daniel and Marian Malcolm Collection

Ivory figures often adorned the tops of staffs used as royal insignia.

Page 88
Monkey Figure
Baule, Ivory Coast
Wood and cloth H. 27 in.
Jay and Clayre Haft Collection

Baule monkey figures, seen as frightening and powerful, are used by divination cults and by men's associations seeking protection from malefactors.

Page 89
Power Figure: Dog
Kongo, Zaire
Wood, iron and other materials L. 27⅛ in.
Rolin Gallery Collection

Nail figures associated with law and justice sometimes depict dogs because they are keen hunters by nature and can track down criminals in the darkness.

Page 90
Female Figure
Senufo, Ivory Coast
Wood H. 9¾ in.
Private Collection

Such figures are placed in the sacred forest grove of the men's Poro Society, where men make blood sacrifices in honor of the deity, Ancient Mother—a reminder that Poro originally was the prerogative of women.

Page 91
Neckrest
Shona, Zimbabwe
Wood, H. 7 in.
Armand Arman Collection

In the African heat, the coolest, most comfortable pillows are those made of wood; by raising the head above the ground, neckrests help to protect elaborate, labor-intensive coiffures.

Page 92
Mask
Grebo, Liberia
Wood, cloth, horn, other materials
H. 15½ in.
The Fine Arts Museums of San Francisco Gift of Marc and Ruth Franklin

Although little is known of its function, the abstract quality of this mask derived from its combination of human and animal features is characteristic of this area.

Page 93
Nimba Headdress
Baga, Guinea
Wood H. 47 in.
Dallas Museum of Art, The Gustave and Franyo Schindler Collection of African Sculpture, gift of the McDermott Foundation in honor of Eugene McDermott

Nimba headdresses represent the goddess of fertility who assures life-giving rain and prevents natural disasters such as drought, pestilence, and disease.

Page 94
Heddle Pulleys
Baule and Guro, Ivory Coast
Wood H. 6½ in., 6¾ in.
Private Collection

The Guro and Baule are renowned for the delicate carving of their heddle pulleys, an instrument which raises and lowers the heddles on West African strip-weave looms.

Page 101
Figure
Mumuye, Nigeria
Wood H. 25 ¼ in.
Drs. Daniel and Marian Malcolm Collection

Mumuye figures are as diverse in form as in function, serving as oracles, healing aids, and embodiments of tutelary spirits.

Page 102
Pendant Mask
Nigeria, date unknown
Bronze H. 7½ in.
Mr. and Mrs. Arnold Syrop Collection

Cast by the lost wax method, this bronze mask recalls pendant masks of Benin which were worn on the belts of kings and other high-ranking officials for occasions of state.

Page 103
Mask
We, Liberia
Wood H. 12½ in.
Mr. and Mrs. Brian S. Leyden Collection

A variety of mask designs served a broad range of functions in this area, but masks often served as agents of social control.

Page 104
Female Figure
Bamana, Mali
Wood H. 35 in.
Marc and Ruth Franklin Collection

This kind of figure is displayed during public dance performances by male initiates who have undergone six years of intense instruction culminating in a symbolic death from which they are reborn as young adults.

Page 105
Ritual Object
Baga, Guinea
Wood L. 24 in.
Mr. and Mrs. William W. Brill Collection

The combination of bird, antelope, and human features allowed the *elek* to protect members of its lineage by pursuing witches and evildoers.

Page 106
Mask
Ligbi, Ivory Coast
Wood H. 14⅝ in.
Minneapolis Institute of Art

These masks are reported to be linked to Muslim elements in Ligbi villages where they appear to protect people from sorcery.

Page 107
Figure
Mumuye, Nigeria
Wood H. 29 in.
Private Collection

Mumuye figures are used by individual diviners and healers as well as by elders, for whom they reinforce status and embody spirits protective of the entire lineage.

Page 108
Combs Yaka, Zaire
Wood H. 8 in.
Marc and Denyse Ginzberg Collection

The aesthetic and social importance of coiffures in Africa is reflected in the elegance of these carved combs, one of which possesses the exaggerated, upturned nose that the Yaka associate with male fertility.

Page 110
Four-Faced Headdress
Bamileke, Cameroon
Wood, W. 12⅜ in.
Private Collection

The costume for this headdress was a long enveloping gown which gave the dancer a shapeless appearance. Janus-faced images often refer to religious or cosmic dualities.

Page 111
Seated Figure
Kongo, Zaire
Wood and porcelain H. 8½ in.
The Fine Arts Museums of San Francisco
Gift of Henry J. Crocker Estate

Sanctified by a diviner, this figure is the receptacle for an eminent ancestor whose status is indicated by the prestigious fly whisk he holds in his right hand.

Page 117
Male/Female Pair
Madagascar
Wood H. 32 in.
William and Niki Wright Collection

Figurative sculpture decorates commemorative grave posts in many areas of Madagascar. The implications of this couple evoke life and continuity, considered appropriate themes for a funerary context.

Page 118
Stool
Luba, Zaire
Wood H. 13½ in.
The Detroit Institute of Arts, Founders Society Purchase, Eleanor Clay Ford Fund for African Art

Though attributed to the Luba, this caryatid stool incorporates elements of several styles including Songye and Holo, and it reflects the historical overlapping of ethnic groups in southeastern Zaire during the height of Luba expansion in the nineteenth century.

Page 119
Staff
Luba, Zaire
Wood, beads and natural fiber H. 41 in.
Seattle Art Museum, Katherine C. White Collection

Eminent Luba persons carry staffs of office adorned with female figures to signify high social standing and descendance from the royal matrilineal line.

Page 120
Mother and Child
Kongo, Zaire
Wood, brass tacks, glass H. 11 in.
Private Collection

In their composure and ephemeral beauty, Kongo maternity figures evoke an ideal of social and aesthetic perfection, and are thought to derive from the ancient kingdom of Mani which flourished in the 15th and 16th centuries.

Page 121
Culture Hero
Chokwe, Angola
Wood H. 14⅝ in.
Private Collection

In Chokwe history, the institution of divine kingship was introduced by a Luba hunter from the east known as Chibidi Ilunga, represented here with a massive coiffure indicating royalty.

Page 122
Mask
Dan, Liberia
Wood, porcelain, iron and rope H. 13 in.
New Orleans Museum of Art, Bequest of Victor K. Kiam

Through its aggressive forms, this mask evokes the untamed, dangerous realm of the bush and would have been worn with a costume constructed from forest materials like raffia, feathers, and animal fangs.

Page 123
Figural Scene
Djenne, Mali 14–17th century
Terra-cotta L. 23½ in.
Private Collection

This enigmatic figurative scene belongs to a rich tradition uncovered from the mounds of Jenne-Jeno, an ancient town whose civilization flourished from approximately the 7th to 18th centuries.

Page 124
Man with a Bicycle
Yoruba, Nigeria 20th century
Wood and paint H. 35¾ in.
The Newark Museum

The influence of the Western world is revealed in the clothes and bicycle of this neo-traditional Yoruba sculpture which probably represents a merchant en route to market.

Page 125
Mask
Yoruba, Nigeria
Wood and traces of white and blue pigment H. 7¼ in.
Larry Mark Goldblatt Collection

The Efe/Gelede masquerade is held annually to propitiate elderly, ancestral, and deified women called "our mothers," who are thought to possess heightened spiritual knowledge.

Page 126
Stool
Wum, Cameroon
Wood H. 15 in.
Fred and Rita Richman Collection

Decorated stools supported by human and animal caryatids were reserved for nobles whose high status entitled them to sit during ceremonial occasions.

Page 133
Gelede Mask
Yoruba, Nigeria
Wood H. 10½ in.
Private Collection

Elder women, both respected and feared in Yoruba society because of their spiritual power, are appeased through the Gelede masquerade at which the artistry of dozens of dancers, musicians, singers, and mask carvers is displayed.

Page 134
Bronze Vessel
Djenne, Mali 14–17th century
Bronze H. 5¾ in.
Mr. and Mrs. Arnold Syrop Collection

Though the use and symbolic meaning of this bronze vessel is not known, most bronzes from the inland Niger Delta come from earthen *tumuli,* and some have been dated to 1,000 A.D.

Page 135
Arm
Nok, Nigeria 500 B.C.—200 A.D.
Terra-cotta L. 9 in.
Private Collection

Once part of a large figure, this detailed, sensitively rendered arm reflects the sophistication and realism of Nok art, subsaharan Africa's earliest known sculptural tradition.

Page 136, 137
Reliquary Head
Fang, Gabon
Wood H. 13¾ in.
Private Collection

The Fang carve guardian heads and figures to surmount boxes containing ancestral relics and to ward off intruders from the family sanctuary.

Page 138
Female Figure
Fanti, Ghana 20th century
Wood H. 16⅛ in.
The Baltimore Museum of Art: Purchased as a gift of Robert A. and Margot W. Milch in honor of Janet and Alan Wurtzburger

Such figures often served as both a plaything for young girls and a votive object for young women, either pregnant or wishing to become so, who wanted to ensure the birth of a healthy and beautiful child. (See note, p.29)

Page 139
Horse and Rider
Bamana, Mali
Wood, H. 23⅛ in.
Private Collection

The equestrian motif is not uncommon in the art of the Western Sudan, where the horse was introduced from North Africa and became a symbol par excellence of worldliness and wealth.

Page 140
Antelope Headdress
Bamana, Mali
Wood, cotton, iron L. 23 in.
Ernst Anspach Collection

The Bamana honor their god of agriculture, an antelope, in masked performances in which a male/female pair enacts the planting of the first seeds.

Page 141
Mask
Ngunie River, Gabon
Wood H. 12 in.
Beatrice Riese Collection

At funeral rites among Ngunie-speaking peoples, stilt dancers wear feminine masks to evoke the return of young maidens to participate in the human realm.

Page 142
Seated Figure
Idoma, Nigeria
Wood and pigment H. 17 in.
The Metropolitan Museum of Art, Purchase, Rogers Fund, 1972

The Idoma place *anjenu* figures in shrines to appease "bushspirits" who inhabit the termite mounds and rivers, and who control the destiny of the living.

Page 143
Helmet Mask
Senufo, Ivory Coast
Wood L. 31½ in.
David Rockefeller Collection

Senufo helmet masks—assemblages of warthog tusks, antelope horns, and chameleons—are worn at Senufo funeral rites to evoke the "open and devouring jaws of death."

Page 149
Male/Female Couple
Baule, Ivory Coast
Wood H. 15 in.
The Stanley Collection, The University of Iowa Museum of Art

The representation of the female as larger than the male is not uncommon among the Baule, who carve single and paired figures for shrines to propitiate nature spirits who may disrupt a person's life by means of illness, sterility, or death.

Page 150
Spoon
Baule, Ivory Coast
Wood H. 6¾ in.
Mr. and Mrs. David B. Ross Collection

Like most Africans, the Baule traditionally ate with their hands, but decorated wooden spoons were used in special contexts, and occasionally by elders.

Page 151
Seated Male Figure
Baule, Ivory Coast
Wood H. 15¼ in.
Marc and Denyse Ginzberg Collection

This figure displays many signs of prestige—a finely carved stool, elaborate coiffure and braided beard, and beads. It probably formed part of the shrine for a nature spirit which may have included other sculptures.

Page 152
Gong Beater (*lawle*)
Baule, Ivory Coast
Wood, brass studs, cotton cloth H. 10 in.
Valerie Franklin Collection

Elaborate little gong beaters called *lawle* are used by professional spirit mediums during divinations which determine the causes and cures for clients' misfortunes.

Page 153
Female Figure
Baule, Ivory Coast
Wood H. 12½ in.
The Detroit Institute of Arts, Founders Society Purchase, Eleanor Clay Ford Fund for African Art

This probably served as the spirit wife of a man who kept it in his sleeping chamber at the center of a small private shrine. Offerings to her helped promote his personal wellbeing.

Page 154, 155
Pair of Face Masks
Baule, Ivory Coast
Wood and paint H. 16⅛ in., 15¾ in.
Field Museum of Natural History

Baule Goli masks usually perform in male-female pairs (eight in all) at entertainment events and funeral rites to represent a hierarchy based on the family.

Page 156
Monkey Figure
Baule, Ivory Coast
Wood and cloth H. 21½ in.
Private Collection

The function of monkey figures is poorly understood because it is sometimes secret, and also because they have different uses and meanings in different areas.

Page 157
Ointment Jar
Baule, Ivory Coast
Wood H. 8⅝ in.
The Carlo Monzino Collection

Shea butter, made from an aromatic nut and used as a body lotion throughout West Africa, is also an ingredient in modern Western cosmetics.

Page 158
Helmet Mask
Baule, Ivory Coast
Wood, pigment and eggshell H. 33¾ in.
The Metropolitan Museum of Art, The Michael C. Rockefeller Memorial Collection, Gift of Adrian Pascal LaGamma, 1973

Helmet masks depicting horned animals with square snouts and bared teeth are called "gods of the bush," or "men's gods," and are danced at funerals and for social control.

Page 159
Mask Surmounted by a Rooster
Baule, Ivory Coast
Wood H. 16½ in.
Mr. and Mrs. Stanley Marcus Collection

This mask was probably carved as a portrait of a particular person distinguished for his or her dancing skill, beauty, or political importance.

Page 165
Doll
Omdurman, Sudan
Wood, clay, vegetable matter H. 20½ in.
Cincinnati Art Museum, Gift of Mrs. Charles Fleischmann and Mrs. Julius Fleischmann

In most parts of Africa, dolls serve a dual purpose as playthings and as fertility figures, and may be given to young brides in the hope of promoting a healthy and prosperous family.

Page 166
Mask
Mao, Ivory Coast
Wood, metal, fiber and oil H. 17½ in.
Cecilia and Irwin Smiley Collection

Little is known of the function of this mask. Applied metal ornaments characterize the wood sculpture style of such neighboring groups as the Marka to the north (Mali) and the Dan to the south (Liberia and Ivory Coast).

Page 167
Mask
Bwa, Burkina Faso
Wood and pigment W. 110 in.
Mr. and Mrs. Thomas G. B. Wheelock Collection

Bwa masks in the form of butterflies appear at festivals to celebrate the beginning of the farming season, since swarms of butterflies signal the arrival of rains.

Page 168
Figure
Kulango, Ivory Coast
Wood H. 25¾ in.
Mr. and Mrs. Thomas G. B. Wheelock Collection

Although a number of these stylistically related figures have appeared in collections, little is known of their function. The erosion of the feet, possibly due to insect damage, may be evidence that they stood on the ground near an altar or shrine.

Page 169
Female Figure
Lulua, Zaire
Wood H. 19¼ in.
Marc and Denyse Ginzberg Collection

Lulua female figures were used by members of a cult, *tshi bola*, which assured the fertility of the people and the reincarnation of still-born infants.

Page 170
Pendant
Luba, Zaire
Ivory H. 3⅞ in.
Marc and Denyse Ginzberg Collection

This small pendant was suspended from a string draped diagonally across the chest of a Luba elder. The smooth satinlike patina resulted from years of wear.

Page 171
Staff
Shona, Zimbabwe
Wood and iron H. 28¾ in.
Marc and Denyse Ginzberg Collection

Knives with complex structural designs were held by many peoples of southern Africa like staves, to display prestige and wealth.

Page 172
Mask
Kongo, Zaire
Wood H. 14 in.
Private Collection

Among the Kongo, masks are worn with enormous banana leaf costumes during protective ceremonies, funerals, and investitures to affirm the proper use of royal power.

Page 174
Ikenga Figure
Igbo, Nigeria
Wood H. 19⅛ in.
The Metropolitan Museum of Art, The Michael C. Rockefeller Memorial Collection, Purchase, John R. H. Blum Gift, 1971

This *ikenga* wears a warrior's grass skirt and carries the iron staff and carved ivory tusk of men who have achieved Ozo, the highest titled rank in Igbo society.

Page 175
Bronze Staff
Soninke, Guinea
Bronze and iron H. 27½ in.
The Metropolitan Museum of Art, The
Michael C. Rockefeller Memorial
Collection, Bequest of Nelson A.
Rockefeller

Iron staffs with cast bronze finials were
often insignia of chief's families, or were
purchased by initiation associations or in-
dividuals and placed around altars as en-
hancements of power.

Page 181
Figure
Kongo, Zaire
Wood with screws, nails, blades, cowrie
shells H. 46¾ in.
The Detroit Institute of Arts, Eleanor Clay
Ford Fund for African Art, 76.79

Such figures functioned primarily as oath-
taking devices: their power was activated
or engaged when a nail or piece of metal
was driven into the figure in reference to
a specific problem or request.

Page 182
Female Figure with Lidded Bowl
Yoruba, Nigeria
Wood and pigment H. 18 in.
Cecilia and Irwin Smiley Collection

The figure of a woman supports an offer-
ing bowl in the form of a cock. The bowl
was used to hold kola nuts with which a
host would welcome his guests.

Page 183
Mother and Child
Kongo, Zaire
Wood H. 10¾ in.
Drs. Daniel and Marian Malcolm
Collection

The cap and necklace may indicate a royal
personage, or the wife of one.

Page 184
Scepter
Yombe, Zaire
Ivory, iron and fetish material H. 18½ in.
Virginia Museum of Fine Arts, The
Williams Fund

Symbols of power and wealth abound on
this ivory staff which once formed part of
the regalia of a Kongo chief.

Page 185
Power Figure
Kongo, Zaire
Wood, glass, beads, fur and tucula pow-
der H. 8¼ in.
Ernst Anspach Collection

Power figures are accumulative works
formed as much by the users as by the
artist: the artist makes the sculptural
framework which is then activated by a
priest, who attaches magical ingredients
and seals them with a mirror.

Page 186
Hook Figure
Lumbo, Gabon
Wood H. 5¾ in.
Mr. and Mrs. Benton Case Jr. Collection

Small Lumbo figures, usually representing
women, were carried to protect their own-
ers from witchcraft. Carved figures also
often adorned seats, canes, sceptres, fan
handles, and musical instruments. The
hook-shaped coiffure is characteristic.

Page 187
Seated Female Figure
Kongo, Zaire
Wood H. 7 in.
Faith-dorian and Martin Wright Collection

The separated, horizontally placed head is
an uncommon, although not unique, oc-
currence in African figures. It may denote
mourning.

Page 189
Housepost
Yoruba, Nigeria
Wood H. 65 in.
Merton Simpson Collection

This post, depicting a crowned king with
his senior wife, was commissioned by
Ogoga, King of Ekere, from the artist
Olowe of Ise-Ekiti to adorn the inner
courtyard verandah of the king's palace.

Page 190
Mask
Fang, Gabon
Wood H. 25½ in.
Lawrence Gussman Collection

This mask, with its elongated, abstract features, was used by the Ngil association, whose purpose was to enforce law and justice.

Page 191
Power Figure
Kongo, Zaire
Wood, fabric, beads, mixed media
H. 8⅝ in.
Robert Aaron Young Collection

This figure's power lies in the medicinal substances inserted in her head and stomach, which allowed her to deflect evil and cast misfortune upon her owner's enemies.

It is the desire of The Baltimore Museum of Art to make public the fact that the authenticity of the Fante figure in its collection has been challenged. Although the figure was authenticated by several distinguished scholars of the area prior to its acquisition by the Museum, it has since been seen by Doran Ross, of the UCLA Museum of Cultural History, who attributes it to the workshop of Francis Akwasi, of Kumase. The Kumase workshop specializes in carvings for the international market in the style of traditional sculpture. Many of its works are now in museums throughout the West, and were published as authentic by Cole and Ross (l977). Since that publication, however, Ross has discovered the workshop, and has corrected their error in his article with R. Reichert (1983). In personal communication (1984), Ross has pointed out that the Baltimore *akua ba* compares closely with two figures (101a & 102a) in that article, and that he has seen at least six Fante *akua mma* carved by Akwasi conforming to it. It is notable that there seems to be no precedent for Fante *akua ba* figures either blackened, or with this degree of formal and ornamental articulation. Concerning the apparent signs of wear and use, Ross reports that the carvers' apprentices spend extraordinary care in replicating this effect, and, indeed, no evidence of falsification of the surface of the figure could be detected under laboratory analysis at The Baltimore Museum.

Frederick Lamp, Curator
Art of Africa, the Americas, & Oceania
The Baltimore Museum of Art

Bibliography:

H.Cole & D. Ross, *The Arts of Ghana*, The University of California, Los Angeles, 1977.

D. Ross & R. Reichert, ''Modern Antiquities: A Study of a Kumase Workshop,'' in D. Ross & T. Garrard, eds., *Akan Transformations: Problems in Ghanaian Art History*, The University of California, Los Angeles, monograph series No. 21, 1983.

Photography Credits

Roger Asselberghs: p.191. Baltimore Museum of Art: p.138. Alan Brandt: p.150, 186. John Buxton: p.73. Mario Carrieri: p.157. Dallas Museum of Art: p.93. Detroit Institute of Arts: p.46, 118, 153. Ekpo Eyo: p.43. Field Museum of Natural History: p.154, 155. Thomas Fiest: p.183. Ron Forth: p.167. Robin Grace: p.169. Zev Greenfield: p.124. J. Hammer: p.53, 56. Eva Inkeri: p.126. Delmar Lipp: p.39, 47. Paul Macapia: p.119. James Medley: p.111. Metropolitan Museum of Art: p.142, 158, 176, 177. Joseph McDonald: p.104. Gary Mortensen: p.106. New Orleans Museum of Art: p.85, 122. Schopplein Studio: p.92. Stephen Sloman: p.40, 41, 44. Sotheby's Inc.: p.70. Allan Stone Gallery: p.174. Steve Tatum: p.149. Jerry Thompson: 42, 54, 55, 57, 59, 69, 71, 72, 74, 75, 76, 77, 78, 86, 87, 88, 89, 90, 91, 94, 101, 102, 103, 105, 107, 108, 110, 117, 120, 121, 123, 124, 134, 135, 136, 139, 140, 141, 143, 151, 156, 168, 170, 171, 172, 173, 182, 185, 187, 190. John Thomson: p. 152. Richard Todd: p. 60. U.C.L.A. Museum of Cultural History: p.58. Virginia Museum of Fine Arts, Ron Jennings: p.184.

CATALOGUE

Dr. Eyo has spent the majority of his professional life with the National Museum of Nigeria. After receiving degrees in anthropology and archaeology, he was the museum's Director of Antiquities from 1968 until his retirement in 1980. During the past twenty years, he has served with distinction in many capacities, including Vice-Chairman on UNESCO's World Heritage Committee, President of the Pan African Congress on Prehistory, as a member of the Science and Grants Committee of the Leakey Foundation, and as President of the Museum Association of Tropical Africa. He is the author of dozens of articles, and numerous books, including *2000 Years of Nigerian Art* and *Treasures of Ancient Nigeria*. In 1986 he moved to the United States where he is currently a professor of Art History at the University of Maryland.

I'm from Calabar, Nigeria, where wood carving is only marginally developed. We live on the coast and, in the past, our economic activities centered around fishing and trading. Our artistic expression was mainly in dance, poetry, and story telling. Our region was among the first to receive Western education in the 1840s. Since Western education came with Christianity, we were taught to look down on these things which the Christian teachings regarded as idols. We were not given the opportunity to go near them. When we came across them, we ran away because we thought they represented evil spirits. What made it worse for me was that my father was a priest. And who would want to see the son of a priest mess around with idols?!

When I left secondary school, I went looking for a job. My parents knew a man who happened to work with Kenneth Murray—the Englishman who was responsible for starting the Antiquities Service in Nigeria. This man told me about a post which was designated Antiquities Assistant. Frankly, I didn't know what it was all about. All I knew was that there was a job, that it would help to keep my body and soul together, and that it would enable me to study at home for university admission qualification. I went in and was given the job as Antiquities Assistant.

Soon after taking the position, there was a religious uprising in Western Nigeria by members of a cult called Atinga. They came into Nigeria from what is now the Republic of Benin. They claimed that they had the power to detect witches. The people would go into a village and they would burn down shrines, and in some cases, burn the houses of people known to keep traditional objects. Often they would bring the objects out into the center of the village and burn them. By this means, they destroyed a great number of art works. So my first job with Kenneth Murray was to go around with him to stop these philistine acts and to salvage the objects.

I was a Christian boy, and it was strange that I should be digging my hands into heaps of rubbish and rescuing what people, including myself, called idols. I followed Murray—not because I realized the importance of what he was doing, but because it was strange to see an Englishman scouting for broken idols from rubbish heaps. Whenever there was an uprising, we followed. This then was my introduction to African art.

When I eventually had the opportunity to enter the university, I decided to study anthropology, and did so at the University of Cambridge. I studied anthropology, not art. These items are connected with living societies, and that's what anthropology is all about. I studied to understand society, to understand why people do what they do, and how these objects were used. I also studied archaeology at post graduate level at the University of London and at the University of Ibadan.

Anthropology, as it was taught at Cambridge, had to do with the study of "other cultures"—i.e., the non-Western world, and these objects were regularly referred to as "fetishes"—particularly in German literature. Otherwise, in the English and American literature, they were referred to as "primitive." They were never looked upon as objects of art. They were looked at then only as objects used by primitive people in their religious, economic, social, and political activities. Throughout my three years at Cambridge, nobody ever mentioned their artistic values. We were aware of collectors who acquired these things, but they acquired them as objects of curiosity and we regarded them as eccentric people. Even after my training, I knew these things only to be associated with the social structure or the religion of people who made them.

The first museum in Nigeria was started in 1948, mainly for the Ife bronzes and terracottas. Kenneth Murray, who knew the importance of these things (which had started showing up in the late 1930s), forced the government to build a museum to house them. When Bernard Fagg, an archaeologist, joined him and discovered the Nok culture and art, a museum was also opened for that, in 1952. There were about six museums by the time I left to study in England. Today, there are seventeen. I returned in 1964 and rejoined the Department of Antiquities.

When I got back to Nigeria, I was posted to Jos, quite near to where, in 1944, Bernard Fagg had excavated a rock shelter. I found that proximity convenient and I started investigating the other half of the rock shelter that Fagg had not done. I then went on to do an ethnographic survey of the Abua people in the Niger Delta area. I was not attracted to big areas like Benin or Ife because they had already been investigated—I wanted something new.

At the beginning of the Civil War, I moved my headquarters from Jos to Lagos. Ife was close by. Fagg was preparing to leave for Oxford, and I was saddled with the responsibility for administering the Antiquities Department in addition to doing field work. I had to arrange to find somewhere close by in which to do field work so as not to leave my desk too long. That is why I chose Ife and I've done several excavations there. The last big thing I did was at Owo, where I discovered the artistic link between Ife and Benin. It was very exciting to see the material out of this excavation; it has thrown so much light on the vexed question of the Ife/Benin relationship, but has not completely resolved the problem.

When, as an archaeologist, I discovered terra–cotta objects in Ife, I was not really looking for art pieces; I was looking for things that would help to reconstruct the history of the Yoruba people. I was so amazed at the things that turned up, that another dimension was added to my search: the artistic dimension. The more I looked at them, the more I studied them, the more I appreciated their beauty, over and above the information about their context. They were beautiful! The more I described them and handled them, the more emotionally attached to them I became. It's like having a baby: you look at the baby all the time, and you begin to discover many things about it which you could not see at first. My eyes opened.

I still remember one night when I got back from my excavation at Owo. Because the Owo site had been vandalized, pieces of sculpture were found in widely separated places. As is the practice in digs, objects discovered in separate squares of the dig were kept separate from one another. One night I had a nightmare and I couldn't sleep. Then, like a dream, I saw two fragments of a terracotta head—one fragment was at one end of the room, the other at the opposite end. They belonged together. It was about two o'clock in the morning, and I jumped into my car and drove to the museum. I opened my laboratory and picked up the piece from one end, and picked up the other piece from the other end. I put them together and it was a beautiful head! It was that kind of emotional involvement.

When you understand a work of art in its context, you can say a lot more. There are many items that I would now admit as works of art which people who are trained

(continued on the next page)

only in art would not. It's because I know the background, the cultural contexts of items. I know why something was made the way it was, and this creates a deeper understanding. If you look at a piece without understanding its meaning, just for the aesthetics, that is an incomplete appreciation. All works of art must speak of social order, must speak of the continuity of society, and must speak of people. They must reflect things around us and they must speak of experiences.

Appreciating a work of art must be at two levels: the level of instant aesthetic impulse and the level of understanding the context. However, if one is not familiar with context, one has to rely on aesthetic impulse. I don't think one is more important than the other. They are complimentary.

Each of these works has something that I find attractive. But generally, they are not the ones which have been reproduced in books over and over again. In my choices, I have tried, though not completely successfully, to get away from materials that had been shown with such frequent regularity, and have tried to find things that are exciting and unusual.

LUBA-SHANKADI DOUBLE BOWL

What fascinates me is the trouble that the artist has taken in putting all these figures together in carrying the bowl. It looks simple at first. Yet the more one looks, the more complex it becomes. I'm intrigued by the embellishment of the ordinary food bowl with such an artistic animal and human motifs. This bowl is meant for the glorification of man rather than the glorification of spirits. It is a secular figure. It is art for art's sake.

I have chosen it just to show the range of things that the African carver can undertake. Many people say that the African carver is only concerned with producing things for shrines, that he spends all his life worshipping his gods. But this bowl gives a different insight into the motivation of African carvers. Not all art is meant for the temple or for shrines. The Yoruba, for example, have carved door panels and carved houseposts for the chiefs. There are all sorts of sculptures which symbolize the position of man in society.

Is it art? Is it craft? Where do you draw the line? For me, I don't think there is a solid line. I have often heard art described as something which provides a visual appeal beyond the utilitarian quality of an object. For me, anything which shows a deeper concept, a leap of imagination (as Janson would say), has transcended any line which would have been drawn between art and craft. While the artist is carving, he is always thinking, always imagining. And sometimes the artist himself can never explain the process by which he has arrived at his final product. This is one such case. I consider this then to be a result of a great "leap of imagination" on the part of its carver. This is good art.

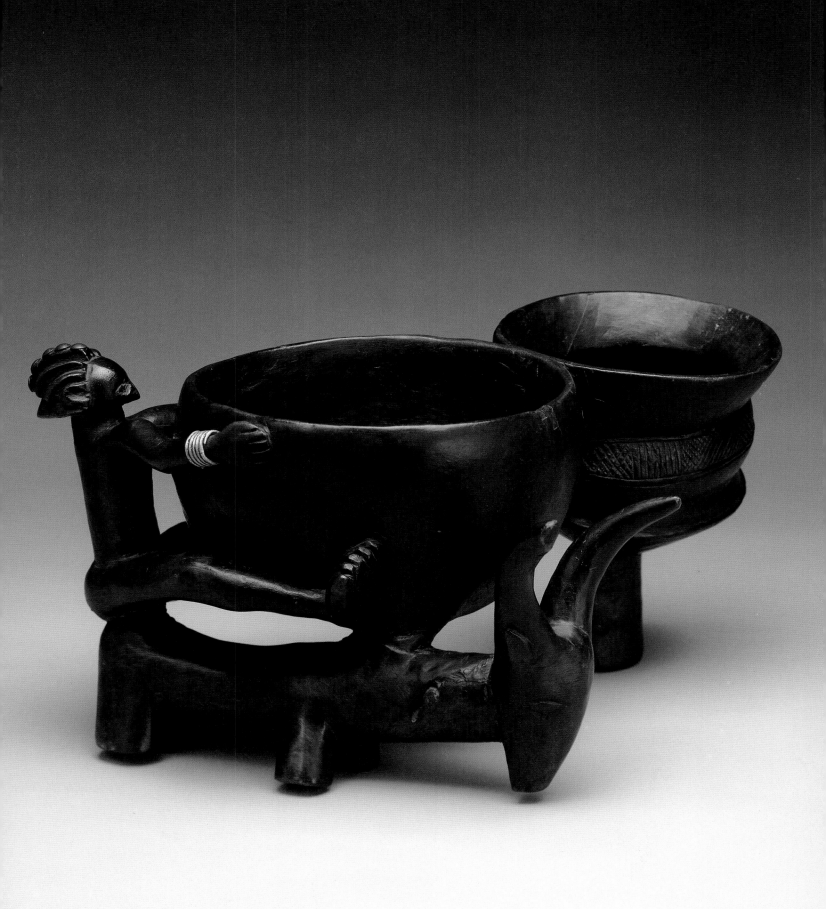

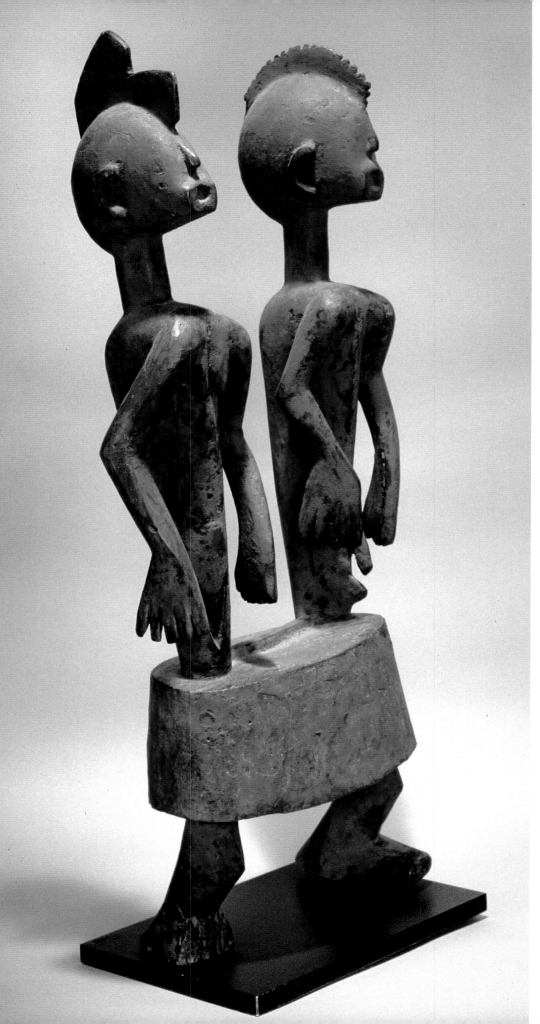

EKPO EYO

CHAMBA DOUBLE FIGURE

I chose this because of its dualism: the male-female dualism. Two objects that are fused into one. They are both very powerful. They are gay, they are happy, they are together, they are healthy, they are hearty. This expression of dualism—that two people have two legs rather than four—is quite a statement. Their faces betray happiness and they are very lively figures. They appear very proud—look at the way they carry their heads. The woman is almost arrogant. They express happiness, satisfaction, and togetherness in such a way that one cannot move forward without the other. One seems to say to the other, "your right leg is my right leg; your left leg is my left leg, and what do we do but go together? And we are happy."

It's like an instruction piece to young married couples: as you marry, you do not separate. What does the Bible say? "till death do us part." There is a whole statement here. It's very important for art; every work of art must have a statement. This says, among other things, that marriage is the coming together of two people who must be fused for good. It is an essential message for any human group.

NORTHERN NIGERIAN FIGURE

To me, this is a very unusual figure. It's the kind of thing that Picasso would have been very delighted to have seen. These cubic forms are extraordinary. They have been combined to make a very powerful figure which, at the same time, is also very delicate. The legs, feet, and arms are very powerful, and then you have a very slender neck. I admire this combination of power and tenderness. Everything from the chest down is very powerful, but above that, very delicate.

I have not seen this kind of figure often; it is rather uncommon. I hate to say that the artist used cubist techniques; rather I think the cubists were inspired by similar works. The lines are so precise, so deliberate; they are cut in such a way that they provide the figure with sheer power. It's very sturdy. To me, it's a different sort of sculpture. The chisel marks are so deliberate and there was no attempt to smooth them. There is a feeling of roughness and ruggedness that makes it a very powerful figure. If that was the artist's intention, he has certainly succeeded. The expression on the face! It appears that she's shouting, tilting her head back, shouting with such great authority.

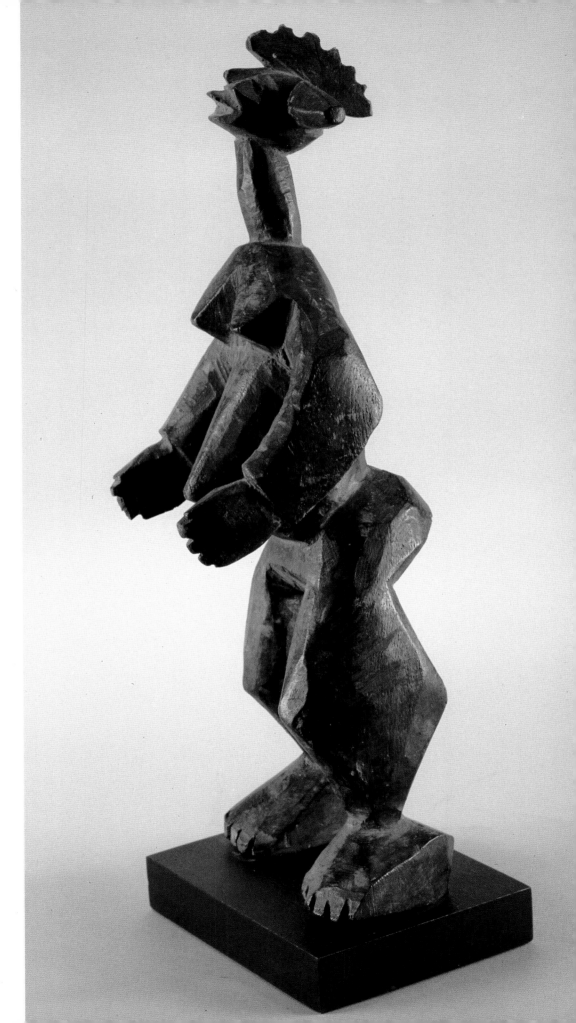

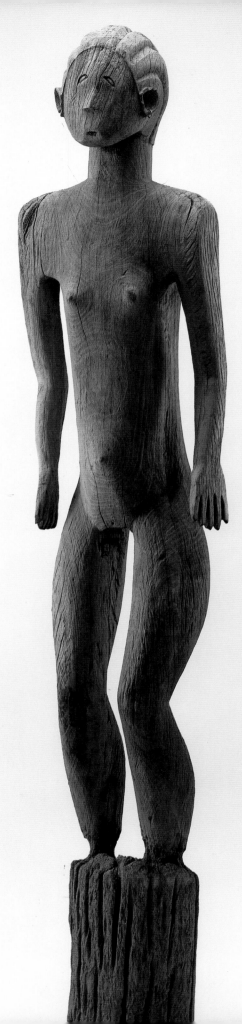

EKPO EYO

BONGO FEMALE FIGURE
AND TIV MALE FIGURE

I chose these because I wanted to say something about William Fagg's notion that African art is tribal and that each style is a universe unto itself. That is to say, that certain forms are exclusive to a particular area or "tribe." But look at the similarity of these two—in fact, they come from widely separated areas. I think these show that Mr. Fagg's notion is not always true.

There is, however, a noticeable difference in the style. The hands of the Bongo figure are separated from the body, whereas in the Tiv the hands are attached to the body. Aside from that, you see similarity in the two forms. They are both made of hard wood. Stylistically, the Bongo is tender and strong. I can see, at the same time, a great deal of tenderness in her long limbs and in her eyes. It's quite moving; the contrast is so beautiful between the upper part of her body and the lower part. The sculptural value here lies from the waist down. There is a great deal of movement below—I would say that it shows locomotion without movement—whereas above, I find it a bit static.

The Tiv figure displays such powerful manhood and manifests strength throughout the entire body. One wonders if this maleness has something to do with fertility that would ensure the continuity of the species, or whether it is merely connected with some kind of chauvinism. Whatever the case may be, there is a force behind the man which the artist has succeeded in conveying. Here is a strong man full of power, and you can see this in his shoulders, in his buttocks, and in his legs. The power is generated throughout. If one wished to make a statement about maleness and femaleness, all one need do is put these two figures together.

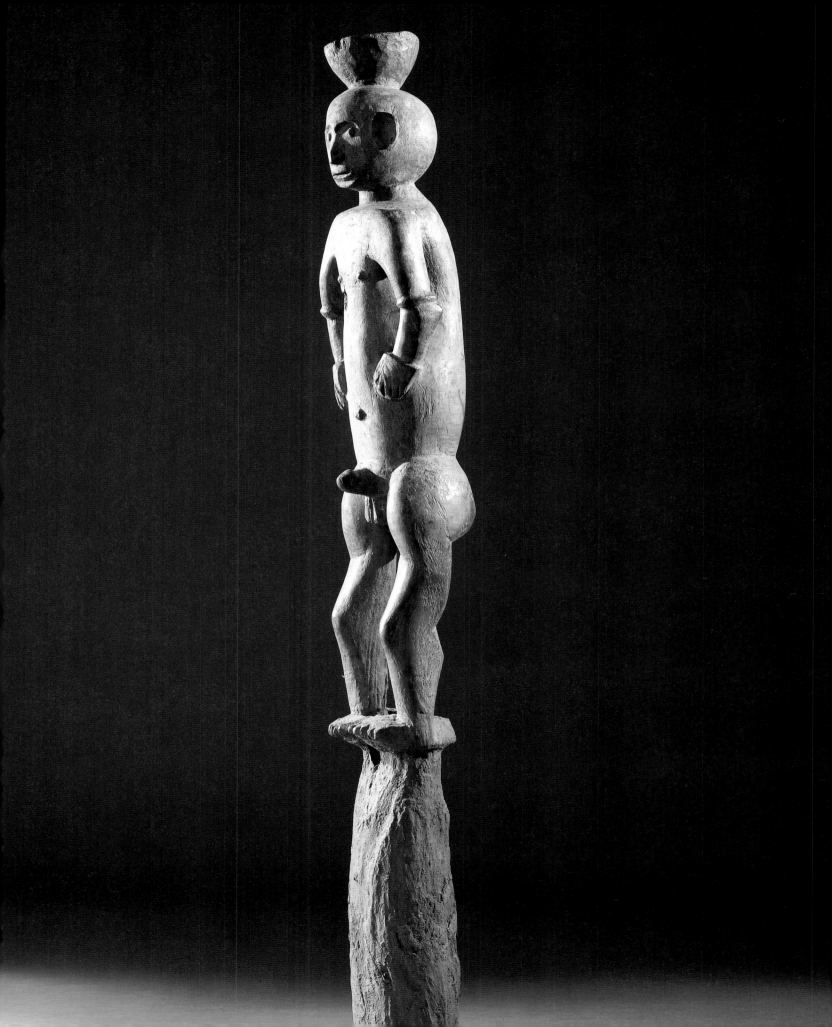

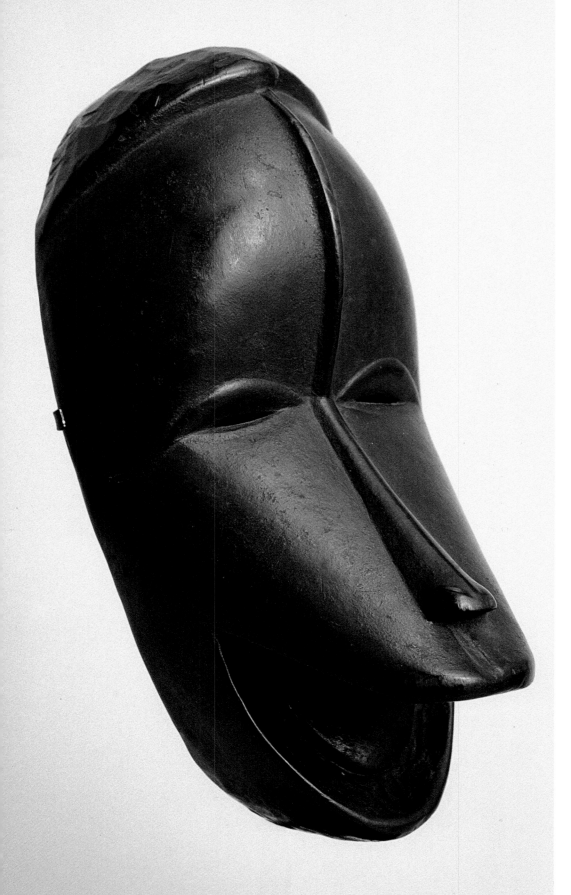

DAN MASK

Apart from all the qualities that Dan masks have—the smoothness, the interplay of lines and planes—see how humorous the expression on this one is! The mask seems to be saying, "ah, I told you!" It's a very delightful expression; I'm sure that it was used for entertainment. It's the way it's been made to laugh, but also the tactile quality that I like. It's amazing when I look at Dan masks, I fall in love with them: the way the planes and lines interact.

You can't look at this and fail to smile. It provokes that. And you smile back. The line from the top of the forehead, which joins the nose and forms an angle there, draws the mouth region forward and focuses your attention on the mouth. The line which starts thin, then broadens out from the nose, and terminates at the upper lip, draws your attention to where the humor is expressed.

The eyes, of course, are the usual Dan eyes. I've always loved the slitted, feminine Dan eyes. It's a lovely piece. Have it at the entrance of your home, and when you open the door and step inside, it welcomes you home with such a cheerful mood.

DOGON FEMALE FIGURE

What interests me in this figure is its hermaphroditic aspects. It's mythical. It wears a very noble face, that portrays wisdom, and at the same time displays respectable breasts—a suggestion of stability. It is interesting. A number of Tellem figures are rather abstract, but this has moved very much towards naturalism. It is one of the best pieces in its class.

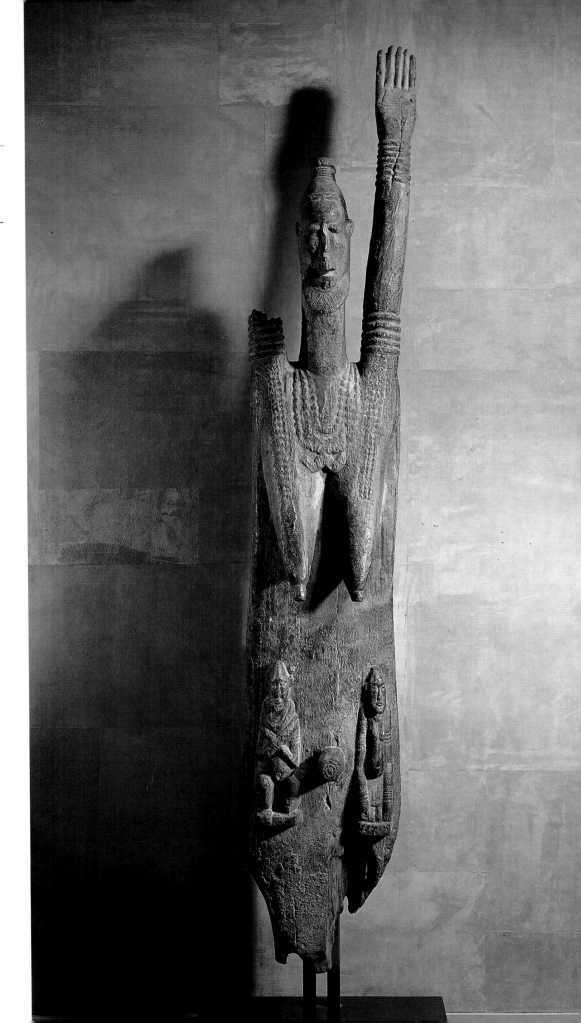

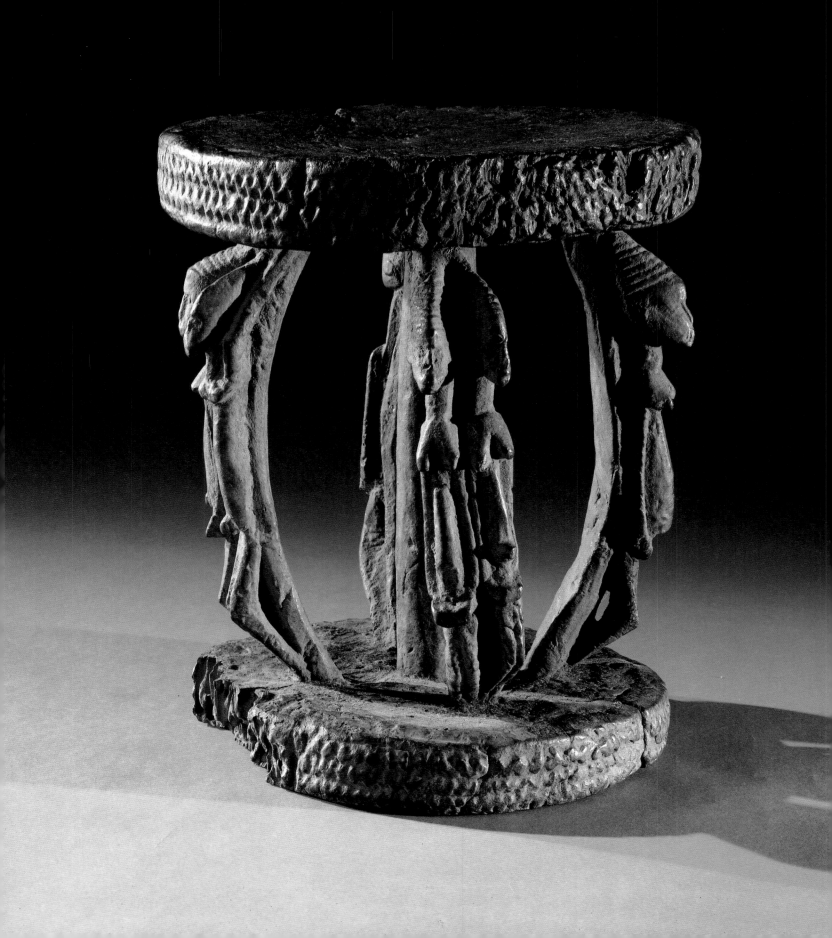

DOGON STOOL

This stool combines aesthetic appeal with meaning. On the whole, elaborate stools of this kind in Africa are regarded as thrones. In Ghana, among the Akan, to be enstooled is to be enthroned. On the face of it, this stool should have been regarded as functional—meant for a king or religious leader to sit on. It is indeed a Dogon stool, but was never meant to be sat upon.

Because it was not meant to be sat upon, the artist was able to execute it in a very delicate manner. The convex caryatids do not seem to offer much support for the weight that stools are expected to carry. Rather he turned them into delightful areas that show an interplay of delicate forms with space. Such achievement came late in European art history. The Dogon artist did this without drawings or models, and the result is fantastic!

The context of the stool is equally fascinating. The figures with raised hands represent *nommos* and are executed in the Tellem style. The Tellem occupied the Dogon area before the latter's arrival. Could this not be a statement acknowledging that fact? It's wonderful.

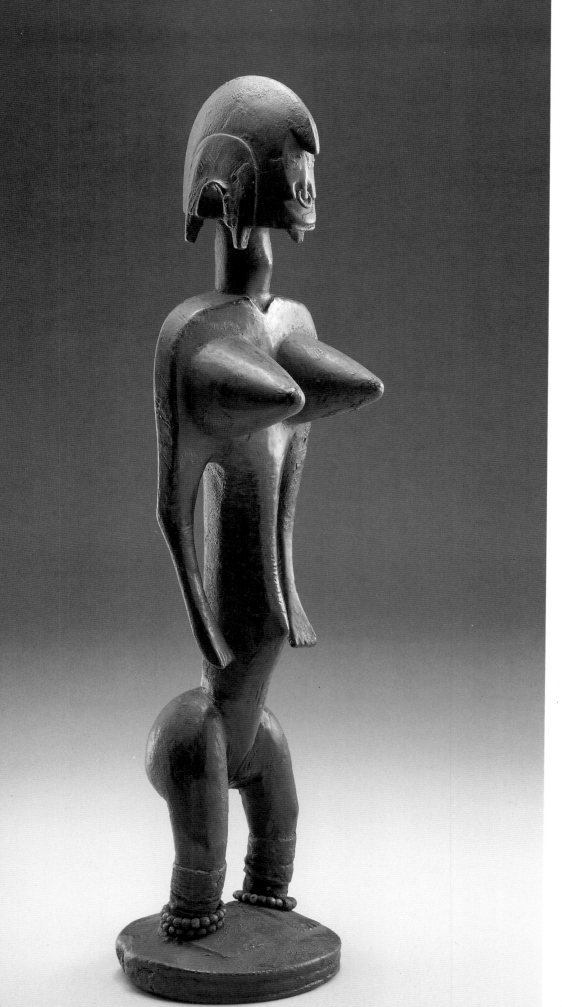

EKPO EYO

BAMANA STANDING FEMALE FIGURE

You know what Cezanne said about works of art: that an artist should be able to see in nature the cone, the cylinder, and the sphere. I think that this female figure is a good example of that. You have the cone here as represented by the breast, you have the sphere represented by the buttocks, and the cylinder represented in the torso. This geometry is all combined into a very pleasing form. There is no wonder then that it is a display figure in the age-grade ceremony of the Bamana of Mali.

YORUBA DANCE STAFF

This figure is familiar to me. This woman here is a devotee of the Shango cult—a humble, subtle person. It's a staff, a symbol of office. It is very beautiful, an exceptionally good one. The carving was done by a master. The legs are frozen into one column, which is where the Shango priest holds it. The hair is done up into four very nice buns. The symmetrical nature is very fine, balancing the double ax on top, which is in the form of two human heads. The two human heads of the ax are very naturalistic; they look more human than the figure itself.

It is well proportioned, but seems to defy the usual dictum that African heads in sculpture are always one-quarter the size of the whole body. The main thing, however, is the tactile quality of the surface, the smoothness—it makes you want to feel it, maybe even lick it—it conveys a lovely feeling.

Normally, the stone axes are plain axes, but these have been modified with the human heads. The axes are believed to have been thrown down in anger by Shango, the Yoruba God of Thunder and Lightning, who lives in heaven. These axes are rendered by artists in infinite variations, but I have not seen many of this kind with human heads.

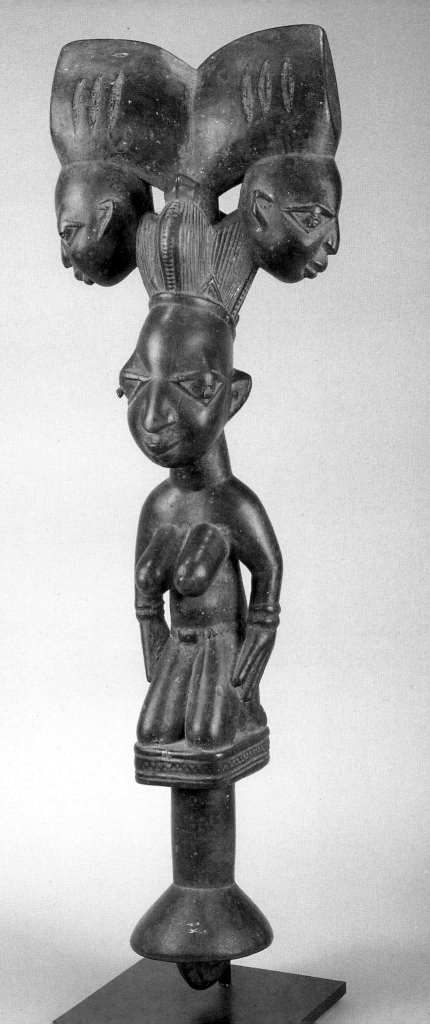

Since 1973, Mr. Rubin has been Director of the Department of Painting and Sculpture at New York's Museum of Modern Art. He has taught art history at Sarah Lawrence College, Hunter College, The City University of New York, and New York University's Institute of Fine Arts. A Fellow of the American Academy of Arts and Sciences, Mr. Rubin has also been honored by the government of France (Chevalier, Legion d'Honneur, Officier dans L'ordre des Arts et Lettres), has published scores of articles, and more than fifteen books on the subject of modern art, ranging from Dada to Stella, Matta to Picasso. In 1984, culminating six years of intensive research, he organized the Museum of Modern Art's exhibition, "Primitivism" in 20th Century Art: Affinity of the Tribal and the Modern.

Though I am an art historian, I don't look at tribal art with an art historian's eye. My interest in all art is what it can say that transcends its own immediate context. There are anthropologists who feel that these objects don't say anything that transcends their context. If that were really true, I wouldn't be sitting for hours in front of the African pieces I have at home.

It seems to me that what an art historian can do and should do is to talk about those aspects of art which are quantifiable and therefore describable in language. Those are the elements of style, and the subject represented, and what you can know of the context. That is open to art history. What is not open to art history is the essential "speaking" of the work, which, if it could be verbalized, would never have to have been made as art to begin with. How are you going to tell me what a Rembrandt painting means? One can say an awful lot—one can analyze his style, one can say many things which are not uninteresting. But when you look at that Rembrandt painting, it's doing something to you which you can't put into words. There's no way in which you can get at the very essence of any work of art because, virtually by definition, it is expressing something which is only expressible in its own language. If poetry, painting, sculpture, music were interchangable, we wouldn't need all these different arts.

I see the role of an art historian, then, as a way to abbreviate the learning process of the language of art. We have to put people in front of pictures, we have to draw their attention to things. But the spark that must pass between the work and the viewers, the real artistic experience, is beyond us. We have to let the picture do its thing.

The value of looking at any art is the way it moves one, and the manner in which, in some small way, it changes life. This is not a "formal", aesthetic response that is cut off from our wholeness. Some anthropologists speak as if you could somehow recreate the tribal context, and that would explain everything about these objects. Well, first of all, you can't recreate that context. The "facts" of that context alter from generation to generation in anthropology; the art has stayed the same, but the facts have been revised. If you are not sensitive to the object as a work of art, you're going to miss the thing that makes these pieces worth preserving above

and beyond their artifactual aspects. And I think they are worth preserving for that reason, because at its best, tribal art is as great as any other art. It's obviously not necessary that the artists have thought of it as art, or have had a concept of art, in order for it to be art.

This functional business can be carried much too far. Most of Bach's music was functional. It's almost the exception in Western civilization to have nonfunctional art. Take the religions and the courts, which are the two main sources of Western art. That's where most African art comes from, so I don't see that it's really that different except in the way that different cultures and civilizations naturally produce different art. Looking at the great works of tribal art, how can I believe that the men who carved them had no aesthetic sensibility to what they were doing?

Ritual? I have some interest, for example, in the rites of Egyptian art. But I wouldn't care about them if the pieces didn't speak to me. The rites are ancillary, in a sense, to my interest. That doesn't mean that I'm interested in these African pieces in a vacuum. These pieces carry expressive messages that have implications for attitudes towards life and experience.

What we call "Primitivism" is not directly about tribal art at all; it is about the influence of tribal art on Modern art. If you are going to study primitivism, you'll want to see something of what was doing the influencing. The show we did at the Museum of Modern Art was entirely from the perspective of what we do here: to study Modern art. We were dealing with a nexus—the moment at which these objects cross the consciousness, either historically or analogically, of Western art. The context of primitivism is modernity!

I don't see how it is possible to be alive and not have a concept of twentieth century art. Even if you don't go to a museum, it's all around you in a low-brow, cheapened form—advertising, for example. Even a slug will have responses. So there's no way of looking at African art with a clean slate. How much contact with modern art? I would say that it is highly unlikely that anyone would be sufficiently sensitized to African sculpture—to really appreciate it deeply and enjoy it a great deal, since it is shorn of its original and specific context— unless they had already been deeply sensi-

tized to sculpture in general. That would not be possible without some considerable contact, just in the nature of things, with Modern art. It almost seems to have required that the Western mind be exposed to Modern art in order to see tribal art as art. When the popular definition of art was the one shared by your average French bourgeois in 1880—people who thought Cezanne was a nut—what they thought was art would not have permitted you to see these carvings as anything but ethnic curiosities. So, in some sense it was Picasso and the other modern artists who opened our eyes to this as art.

What I'm really trying to insist on is that the choices are not between a total contextural reconstruction—which is a mythic pursuit—and a pure aesthetic response, whatever that is. We don't respond to art objects with one particular set of responses that are isolatable as aesthetic. We respond to them with our total humanity. We are moved in areas which I don't think any physiologist or psychologist would call aesthetic. What makes art ART is that the work is invested with an expressiveness that is not particularized, and that it expresses feeling through the structural relationship of forms, and says things that you can't say any other way.

The response that you get out of the object **qua** art, takes place on a different level than the purely intellectual response to its functional context or historical implications; the charge, you might say, on the level at which it's art, is far more intense to people who feel art. It's in the gut.

As with some modern art, some tribal pieces are seductive at the beginning, but just don't wear. The greater the artist, the more the object will wear, the longer I tend to look at it and still find that it's moving me, speaking to me. When I have totally plumbed an object, I don't look at it anymore, because it's entirely inside me; it doesn't say anything new, and I find my eye not resting on it. That's the signal I've reached the end. With the greatest art, you never reach the end.

I look at my tribal pieces every day, and I look at them hard. Those that remain have passed the acid test. I am heartless. I make no allowances. These guys have to be as good as Picasso and Brancusi or they don't

(continued on the next page)

interest me. I'm obviously only interested in them for something they have that by definition transcends their origins. Picasso once said to me that he never read anything about African art; he said, "everything I need to know about Africa is in those pieces." What Picasso meant by that is that the real genius and spirit of a civilization comes through in its art without one having to know that much about it.

MAKONDE MASK

This is one of the few truly frightening and alien pieces of art I've ever seen. I'm not easily frightened by art. In ninety-nine point nine percent of art, I don't find a sense of a psychology which is alien to my own. Yet when I look at this Makonde piece, I feel the presence of something which is perhaps not really ultimately alien, but which I believe has been so completely surpressed by modern civilization, that we don't admit it to ourselves. It's not communicated by anything that's easily verbalized; if it were, you perhaps wouldn't have to make a sculpture out of it.

In a certain way, it's one of the most extraordinary pieces of art I've ever seen. But it's also one of the most upsetting objects I've seen. It has, however, many other qualities besides the terror. It's humanity is wide. Think of the piece as a wedge aimed toward the unconscious; the part that terrorizes me is the very bottom, but it's got a wide humanity that leads to that. It expresses something about the nature of the inherent violence of the human mind. It's difficult to say what—it's in the expression of the face and the shape of the head, and this is reinforced by the scarifications. That mouth is something else! It's almost like an animal mouth. The eyes—the heavy lid is like a wall and someone is looking out through cracks. The particular stylization and scarification come together here in a way which I might say is analogous to a medieval armored helmet. Those helmets exhibited qualities of power and dignity, but they were also supposed to frighten.

It seems so complete. With a typical mask, one that covers only the front of the head, you evoke a real person behind it. But the helmet mask is a different thing—everything is hidden. I wouldn't want to believe in this mask in the way that it was believed in by the people who first saw it. It's really talismanic; it's like one of those things you see as a kid, when you're at first fascinated and then ultimately horrified by it. It's one single perception. It's like a sudden slice of a sword down into the center of the mind, but deeper than the sword normally cuts. In the end, however, the very greatest works of art go beyond this. They seem to me to provide a whole structure for experience, and not merely a single insight, no matter how profound. It's a piece that I normally would not go for personally. But this particular mask is so mesmerizing that I couldn't *not* choose it.

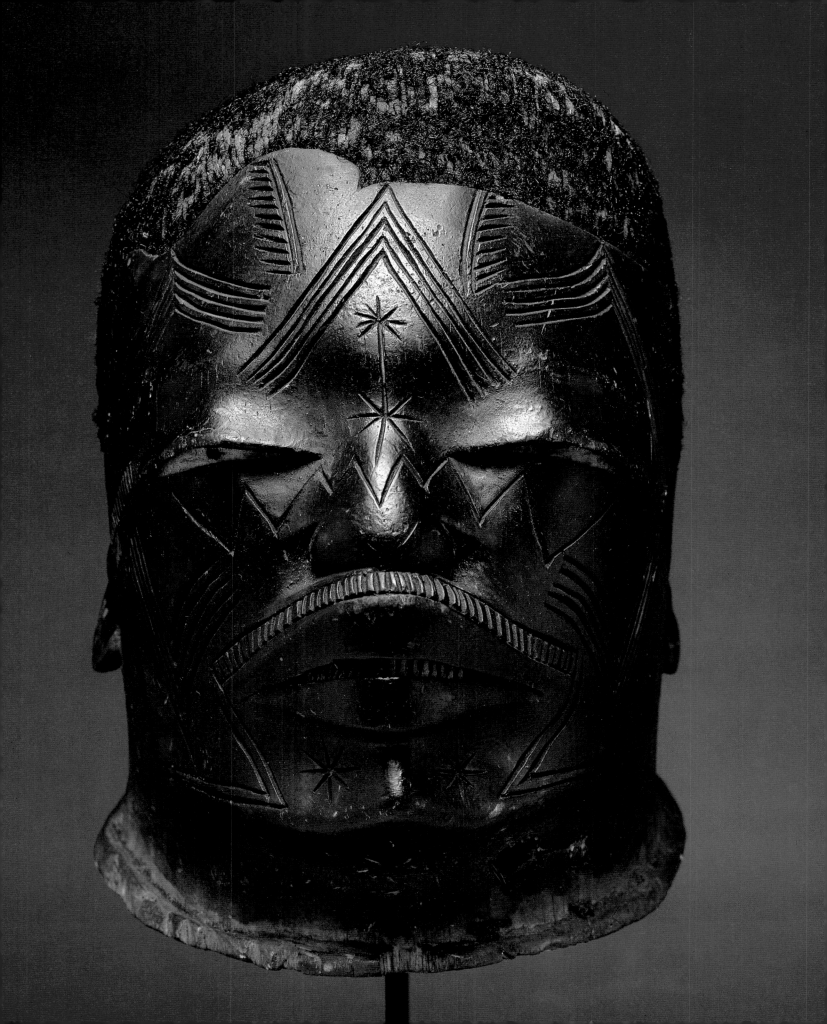

WILLIAM RUBIN

ADUMA MASK

In terms of *conception,* this is quite extraordinary. When I look at it, I'm dumbfounded and amazed. I'm impressed by the extremes to which the language of signs has been carried. Tribal structures are complex. Much more than certain other cultures. The Africans thought and expressed themselves in a language of signs that was carried to an extraordinary degree. These objects have a particular resonance for people who like twentieth century art because Modern art is also a language of signs. It's no longer—as art was throughout most of its history—a language that is centered on description.

The sign element—as opposed to the directly depicted element—is very strong in some African cultures, and it is carried to real extremes in certain types of African art—and this would be one extreme. Of course, one always has to make a distinction between what is interesting and challenging and extraordinary on a conceptual level in a given piece, and what comes through, finally, on a level of pure experience, as the greatness of the art. From the photograph, at any rate, this is an extraordinary conception; I couldn't say without seeing it whether it comes together equally well as art, whether it has real aesthetic density.

The curve at the top is very beautifully worked, as are the proportions of this "nose-face"—it's almost as if the face were made out of the nose alone. Even if you took away the bottom, it would already be extraordinary. The notion of unifying the forehead and the nose, of having the whole expressiveness of the face carried by one of the most inexpressive of features, namely the nose, and characterizing it that way, is what becomes possible in an art that is essentially a language of signs.

There is no other art in the history of Eastern or Western civilization prior to the twentieth century where you get this incredible economy of signs. So I am fascinated by this. It is an instance of how much meaning and expression can be

communicated by a *seemingly* simple formulation. That still leaves open the question of how much, on an aesthetic level, it really speaks.

MAHONGWE RELIQUARY

I think this is really a wonderful example of this type. This conception of a head, where you have a kind of concave shell that is concave vertically with one rhythm, so to say, and horizontally with another, is really superb. The strips of metal are quite beautiful, as is the way they divide to make a mouth. The expressiveness of the head, with its button eyes and its mouth—the conception is wonderful. The proportions of the bottom part and the head are beautiful in this piece, which is often not the case with these reliquaries.

I think that there is something here for Western eyes which might not have been intended by the man who made it. There's a kind of elfin wit about it that we might find analogous to Paul Klee—the beady eyes, the way the mouth is formed by just parting the lines of copper. Or maybe Klee, who saw such objects, simply personalized a more austere, collective formulation.

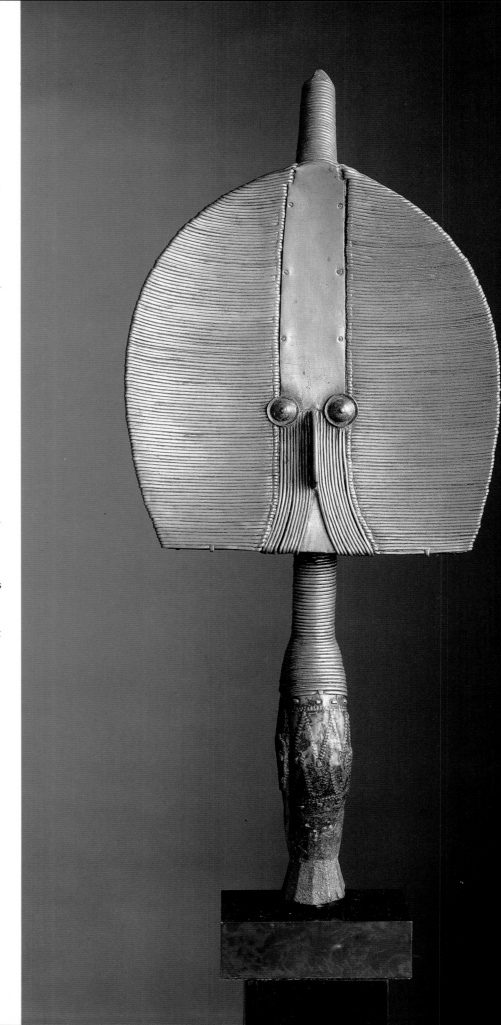

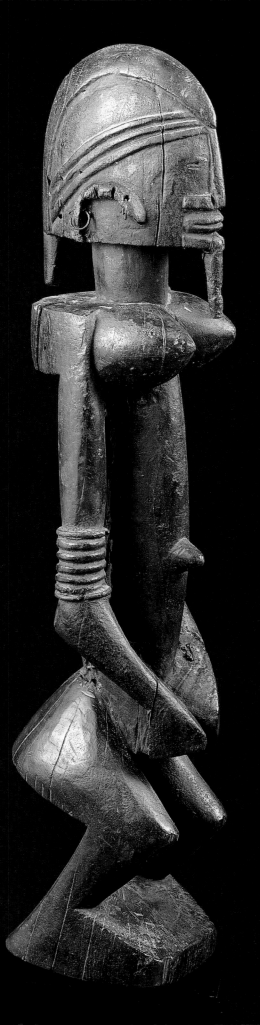

DOGON FEMALE FIGURE

First of all, it's a very fine piece. It's made by an artist—or comes out of a workshop at the very least—of which about 17 or so pieces are known. I have one myself, and I have it because this particular stylized and geometrical solution for the representation of the human body is, I think, both beautiful and extraordinary. The series has a set of qualities that sets it off against other styles within Dogon art—to which, by and large, I find myself being very receptive—just as Dogon art sets itself off against African art from other regions.

I'm drawn to the particular stylization in the way the nose is made—how it comes down just that way and then turns off into a kind of "L"; the way in which the bottom part of the nose—which becomes a horizontal band across the whole front of the face—is assimilated to a rhythm of the horizontal bands of the lips; and the way in which the breasts relate to the shoulders, and the arm to the body as a whole. This solution is not only characteristically Dogon, but a better solution than certain other peoples in Africa were able to come up with. In this particular piece—to judge from the photo—the legs are not as convincing as the rest of the body. They aren't as sure, they have less definition, and that is where the consistency of the style falls down a bit.

I'm asking something here that these sculptors were not asking. And that's not unusual. I would say in this particular piece the head is wonderful. That doesn't surprise me, because in this group of objects, when they are good, the heads are extraordinary.

In African art, there are vast differences from work to work, even in cases where they likely come from a single hand. The whole notion of African artists repeating the same thing all the time is a myth. Authentic African art is never the same; the changes from work to work, or from artist to artist, may take place in a narrower range than the changes that take place in Modern art. But not any narrower than the changes, for instance, between Renaissance artists around 1500. The myth of

"sameness" came from people who don't look, and from anthropologists who had some stake—for reasons of theory—in suggesting that tribal art was all simply made by copying the same model.

FANG RELIQUARY GUARDIAN

The head is so perfect it almost worries me—though not really. There is something almost Cartesian in the way this piece builds up. What interests me about it—and it's very difficult to make out in the photograph—is the way in which the legs seem to be cut back at an angle from the knee to the foot, and the seeming cylindricity of the body. The way in which the arms are brought in, over the knees, and then the way the line descends is magnificent! There's also something here that has to do with fineness and with polish, and with the exact weighing of every volume and inch of the surface that puts it in the highest order of great sculpture.

At least from the angle at which it's photographed, it's really a whizbang piece! If the photograph isn't deceptive, it's one of the greatest Fang pieces I've ever seen.

There is a kind of stylized quality to a great deal of African beauty. It's a kind of beauty that is involved with a different notion of perfection and idealization in bone structure than in the West. If I were to look for this piece's counterpart in Western art, I would look in fifth century BC in Greece. This piece is, to me, the African counterpart to a classical Greek sculpture. I suppose there is a sense of exhilaration that comes from perfection—which all classical art aspires to. It's the idea that perfection is achievable; it's perfectly obvious, that in African terms, this is an art of perfectability.

WILLIAM RUBIN

BEMBE FIGURE

This has a characteristic Bembe head—and it is a very good example of that type of head—which I find deeply moving. I never bought a Bembe piece for myself (though I tremendously love the heads), because I never found one where both the head and the body were consistently high in quality and in style.

It's a highly stylized, archtypical head, and a conception I find extremely moving. The body is not nearly so stylized; it's much more naturalistic and conventional. If you look at the way in which all the aspects of the human head are submitted to a singular concept of abstraction in the head—the stylization of the hair and the beard—the head is almost of another piece from the body. You see this in a lot of African things, the votive figures of the goddess Nimba for example. There, the heads are highly stylized—as in the giant masks. But the votive full figures with Nimba heads are like two sculptures joined in one figure; the bodies are more naturalistic than the heads. That was accepted, but it is alien to our way of thinking. And that's where the absence of a concept of art *does* make a difference. This dualism is found also in Egyptian art; they too had no word or concept of art. No civilization which has a concept of art would make that kind of piece.

PENDE MASK

This is quite beautiful. Among the African styles that are essentially depictive, the Pende are unusual in the degree of linear abstraction they get into their work. The edges of forms in Pende art are always very developed and precise. It's almost like a drawing in wood. At their best— and this is a very good one—their masks are exquisitely stylized, while remaining close to depiction.

The play of the convexity of the fore-

(*continued on the next page*)

head against certain concave areas at the bottom is something that could be said about hundreds and hundreds of Pende masks. But when they are good, as this mask is, these contrasts are more intense.

In sculpture, there are two things that are essentially alien to one another: volume and surface linearity. The presence of a lot of surface linearity usually takes away from the sense of pure mass in sculpture. The two things are in opposition. The surface belongs more to drawing, and the other—mass—is more proper to sculpture. What I think is so nifty in this Pende mask is the way in which intense mass and surface drawing are made to cohabit. Such observations deal with its quantitative aspect; they belong to what I can talk about. But in the end, what really moves me about this mask is nothing that I could put into words. It's a great mask. What really moves me about it is ineffable. That is the way all great art is. There's no way it could be put into words. Could you put the Ninth Symphony of Beethoven into words? Could you put that Leger on my wall into words? I don't believe that any work of visual art can be put into words.

WILLIAM RUBIN

GREBO MASK

This is one area where I think I know as much about the masks as any anthropologist on earth, and probably more. Because Picasso had two Grebo masks—and they were of particular importance to his work—I looked at every Grebo mask I could possibly see anywhere. There are no two that really look alike. Though there are, of course, certain common denominators.

This piece, for example, has a very particular relationship of the top part to the bottom part. I've never seen the curve on the top part on another piece—this way that the forehead curves out and comes back. I've seen asymmetrical eyes before, but never with a circle and an "X." I have never seen the mouth—the typical Grebo mouth—with teeth, and then this lip-like shape coming down in this way. Maybe it can be found in another, but I bet my bottom dollar that in that other I will find five other things that you can't find here. One could in fact make a strong argument that these typologies changed a great deal over any length of time. And nobody can prove it one way or another. I'm much more impressed by the *differences* between any two pieces.

I'm not hellishly attracted to this Grebo mask. I think that Grebo masks are remarkable, but none of them move me deeply. And even the second one that Picasso bought—which is one of the best Grebo masks—is still not what I would call a great work of art.

I chose this only because Grebo masks have a peculiar interest for the historian of modern art. It is one of the few cases where we know that the contemplation of a tribal object directly influenced a major modern artist in a way that the artist himself was conscious of and spoke about. I think this is a very *interesting* mask. The notion of the eye as a cylinder is what interested Picasso. But that is true of *all* Grebo masks. What makes one better than another is everything else. And this is a good one, a very good one.

I think the eyes are quite wonderful in the sense that here you have the human face, which is basically symmetrical, but in the last analysis, also asymmetrical— which is true of all human heads. The eyes are basically symmetrical; most of the Grebo masks treat them symmetrically, by putting something like these concentric circles at the end of the cylinders. This mask has one eye with an "X." Given the symmetry of the whole piece, it's at once an interesting and arresting aspect of it. Whether this had some kind of implication of a religious sort, we don't know. Whether the man who made it was one-eyed or had some kind of facial tick, we can't know either. It may indeed only attach to a sense of artistic "play" in the artist's mind. That is, some notion of opposition as opposed to similarity. The meaning for me here is the shock of contrast within a structure of similarity. Everything is not only otherwise symmetrical in this piece, but it is unusually unified in the sense that it has one color. The color gives it a oneness, as does the symmetry. Then you have this single, boffo change—a perfect example of how artists did not just imitate models.

WILLIAM RUBIN

MANGBETU HARP

One of the reasons that I am especially drawn to African instruments is that they were of special interest to the Cubist painters whom I admire such as Picasso and Braque. They were of interest to them because of their conceptual nature, and because of their emphasis on expression.

I think the fact that musical instruments are among the most unusual objects that the Africans make has first to do with the artistic invention required to satisfy the desire for anthropomorphism on one hand, and the practicalities of a musical instrument on the other. The Cubists, in general, loved musical instruments. They were fascinated by the shapes, and they were constantly making analogies between the forms of musical instruments and the human body—the tendency of the violin, for example, to read as a female torso. Of course, what interested them in the African instruments was that you got, in effect, the literalization of that metaphor: the human body *and* the musical instrument.

Picasso himself had very little musical sense; the extent of his interest was pretty much Spanish guitar music. Braque had a little bit more, but not a great deal. What connected them to these instruments was basically associative in the sense that music belongs to the world of spirit, the world of pleasure, and to the world of improvisation. Any ritual aspect of such instruments would have passed right by them. Also these African pieces are instruments which a person can play alone; they don't require an orchestra to play along with. Like Braque's accordion, they didn't necessarily propose formal music making, but could imply something more relaxed and personal.

This particular instrument is a very lyrical kind of thing in the elongation of the body—which is to some extent, forcefully suggested if not necessitated by the fact that it has to traverse a certain distance from the sound box of the instrument. But if elongation of the body is therefore almost a given in the piece, then what is interesting is that the artist has recognized

that, and has made the head of the figure conform to it.

The curvature of its lines and the fineness of the "drawing" add to a sense which makes it seem at one with its purpose. I think it would have been an object very much appreciated by the Cubists. I don't like it simply because it interested the artists who interest me; I like it because I like it. I think, though, that I can't get away from the fact that I have a historical interest in the things that impinge, seriously—as these objects did—upon the culture of modernity.

MFUTE FIGURE

This is quite unusual in its almost caricaturizing silhouetting of the body's extremities. It's not my personal dish of tea, but I find the conception fresh and inventive. In some ways, it's almost a preposterous piece. But when naturalism is pushed to extremes of a certain sort, you almost get a caricature. Caricature has played a very invigorating part in the work of some Western artists. Not that this African artist had any notion of caricature. Except that all caricature does something which tribal artists do: they accentuate what is most important and characteristic and individual about a given situation. This piece differs from a great deal of African art in the degree to which the sense of manipulation has been applied as much if not more to the body than the head.

29.

63

*B*orn in Charlotte, North Carolina and raised in Harlem, Mr. Bearden has been a songwriter, social service case worker, a set and costume designer for Alvin Ailey's Ballet Company, and, of course, a highly celebrated artist. His work is in the permanent collections of the Museum of Modern Art, The Metropolitan Museum of Art, The Whitney Museum of Art, and the Museum of Fine Arts, Boston. Mr. Bearden is perhaps best known for his large scale collages (though he works in other media as well) which apply both the concerns of the Cubists and the traditional forms of African art to recreate the world of black Americans. His themes concern both urban and rural Negro life, jazz and folksongs, street life, and rituals ranging from baptism to Voodoo.

My interest in African art goes back to a show at the Museum of Modern art in the 1930's, when I was a young boy. There was a gentleman in Harlem on 138th Street named Mr. Siefert. We used to call him Dr. Siefert. Dr. Siefert—he was a contractor, I think—had a great collection of books on Africa and Afro-American art and history, almost rivaling that of the Schomburg Collection. He was very interested in meeting young artists. And on this particular day he put on a morning suit, and he took some of us down to the museum for the show.

One of the pieces I recall very well was a kind of a war god holding an ax. Dr. Seifert, in his own way, ethnologically traced the name of this particular god, to the Ax God Thor of Northern mythology. We gathered around and went after him from piece to piece. African art, you know, didn't have wide popularity then, and there weren't many books, like we have now.

When I began to study certain things, I began to look—in my own work—at African sculpture. But that was much later. A lot of magazines—even black magazines—wouldn't print this art. It seems people had the idea that this was something that was primitive or belonged to magic and things that people might want to forget. If it wasn't Titian or Ingres or classical Renaissance, people had no interest. And then came African sculpture, and it was looked upon as curios, ethnological things to study, not art.

I had to search out African art on my own to understand it. I didn't know how to go about looking at that time, or just how to incorporate it. And also—let us say if you look at a Titian or an El Greco, just two names that come first—the mythology of what they are talking about, or their intent, the religion, was right there: a virgin holding a baby—motherhood; or Rembrandt, the woman by the well or religious things that he did. But this African art was something else that I wanted to look at and see what the philosophy was, discover what were some of the ideas that emanated from this work. I wanted to try and understand the African vision of the world—because there were so many varying African forms: some might be rather realistic like Benin bronze, and some very abstract. But this is the thing: to get a sense, a feeling—not just

looking at them and admiring them as decor to put some place. But to discover what is it that motivated the art.

African art appeals to me because it has offered another dimension, a way of looking at the world. I have been permeated by African art by looking at and trying to understand the design: how is it possible to simplify in a drawing—to see a head just as an oval shape; how to understand its symbolic quality—in my own terms. So I had to put the books down and just look at how I felt about it. The books get in the way sometimes.

We are faced with chaos in life. Or could be, anyway. To the artist, when he looks at something—Monet at a haystack, or an African, at a tree trunk—he is trying to look at the particular chaos and be redemptive about it; to find something in there and bring some passion, where it can move people. The demagogue on the other hand, says, "now you're dealing with chaos, just vote for me—you may loose some of your liberties"—but he sees chaos as his opportunity for power; the artist, on the other hand, sees it as a chance for redemption. The thing about art that all of these people have in common is that they look at chaos. The thing about art that is different from science or most anything else is that it could have been stopped at any time, and you would have had a complete art, even with the caveman. But all of our epochs have the power of completing their intent. And then we move on to some other resolution of how people dealt with the world before one had ambition.

When I was a boy in the South, in North Carolina, around spring, every Sunday morning they would have baptisms in the streams. So I tried to depict or imagine one of these events in collage. I used various parts of African masks for parts of the features of the people. I am very interested in myth and ritual. I used various kinds of African sculptures, because the people—when they were brought here from Africa, came from various tribes. So I tried a little bit of this, a certain fragmented depiction of an event that was happening in, let's say, Mecklenburg County, North Carolina, and also extended—artistically and mythologically—to a certain past. That is the way I have often used the African sculpture—the baptism for example, to bring it back by working in some event, some remembrance I have of Charlotte and Mecklenburg County. In this particular instance it didn't matter to

me how the pieces were originally used; probably it should, but it didn't. I might have, say, a Dan head for the nose or mouth, or use something else realistically. It was all mixed up to show Afro-American.

I continue, quite often, to use African images in my work. There was a man who was a great guitar player in Charlotte, named Jefferson Cooley. And I was looking at something in St. Martin (W.I.), a reproduction in a magazine, and I said, gee, this reminds me of him. So I just cut it out and put it down, and then I doctored it—changed this and that; but that brought me right back to Jefferson.

I judge African art by looking at the pulses. I look at it as a melody. And pulses—see, if I did this and played this where my fingers are, [he says, holding up his left hand, fingers spread evenly apart, so as to represent a musical instrument] and I did this [he continues, using his right hand as the hand that plays the instrument his left hand has become] da da da da da [he sings in a monotone] and if I keep on doing that, well, that would just drive you nuts. But if I do this [he adds, spreading one finger apart from the others] I'm changing the pulses or the intervals in between. So I look at African sculpture for the pulses and the intervals—and after that, the melody which calls for repetition.

I learned, I hope, a lot about painting from listening to Earl Hines. I listened and listened and listened to Earl Hines until I couldn't hear the music, only the silences—in order to pick up the intervals of his playing. All of this in jazz music, all of this—when you ask about it—comes from the drum. I see all this art in drum beats: let's say you are listening to Louis Armstrong—da de dah dah de dah—you're hearing the rhythms of the drum. These pieces of African art are the plastic expressions of the drum.

MBAGANI MASK

Here you have a mask that can protect
you from the chaos I mentioned earlier. I
can see it as that. Beyond the design and
the other qualities, I see the question:
how do I deal with chaos, the nature of
evil, and other things in the world?
When I saw this, I thought: that would
protect you against *anything;* you put that
on, and you're well-protected!

In all of these pieces, the first thing I
look at it is design. The very presence of
this has to do with somebody looking at
you like this. It must have been used for
some kind of initiation purpose. I admire
the curvilinear movement, the very shap-
ing of this like a tear drop—the form
seems to catch a certain spirit with this
great tear drop.

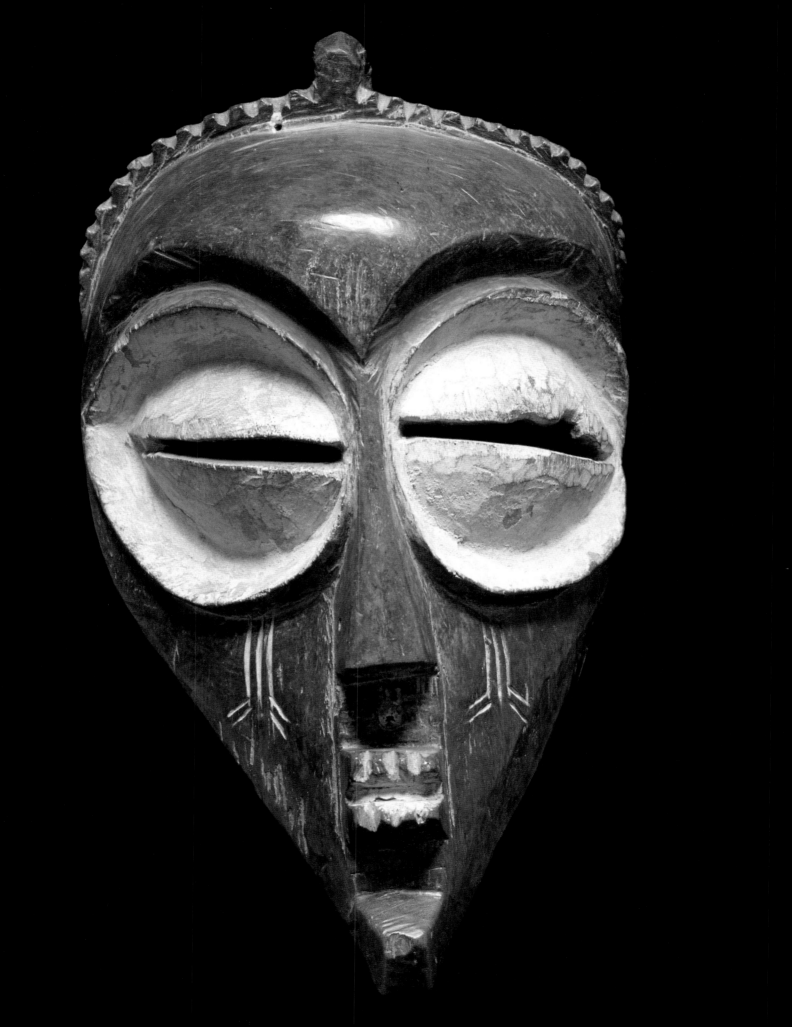

LUBA-SHANKADI FIGURE

The thing about this that struck me is that you have this Early American design—Shaker, with the chairs. They seem so functional: you sat down in a chair with no fancy decoration, it was just a certain plainness that you felt—where everything had to be just right. I felt the same about this. The shapes and the very simplicity of it have some kind of relation to the Shakers—although I don't think the Shakers would see this.

I guess there is something in great carvers and great men that see this. I also like the headdress's relation to the earrings and the relationship of shapes—when you look at the profile, the beautiful stance of this. It's hard to describe something like this because every element in it seems to flow so well into the next. I like all the elements because of how they are related to everything else.

This would be a more square melody—I don't mean in the sense of the slang expression—but I mean more compact, more contained. This is more within itself, so it wouldn't run all over the place. Firm beating, and constant coming back and playing the repetitions at a higher pitch. The legs, the hips are so firm; it's right on to the ground, it's so compact. Bap bap bap bap—a firm, solid beat.

I would like to know what the artist had intended. Like Monet's haystacks or his cathedral: it meant a great deal to *him*. But a lot of people just see the light, the color, and other things. But why he chose them, or why the man who made this sculpture chose this, or another artist chose a tree—it is sometimes a meaning that they would not know themselves.

SENUFO FEMALE FIGURE

I think that this is one of the most intricate pieces of carving in my selections. Again, every element and every aspect of this seems to float so well into the other. It also reminds me of some American Indian figures. For a female, it is so strong. I wonder, at the top of her head, what the little animal means. It's a work of great force. The whole aspect, the whole thrust of the figure; the way she's standing—but there's also this feeling that she could be seated, the way the back of her buttocks is here. Say if she was on a chair, she could be resting on that. This is what's so interesting, the curvature. It has this forceful power. It seems to be *bursting* with power, as if she's a woman going out hunting for something. She's holding a gourd in her right hand, something she could shake; and this in her left is some kind of a stave. Whether this is a part of a dance, I wouldn't know. When they say it's a female figure, and then to see on the chin what looks like a goatee, and the scarifications on her face and body—it gives this lady a tremendous force and power. Look at her shoulders and her neck: she is very animated. It's almost like someone on guard. I mean, if something needed to be actually or symbolically protected, you put this figure up, and oh, you wouldn't go near it.

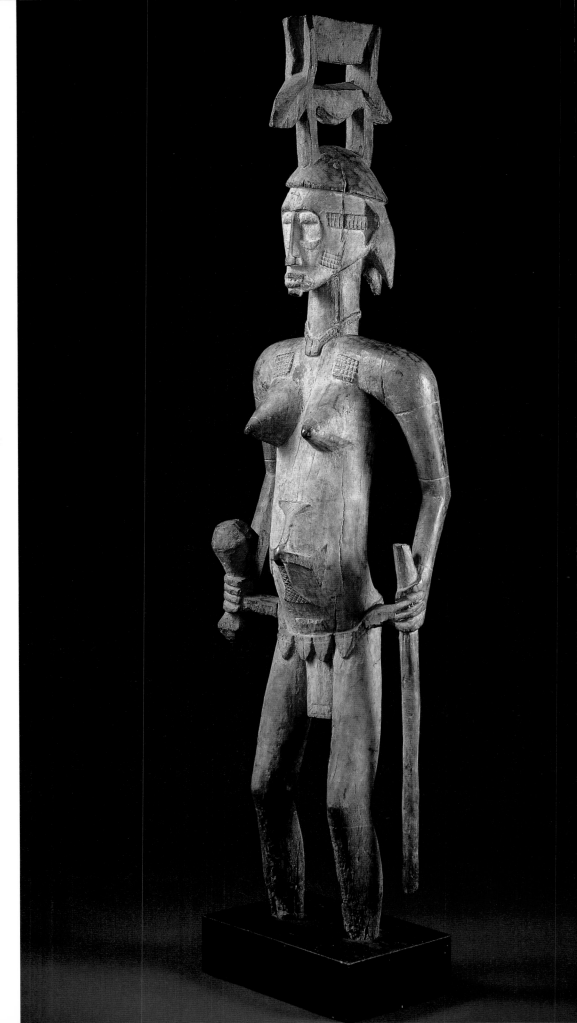

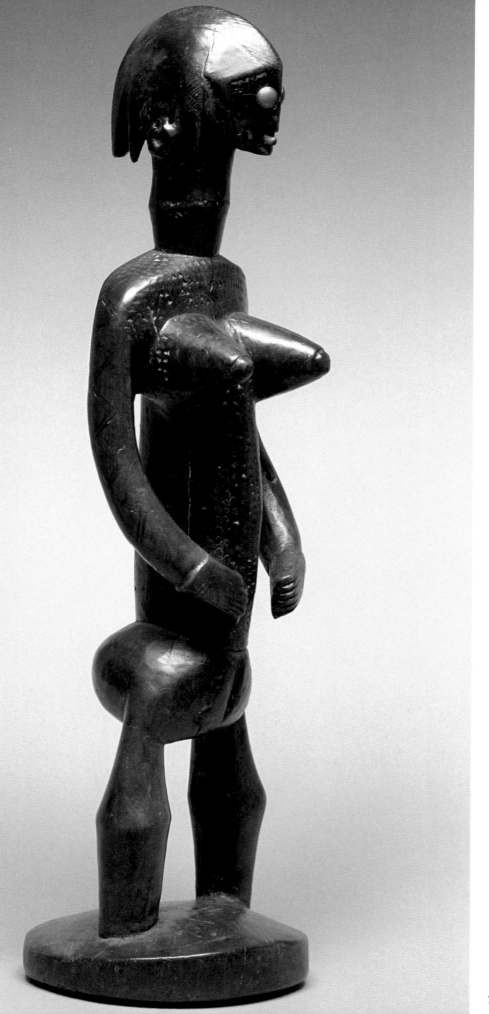

BAMANA FEMALE FIGURE

This is what I meant too, by presence. I mean, the cut of the vagina, the turning of the breasts, the head, the whole relationship of parts and the carving of this. I imagine the respect for the wood; that someone saw this and there was kind of a spirit released from the wood itself, like Michaelangelo's statement about a figure waiting for him in the raw stone. It's superbly designed—the neck, the breasts. It's beautifully conceived: every relationship—to the head, the nose, the lips, to the turn of the chin—it's a feeling that this couldn't be done any other way. There is melody here, but it's more of a straight melody than a curved melody. More drumlike. You can beat this one out.

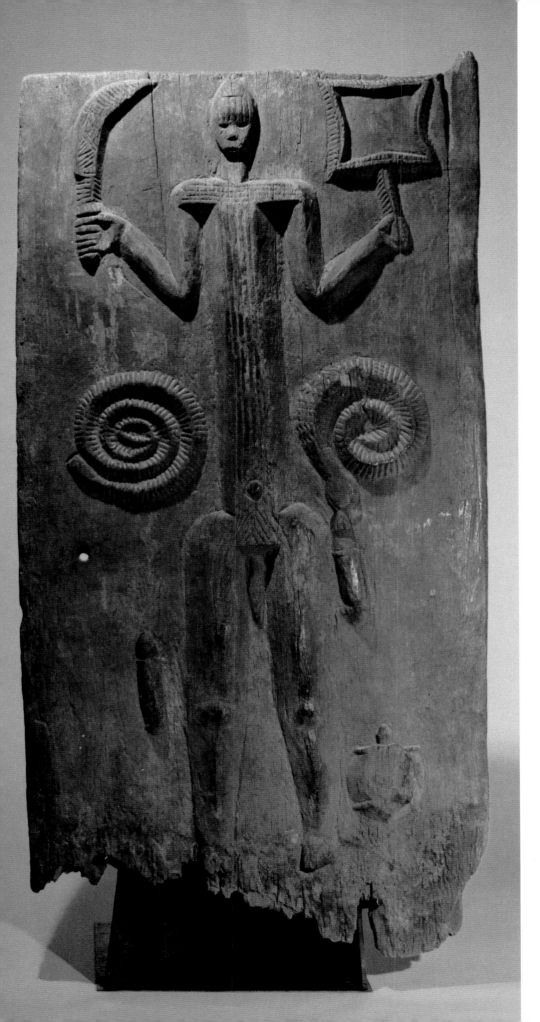

ISHAN DOOR

I see this as various things. These coils look like snakes and the heads of snakes. It seems filled with fertility. The man's penis is repeated—the very coils of life; the long, straight body of either the male or female person. It could be some androgynous figure. The things in the hands— on the left—the scimitar, looks male; the thing in the right hand looks female. It's protecting the door. For me it has to do with the rights of fertility. It's perfectly rendered. It's hard for me to tell everything, because obviously time has eroded a lot of it. But this is not deceiving. This is a marvelous concept.

DOGON MOTHER AND CHILD

What interested me about the Dogan Mother and Child was the simple beauty of the silhouette. You see, again, it's fashioned out of these repetitions—the bottom is a smaller version of the top. Not as a fact of design, but the child that is so low here, has a symbolic quality to it. Because most of the people would have held the child up here, to the breast. So you have the feeling that the child is also coming out of the womb and climbing up someplace. That concept interests me. And the very straight back of the mother—it gives such beautiful support to the child, like a tree which he can climb. I also like what I see as the security of the mother. Symbolically, instead of holding him up, it's showing that the child is a child who is being held, but who has also just emerged from the womb. And almost, in a certain way, the mother is laid down with her arms back, giving birth.

SENUFO RHYTHM POUNDER

Now this is a whole different aspect of the female figure, as differentiated from the other Senufo figure. This seems more composed. Both are abstract, they have that same design quality. The African sculpture has this great expressive quality—and they had—something to tell you about the female or about whatever they were carving. Again, it's the rhythms of this which are so beautiful: the head, the three gourd shapes, the head and the two breasts, the length of the arms coming down to her waist. The head seems to be just a little tilted off from the center—to give it just a little irrationality. This is a peaceful woman, and probably this was carved to beat out a rhythm. While both women are beautifully done, you can see this one continues to turn on itself, the way the head turns, the breasts, from the top down to where it culminates in the fingers of the hands. They didn't let naturalistic appearances conflict with what they had to do as far as expression is concerned.

Always, I think, in great art, some part of it must be left for the imagination of the onlooker to complete. It's the simple and expressive things that make the figure. Also, the gaze is inward. If you look at the French monuments, they are very much looking right at you: "why weren't you in church?" they seem to demand. But this gaze is inward. Inward are the spiritual aspects that I see.

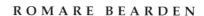

ROMARE BEARDEN

KUSU MALE FIGURE

I like this very much because of it being shaped out of these triangles: the nose, the head, and almost the lips, and then down here in the legs. Here again, this man with the beard seems to be just so right. I can almost feel him. I've met some people, it seems to me, who looked like this. And everybody I met who looked like this, I liked. The arms are broken a bit, but that's all right.

YORUBA BOWL

This work, to me, has so much presence. It's such a marvelous fixation with this man and this horse. I seldom see, or know of works of Africans on horses. But the other interesting part of it is that he's merged to become part of the horse itself. The faces of the man and the animal have become like a dream. His eyes and the pony's eyes are closed, and he's merged with the horse and the horse is more like a rocking horse, a little dream.

And it's a perfect thing, with this bowl, to present to someone, say some oil or some flowers. It's beautifully carved and beautifully designed: the simplicity, and the merging of the man with the horse. To give you an example of what I mean by presence, a long time ago I went to the Russian theatre and they were doing Chekov. I looked at the playbill and it talked about this man who was in it: one of their great actors with all kinds of awards. But he hardly spoke in the show. Yet people couldn't take their eyes off him. He didn't say anything. He just stood there. But as an actor, he had a certain presence, just standing there. And this same word—presence—is what you feel about this man and this horse and the union.

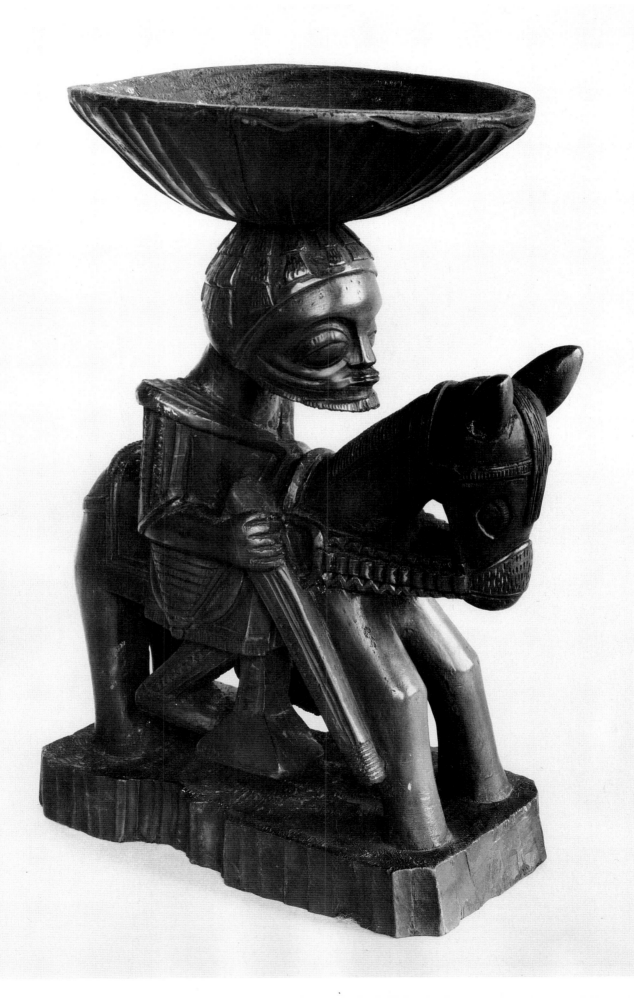

ROMARE BEARDEN

IGBO IKENGA FIGURE

Here you have this headdress of this figure. The way the shape moves around in that curve—I see it again, that same movement, connected in the legs. This is developed—the whole piece of sculpture—on the straights and on the curves. [With his hand on the photo, beginning at the top and continuing down to the base, he melodically sings]. See: curve, curve, curve—the same way—curve, curve, curve; then going *against* the curve [his hand is upon the figure's legs] curve here, the curve, the straight, the straight, *this* is like *this*, and you see that these things are all based upon this curving movement and it's held by these two horizontals— that's the first thing: I would look at this melody—and then I'd see if I could play it.

It would not be a very good melody for so-called jazz, I don't think, because it's too circular. It's more like French music, where people are constantly turning in French country dancing. But in jazz—or so-called Afro-American classical music, it's a linear music that's going someplace straight, no matter what the digression. In a certain way, I can hear the drumming in this. Dum dum dum—Bum Bum bohm— and going back, and taking it in another way—this is a D curve, D-ump. That's why I mean a melody. And when I hear it, I can play it like that. It has a sense of balance, but the sense of pulse and rhythm is what's important. It's the intervals between sizes; repetitions, the change of pulses.

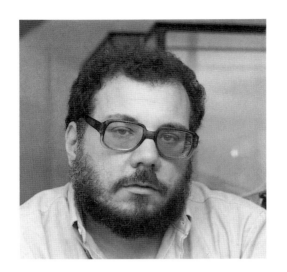

Currently Curator of African Ethnology at the Smithsonian Institution's National Museum of Natural History, Mr. Karp is also Senior Editor of the Indiana University Press's series, "African Systems of Thought." Anthropological in orientation, the series is multidisciplinary in scope and includes contributions on history, literature, folklore, philosophy and religion. Mr. Karp is himself author of numerous books and articles (ranging in subject matter from beer drinking as a social experience to the social aspect of African cookery; from marriage to semiotics, to African belief systems and kinship). Since 1969, Mr. Karp has spent more than three years in field research on the African continent. His current interests are social theory and change, and systems of African thought; he has previously delved into aspects of spirit possession, social organization and belief systems among the Iteso of Kenya.

I began to notice African art only after I came in contact with students in African art history and anthropology who worked with it. My whole interest was in social relations. I had done my course work almost entirely in social anthropology at universities without African Studies programs. As a result, my primary interest was in understanding systems of social relationships, and it still remains so. But if there's no contact with disciplines that examine the material and aesthetic worlds in which social relationships are found, the result is research with an impoverished conception of life. This impoverishment is easily demonstrated in the lack of training given to anthropologists in material culture studies. It works both ways: the study of art or material culture by itself—without fitting it into the contexts of culture, society, or history—is equally impoverished.

Neither anthropologists nor art historians have thought about what they study and how their own cultural assumptions affect their research. I don't think anyone really knows how to move from a discussion, say, of Baule heddle pulleys, to generalizations about African art, culture, or society. "Africa" is more a term of art than an effective descriptive category. Very often the things we say about Africa are what we could say about societies elsewhere as well. It is equally true that there is little that can be said about art and society in one part of Africa that holds for all of Africa.

Another problem is that the terms we use—like "Africa" or "art"—are taken from Western notions and are imposed on other worlds. They make sense to us, but in some African contexts, I find it very difficult to draw distinctions between "art objects" (classes of things subject to aesthetic evaluation) and non-art objects (like human bodies). In the African societies I know, these are **both** subject to aesthetic evaluation. The distinction between art and non-art just doesn't work. I think most African societies have **artistry** but not art. Much of African "art" is not art to Africans, but rather considered as utilitarian objects or a part of ritual events. Even the conventional boundaries don't hold. The design motifs found in so-called art objects, for example, can also be found in patterns of bodily scarification. We go to Africa and collect some things, studiously ignore others, place what we value most in our collections, and then pronounce on "African Art" assuming that our pronouncements reflect the way Africans organize their world.

It's not just a question of whether the people in African societies divide the world the same way we do—human/non–human, art/non–art, etcetera. I think that in many African societies, the product is less important than the making of the thing itself. This is why what we think of as behavior can be evaluated the same way as objects: dance is judged the same way as textiles, or masks and rituals and political meetings.

How something is made becomes very important in the way many African peoples think about and evaluate their things and their actions. This is why gender imagery and symbolism play such an important role in so much of African and non-Western art. One thing that people "make" is other people; people are fashioned just as pottery is fashioned—the body is modified by, among other things, scarification. The act of fashioning also involves what I call "social inscription:" people are made members of society through the work that is done to them. This can involve modifying the body through circumcision or through learning and childrearing, as well as through the very act of producing an object or a person. The sexual symbolism we find in much African art demonstrates this obsession with fashioning. Male and female experience is often represented as separate in order to show how necessary it is to bring them back together for social and physical reproduction.

Yet I don't want to deny the aesthetic qualities of objects or the reactions we have to them. So much of African art is striking and compelling that I'm really torn between the arguments that are made for universal aesthetic criteria and the idea that we can only truly appreciate something from the point of view of the people for whom it was originally made—that aesthetics are "culture bound."

The argument against the culture bound view—that you can only understand an object by examining it from the point of view of the culture itself—raises the question of whether outsiders can ever **ever** understand an object. If the aesthetics are unique to a culture, then there is no bridge, no translation possible between our aesthetic standards and theirs. But the other side has problems as well. The argument against universal aesthetics—that there's some kind of elective affinity between us as receptors and the artistry involved—seems to me not to take into account that aesthetic appreciation is skilled work. Very often, the way these criteria are learned is not in an art context, but in an everyday context. People learn through schooling; they learn about means of fashioning things that they **use** in life, and that's what allows the artist to create something for his audience. The artistic experience is shaped by both artist **and** audience.

I find fascinating the degree to which African art objects are substitutable for one another. What's important is not that it be a great object, but that it stand for or symbolize something. I think that there are aspects of any work of art which reveal themselves to people who are prepared to do the work of appreciation. I think a work of great art must have some kind of balance, that it be a work of consummate skill—which was the ultimate Renaissance criterion of aesthetic appreciation. One thing that can make a work of great art appealing is the displayed experiences: the experience of aging, or the procreative themes—these are obviously something about which we can exercise an act of empathy and begin to penetrate into that world portrayed in art. On the other hand, there is the "beholder's share," the work we do in order to put back into art all the qualities which a work of art may symbolize—whether they be abstract principles or realistic, everyday events—and a lot of that **is** culturally specific. And a lot of that is inevitably lost when the audience lives in another culture.

What we are doing here, I think, is using African objects in various ways, just as they are used in various ways in African societies: as objects of symbolic condensation that stand for a whole lot of things. They are also mnemonic devices. This mnemonic process—that you are doing with every one of the co-curators—stimulates all of our memories. It is like Proust's madeleine—recalling for me my reading in African ethnography and experience of life in African societies.

I'm trying to use my anthropological perspective as part of the process of selecting these ten objects. I want to find things that an anthropologist can discuss. This involves setting things in context—seeing them on the one hand as exemplifying cosmology, ideas about the nature of being, ideas about the nature of the world, society and actions, and their effects. On the other hand, this also involves looking at the contexts in which the objects are used, at how they emerge in performance, and so on.

EJAGHAM SOCIETY EMBLEM

I like this power object, this fetish, as it used to be called, because it exemplifies the elements involved in power; I like it didactically. And I also like it because of the collage element about it. It combines natural and seemingly non-natural sorts of things: grasses with man-made objects—tools, a drum, other sorts of things—it's got that commingling that power is associated with. It has a wonderful texture about it. Though I suspect it's the sort of thing that does not appeal to American and Western aesthetics at all. You don't see a lot of them in museums or private collections; they weren't collected so much. I'm not sure I'd want it in *my* living room. It's a puzzling form of craftsmanship to us. I don't know whether it reflects intentional artistry at all. But, boy, it does have that textured quality I like. And it intrigues me: I wonder if there are aesthetics associated with it; whether or not there's such a thing as doing a fetish object like that right, or whether or not in fact it's accidental. There *is* pattern in it. It has a round object in the center; it seems to focus us in on a center. And maybe it's that focusing quality that I like; this discursive, yet focusing quality that sort of brings you in on the thing.

I'm attracted to rough textures, no question about that. I like stucco houses—I grew up in one—rather than smooth sorts of things. I think it's texture more than material that appeals to me: my own sense of touch is an important element by which I appreciate things.

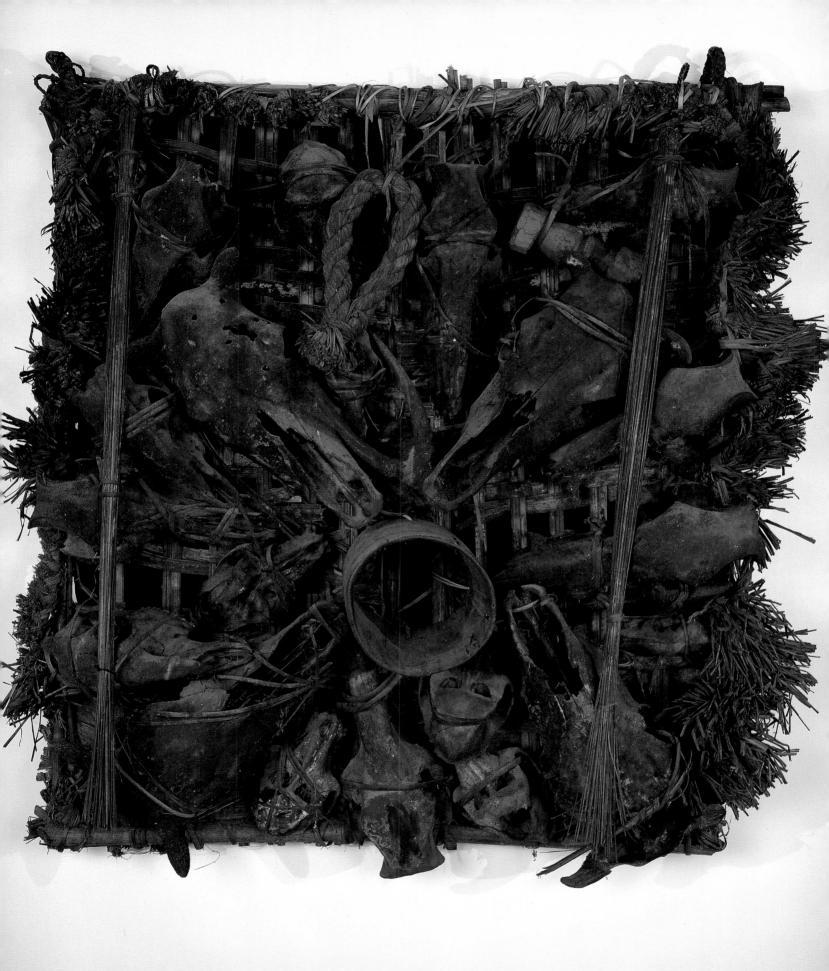

IVAN KARP

YAKA PIPE BOWL

This is terrific. There's an extraordinary
way in which the shape of the bowl has
been used to emphasize eyes and face in
this pipe. There's something going on
with the eyes which I find really appeal-
ing, at the same time that I find it hap-
pening in a utilitarian object. It's the hol-
lowness of the eyes. We're dealing purely
with what *I'm* bringing to it; my sense of
something penetrating into the soul. Peo-
ple fondle their pipes. The other thing—
this is the reason that I picked this and
the Shona neckrest—is that they are per-
sonal objects. They are not art in the
sense of something set apart, but they're
objects which are functionally associated
with the person; something you own,
something you place your head on. They
show a wonderful elaboration.

And the patina of use! By use, I don't
mean function. It's not made to be pre-
served. Most African art is biodegradable,
it's meant to be used up and thrown
away. For me, this patina glows; it's very
important in the way I judge things.

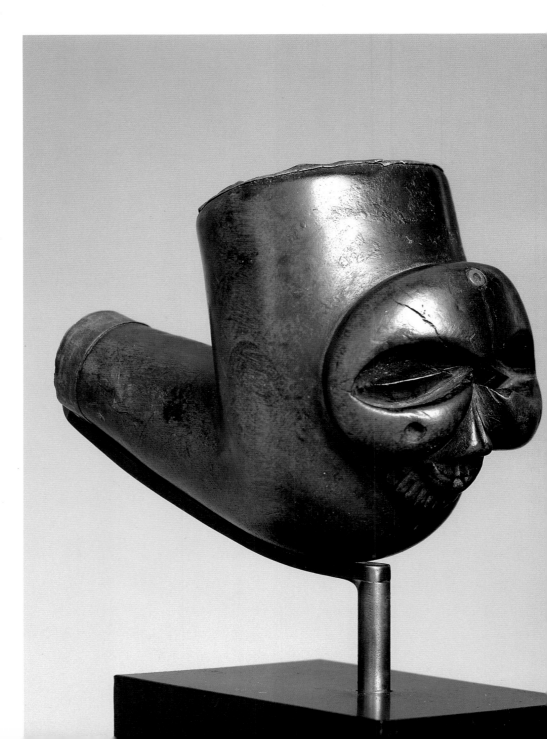

KONGO KNEELING
FIGURE

This is just utterly beautiful. This has
nothing to do with me as an anthropolo-
gist; it has a lot to do with what appeals
to me. It's ivory, it has a sense of age, it's
got a patina about it—it has a color, an
extraordinary warm color, and I like this
because of its combination between con-
vention and realism. There are obviously
culturally specific conventions of portray-
ing the angularity of Baule faces, differing
from patterned Yoruba faces, or the sym-
metry of Luba faces. But if you took a
Luba face and a Yoruba face and put
them next to one another, you can't tell
me that these two people see human faces
in the same way.

I also find the modification in conven-
tions of portraiture—that particular style
in which the convention is portrayed—
very attractive. I think that what I like
about it is the rounded quality that almost
makes you want to reach out and touch
it. The quality of symmetry, the place-
ment of features in the face—I think is ex-
traordinary. There's a real tension be-
tween the cultural convention and the
artistry of the face and also the posture
which is just gorgeous. It strikes me as a
kind of flowering, the highpoint of that
particular set of conventions for portray-
ing a human face. I like the proportion of
head to body; the tension of the shoul-
ders, the hands on the thighs. It really
seems to me to have a very nice balance
between body and head—not a realistic
one. That combined with the patina
makes it a beautiful piece of art for me.

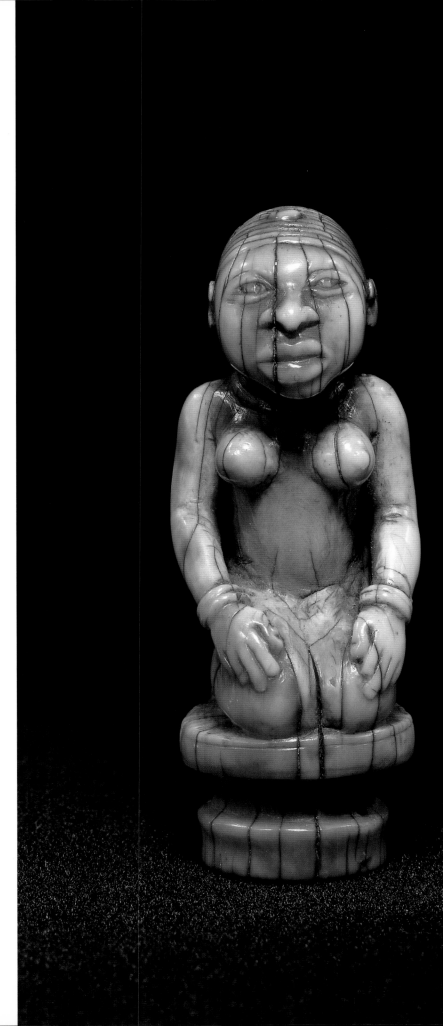

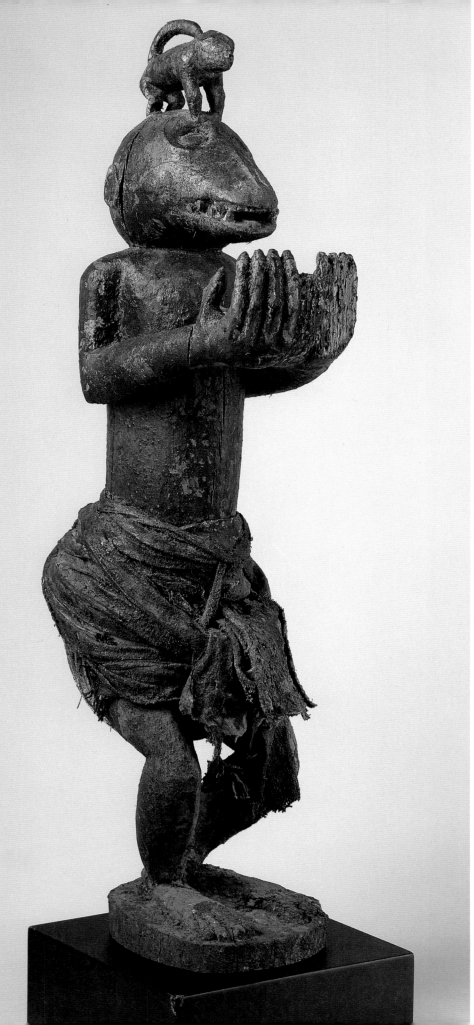

IVAN KARP

BAULE MONKEY FIGURE

I like it because it combines a number of elements. First of all, it represents animal symbolism in African art. There's a lot of anthropomorphizing of animals in folk-lore. This certainly has an anthropomorphic quality—the use of cloth—and so on. The other thing I like about it is the gesture of the hands and that in-human head. It's got a very nice tension about it which I particularly like.

Monkeys are interesting, obtrusive animals: there's an almost human-like quality about them, yet they are not; they're almost non-rule-governed humans. There's a wonderful Iteso folk story about an illness that affects children, and a ritual that's performed. The ritual is called "washing the baboon." The story behind the ritual is that one day a woman was digging her fields, and digging defeated her. She said to her husband, "I can't do this anymore. Let's go off into the woods and live like baboons." That is, they would live by gathering, not by fashioning the world. Well, they went off, and pretty soon they *became* baboons, and they are the source of the illness because of the bad odor that emanates from them and is carried by the west wind into households and attacks children. In other words, the retreat from work, from fashioning—from creativity in this sense—is continually threatening the world.

KONGO POWER FIGURE

What do we mean by power? I live in Washington, D. C. , so the way *The Washington Post* or politically oriented figures talk about power is rather different than what I think should be meant by naming some object a power figure in an African society.

I suppose that one reason they are called power figures is because whoever owns them has the capacity to do some-thing to someone else. That power is the

control that we can exercise over people, objects, the environment. It may very well be that African societies are a little more subtle in their understanding about these things. In everything I have been told about fetishes, it is invariably pointed out that they have a certain ambiguous element. That fetishes are very dangerous and there is a very high chance that the whole thing will boomerang and that whatever you are trying to do will kill you off rather than someone else. This is a subtle understanding of the ambivalence of power expressed in the idea of a fetish.

Power means more than "power" in the sense of control. It means a whole range of things, from the control that we have over people; or that one may have over another person, or over a natural event, or over an object—to the energy necessary to make something happen and the capacity to bring something about, which is different for different people.

I find the use of nails really intriguing. Very often in West African societies metal is used to represent an abrupt movement. A transition that's not the smooth sort of continuity associated with water so much as the abrupt discontinuity associated with radical change is expressed through knives, spears, and cutting. There's an association with penetration, with violence. Iron is hard and enduring. That's why it's such a powerful symbol of authority.

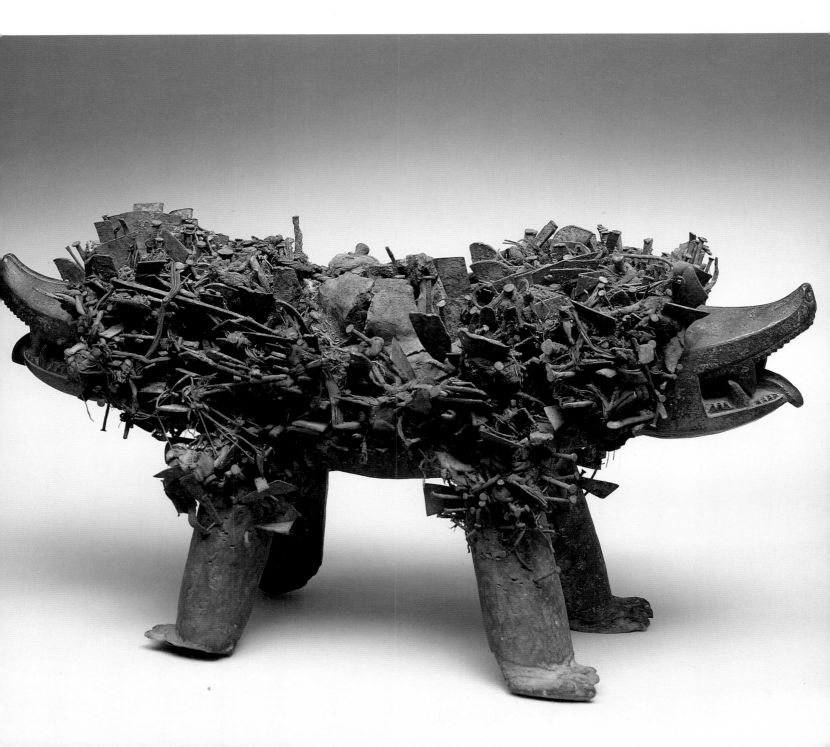

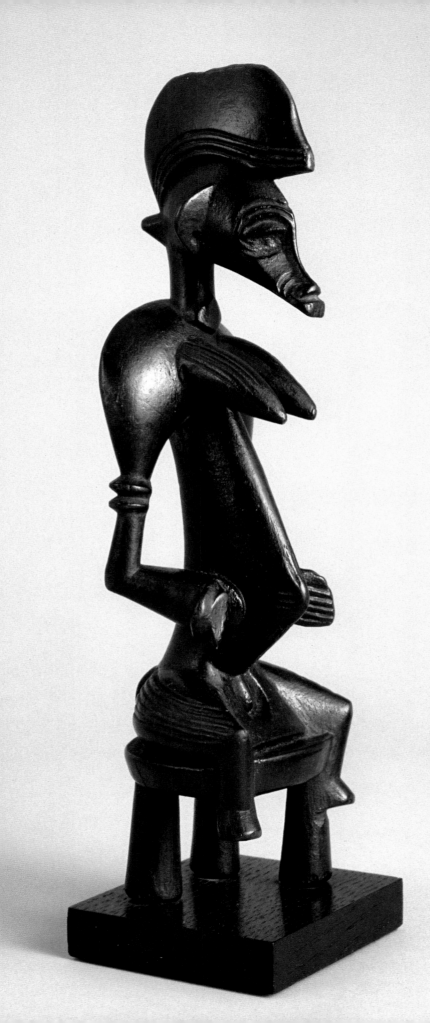

IVAN KARP

SENUFO FEMALE FIGURE

This is like the top of a staff that is given to champion cultivators among the Senufo. It's an almost ideal manifestation of a very complex system of thought because of how it illustrates the interdependence of male and female in social and physical reproduction; the degree to which the world is produced by the labor of men and women and their necessary interdependence in the sexual act of procreation—is an important symbolic element in African belief systems and cosmology.

These staffs have female figures, and yet they're given to male champion cultivators. Anita Glaze (who did field work among the Senufo) is very clear about the serenity of the female in contrast with the frenzied activity of cultivation. What she doesn't say—and what may be a possibility here—is that represented in this staff, may also be differences in the roles that each sex plays in the sex act itself.

This also happens to be a beautiful example of the genre. Stylistically, there is an extreme emphasis on elongation. In one plane, you have the jutting stomach, the jutting breasts, and the jutting face. It's just a gorgeous example of artistry in a particular style.

What is very clear is that the posture of the woman, the emphasis on the breast, the belly—all have to do with her procreative potential and capacity. Her facility is to produce people and reproduce the world, just as in their way, men do in hoeing and cultivation. The female image of sexual procreation and the male activity of agricultural production are incorporated in this female emblem belonging to the male champion cultivator. It becomes an ideal physical instance of the way that African belief and ritual systems focus upon the different activities of the sexes, their images, and their emotional capacity in social and physical reproduction.

SHONA NECKREST

I like the tension of form between the straight line of the bridge and what I guess are the breasts underneath it. The tension comes from combining the rounded legs which complete an object that appears to be all angles. The tension between the straight line angle and the rounded quality of the parts makes for what my colleague Roy Sieber would call a 'tasty object.'

I think it's a rotten shame we can't touch these things in museums. One understands all the practical reasons, the necessity for preserving the heritage and particularly for preserving it under conditions in which it will not be hurt. But there's an ironic element to this: that we take these biodegradable things and we try to preserve them as much as possible, without touching them. Whereas I think the qualities they acquire, they acquire through their use. The patina appeals to me aesthetically, but it also appeals to me because it carries the history of the object.

Maybe there's some way we aesthetically respond to it that is also a kind of inchoate way of responding to its history; these are not historyless objects; they have a history of use, of involvement in people's lives which enhances their appeal for me. In Africa, objects have histories, but in our own museums, we systematically deny that history. What makes these things "African" is not something innate, but how they've been made and what has been done with them. They have *African* history.

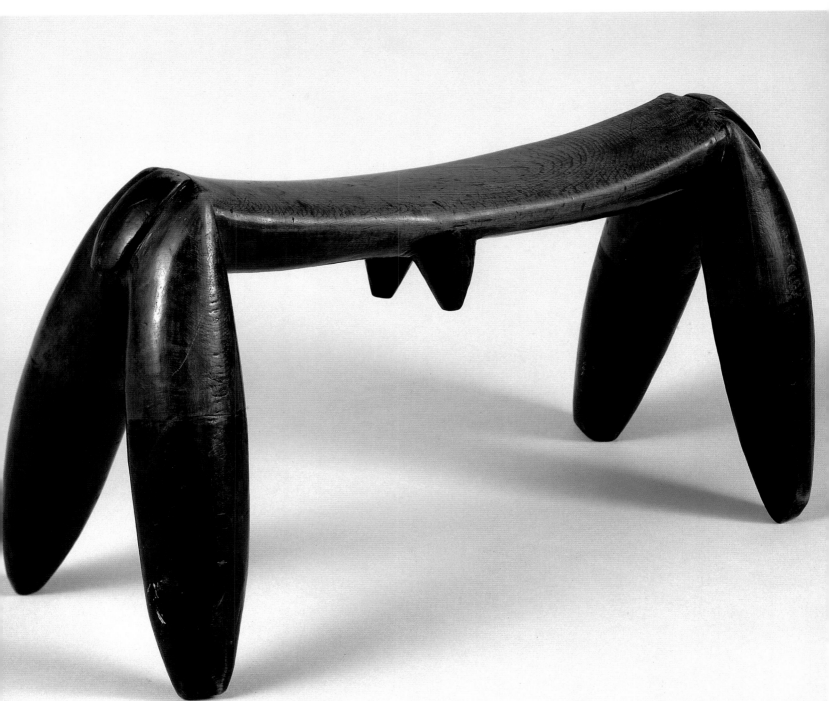

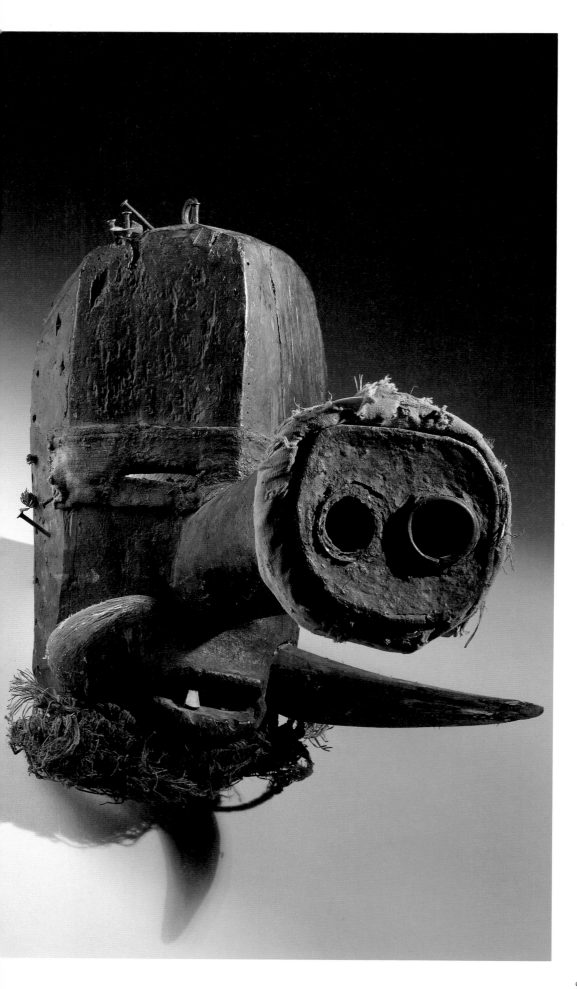

GREBO MASK

Now, this raises real possibilities about monstrousness. I'm fond of this. There is something in the ethos of anthropology— and a lot of anthropologists react against it—which leads to an evaluation of the exotic, but not necessarily the grotesque. My own taste has always been for the arts of irony, humor, satire, that sort of thing.

But I like it because it's truly monstrous. Not only do I like monstrousness and grotesque things, but it's got a lot of interest: it has the nails; it has that elongation of nose, the inappropriately placed horns; it has that kind of commingling of categories and violation of boundaries characteristic of liminal moments in life. Liminal is something that exists betwixt and between, when what's usually bounded is violated. Ritual is a movement, as in initiations, in which one moves from one status into another. That's where you find the breakdown and the creative commingling of categories associated with the grotesque. I use monstrous in quotes; it's a Western term. But it seems to me to be appropriate when you get monstrousness in this sort of thing: the animal and human combined and the grotesque enlargement, which I think is intentionally grotesque. A lot of African grotesques are either grotesque because they're portrayals of an illness, or they are intentionally grotesque for a purpose. I think this one is very, very interesting for just those reasons.

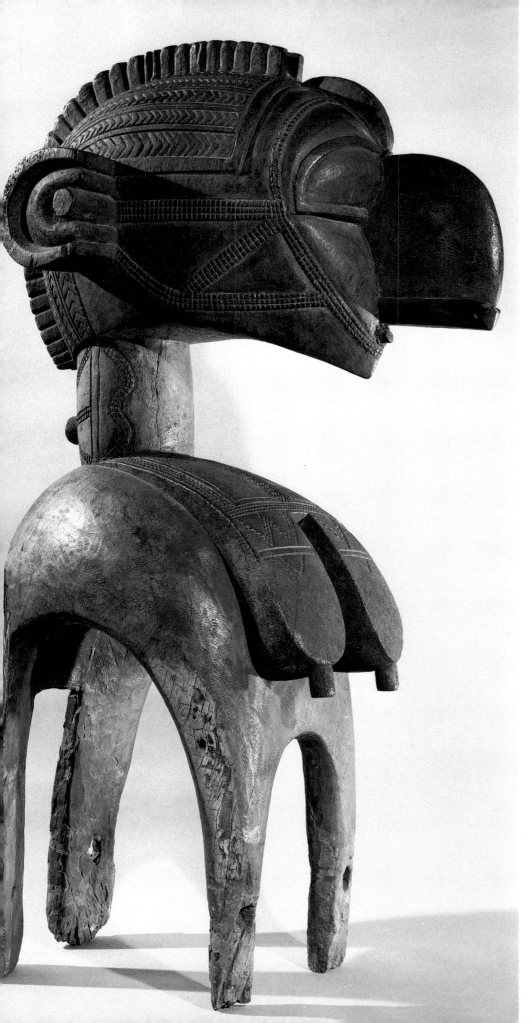

BAGA DANCE HEADDRESS

I selected this because I really like Baga art. For one thing, the thing is so damn big—which is very unusual for Africa. I've never seen the dances in which they are used, but God! They must use an incredible amount of skill; they must weigh a ton. For me, this again is a personal (as opposed to disciplinary) response. It's almost like the art of caricature; it's got a lot of elements all brought together in one thing. You've got a very high elaboration of headdress, body, the woman's breasts, the caricature of face. It's just something that I find very, very, very appealing because of the almost playful element—the playing with the human form, the relationship of nose to face, the enlargement of the nose, the alteration of the breasts to conform to the frame that holds the headdress on. I like the lines and what they do with it. There's a kind of symmetry about the scarification that I like, which you find in general in African art.

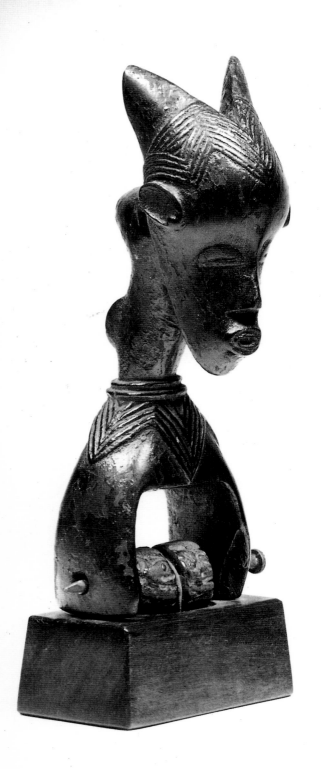
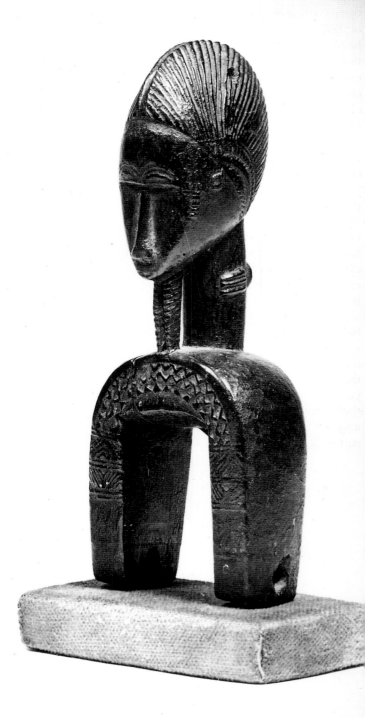

IVAN KARP

BAULE AND GURO HEDDLE PULLEYS

One of the reasons I like them is because it's a wonderful combination of the useful and the decorative. First of all the shape—there's a wonderful balance here. But the other thing is the degree to which we have conventions of art and the elaboration of the head; it's about as extreme an example as you can find of the aesthetic elaboration of the utilitarian object. This is obviously very important both to the aesthetic sense, and the cultural sense.

It's typical of Baule faces: the hairdos, and a wonderful emphasis on heads. African art is also indicative of the notions of what a person is. And a person is composed of various elements and capacities. There's real tension in a lot of African views between head and body, between head and heart. I suspect that the modifications on the head—the hairdo is another way of modifying the body—have a lot to do with the notion of what makes someone a complete person. The Baule have developed this to a very high degree. I think that what's distinctive about them is how delicately carved they are. In the features, and the amount of attention paid to hairdo, to body ornament—I think that there is a lot more attention, care, and skill going into these than the general run of Baule, or Ivoirian heddle pulleys.

A painter, sculptor, and filmmaker, Ms. Graves' work has been widely exhibited in Europe and North America and was included in the Primitivism exhibition at the Museum of Modern Art. Her paintings and sculptures are in that permanent collection as well as those of The Metropolitan Museum of Art, The Whitney Museum, and Houston's Museum of Fine Arts, among others. In the late 1960s, Ms. Graves' exhibitions featuring life-sized camel constructions (using burlap, polyurethane, and animal skins) placed her at the forefront of artists then involved in redefining sculpture. She has pursued a career-long investigation of perceptual issues concerned with illusion, reality, and motion.

In the late 1960's and early 1970's, I was interested in North American and South Pacific sculptural objects and I made a number of sculptures which were specifically indebted to some of the cultures of these areas. More recently, I've been thinking about African material. If I want to own an object, it's because there is something in it that has potential for me to appropriate or reinterpret in some way. Or it is something that continues a direction that is already in a work of mine.

In African and Oceanic sculpture there is a sophisticated simplicity in the unexpected scale and the placement of forms. This is distinct from Eastern and Western cultures that rely more heavily on the use of spatial perspective.

By unexpected placement, I mean such things as the way in which an arm will come out of a shoulder and will be read abstractly in a number of contexts, or as a separate abstract form, depending on its position within the sculpture. In many ways, there is a completely different definition of ''backness,'' let's say. What one would assume in Western art is that we know what a back looks like. And even if it weren't drawn by an artist, it would follow the Western tradition of what ''back'' has been. In the case of African art, the rules have evolved out of a tradition which involved a different sense of spatial perspective. I'm constantly surprised and delighted with their artists' intelligence, imagination, and invention in coming up with visual solutions. Since African art was source material for Cubism, it's impossible for me to separate African objects from this legacy.

The art is here for us to appreciate intuitively. One may get more information about it which enhances it, but its strength is there for anyone to see. We share our humanity and the wonderous ways in which it's manifested. The differences as well as the similarities are part of this wonder. That's why this art has such meaning to us who have no understanding of the cultures, and why we can sit here and talk about it, and why a museum of African art is of such great value.

Basically, my selections fall into two categories: heads and full figures. They are all utilitarian sculptures. I selected pieces with complex ''part-to-whole'' relationships. I related abstract part to abstract part as if I were building a sculpture. Also, I was concentrating on how the various forms within a given object interact to become a complete structure, or a whole of parts which are interfaced. Surface incident and the quality of the form itself—the way in which it was defined in the specific object—were considered last.

MUMUYE FIGURE

Whether or not there are a thousand or ten thousand or one of these, I think it's extraordinary. To me it's related to the Kongo Seated Figure (p.111) where I said that everything was anatomically wrong. But it works. It's visually successful and is a complete piece because abstraction dominates over anatomy. It forces one to read this as an extended neck with diamond-shaped arms (which are joined together over the ribcage, exclusive of the shoulders); the horseshoe silhouette of the legs and pelvis, the exaggerated open square earring—it's all so strong in its abstraction as to bypass anatomy entirely. This is a case where you read the spaces *between* the forms as contributing to the meaning of its three dimensionality.

It consists of three overlapping parts: legs, torso, and neck with head. It's also partially painted, which is unique in terms of my choices, though it isn't exactly why I chose it. There are a number of ways in which these forms give additional meaning to each other, and yet are subservient to the whole. I guess, ultimately, that would be one of the ways to define a successful object.

NIGERIAN PENDANT MASK

If I had to select only one, I think I'd select this piece. It is difficult to believe that a bronze with this many interstices and decorative details could have been cast directly. I relate it to the directly cast bronzes in the Gugong, in Beijing, during the Warring States period—the Eastern Zhou Dynasty in the fifth to fourth centuries before Christ. They had a means of interlocking clay molds which enabled them to achieve lacey, lattice-like surfaces.

The age of the bronze is quite evident in the patina. It's encrustated. The color red in the center of the forehead is particular to archaeological pieces, denoting the chemical bonding of its surroundings with the copper and the tin. The fabulously intense green oxidation of the copper, contrasted with the warm beige tones, is the result of lying in the earth. The complex detailing has partly eroded over time and that calls to mind some rhetorical questions about its original form: the part-to-whole, the negative-positive, figure-ground, information and lack of information.

WE MASK

This piece is a vertical elipse in profile, divided into four, more or less equal parts, made of horizontals and convex hemispheres. It appears to have a comic overtone to it. Except that the abstraction, for its limitation, is so profound—which is why I chose it. I admire the distances of the spaces and the detail of the carving. The incisions at the top of the circle of the skull indicate that straw hair must have been attached. The dotted holes around the mouth indicate a beard in the negative. The mouth and the enlarged nose—which I can also read as cheeks—and the slanting eyes, remind me of laughter.

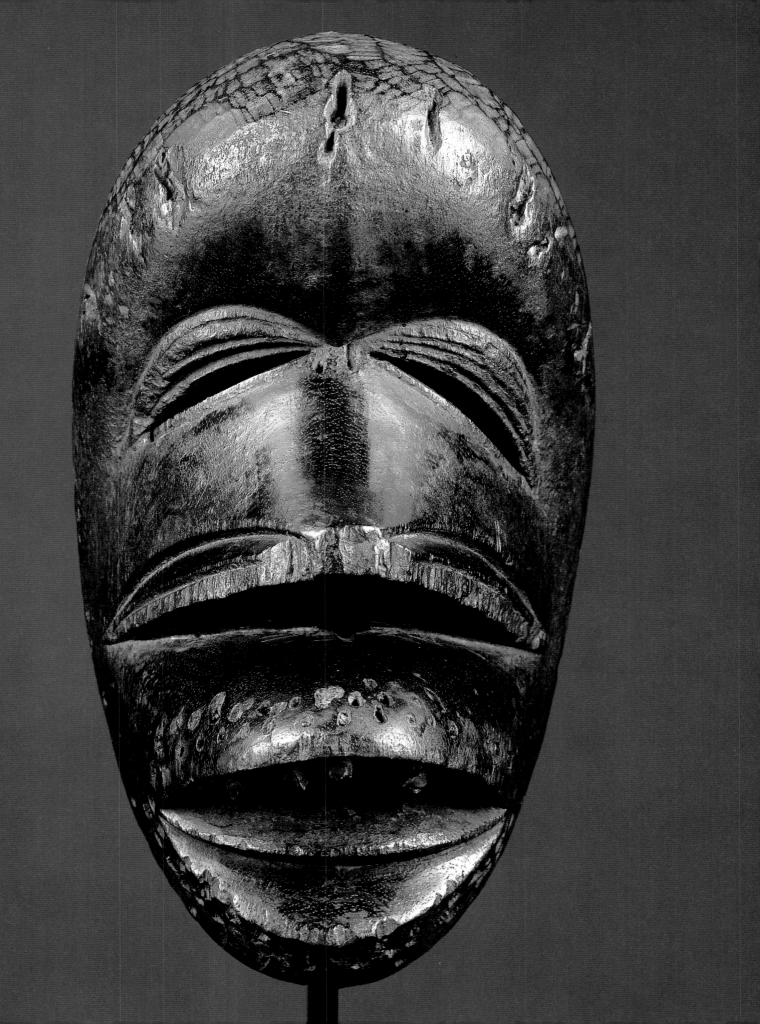

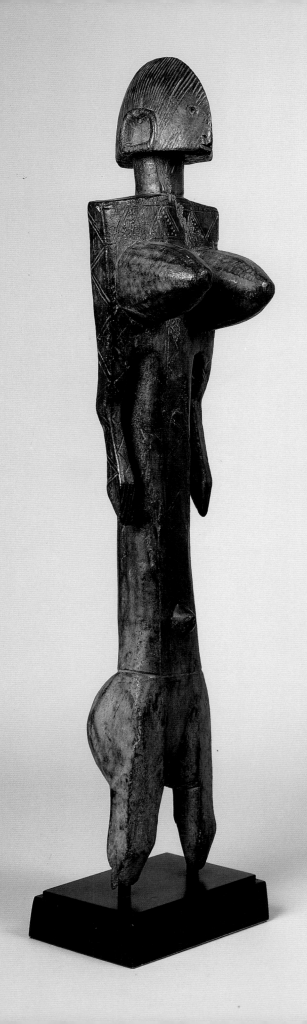

BAMANA FEMALE FIGURE

This Darth Vader, Samurai, medieval knight's head could have inspired Brancusi. The side view is of four hemispheres projecting at a ninety degree angle from the stick–like torso: head, breasts, buttocks, and navel. Seen frontally, a cone (the head) tops a cylinder (the neck) placed on a "T" shape (torso and arms), which rests on an inverted "U" (the legs and pelvis). The massive, conical breasts project from squared–off shoulders incised with geometric scarification. The arms, bent at the elbow, grow out of the torso, and the hands are bent downward. For me, the detail, the refinement, and the variation of forms make this quite a beautiful piece.

It's a peaceful attitude. And the patina is wonderful. It's obviously been handled a great many times. In wood or in bronze you can sense meaning by its surface. You see a beautiful surface where the wood has been cared for either by touching or by oil, and it gives a sense of importance and meaning—a spiritual power in the case of this material, or an aesthetic significance.

BAGA RITUAL OBJECT

Among the one-hundred objects which I could select, there were three which had large beak-like proboscises. I read this simultaneously as an African hornbill bird and a man with a long, pointed beard. The design of the base (which looks like a seat for a king) contrasts, reiterates, and is in equilibrium with the design of the head.

I like the design of the base and the way it contrasts with the design of the head. Both are positive and negative shapes. The triangles on the headdress are negative spaces which echo the triangles in the base. Also the profile of the man's nose is now a positive shape. The projection of the sword-like beard is also a

triangle, but an extended one. And the use of nails around the top of the circular base compliments the detailing which is made by the use of nails in the head.

The form of the skull—an extended crown—reminds me of Mayan or Olmec bound and elongated heads. The drawing in the head is repeated in the base. This interests me as a sculptural problem: think about Brancusi, where there is no such thing as a base; there are only forms: one of them finally has to stand on the ground and one of them has to be on top. I like what the artist has done with the abstract interfacing of the so-called base with the so-called head.

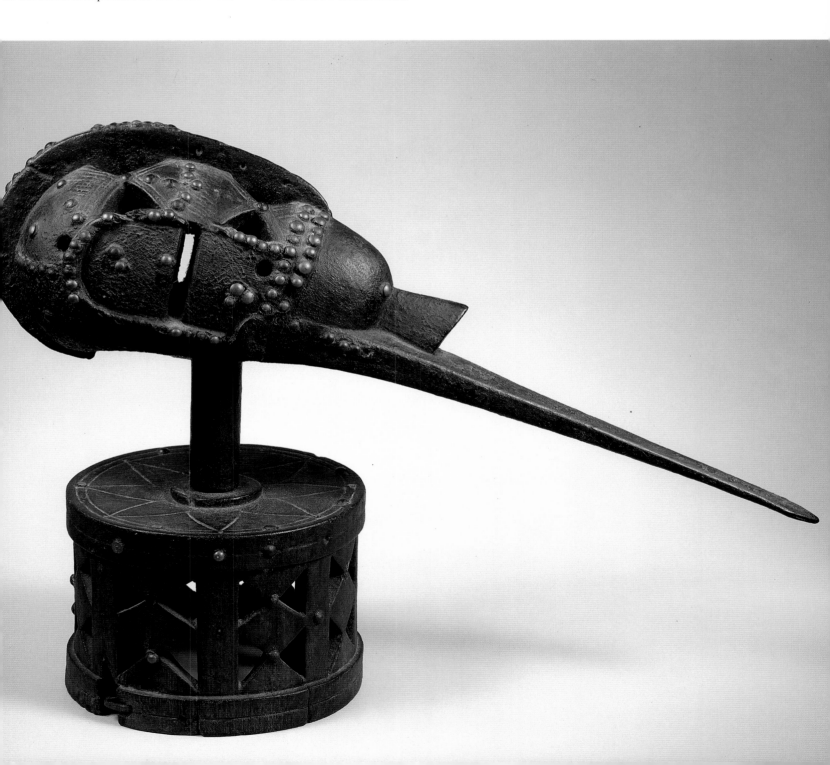

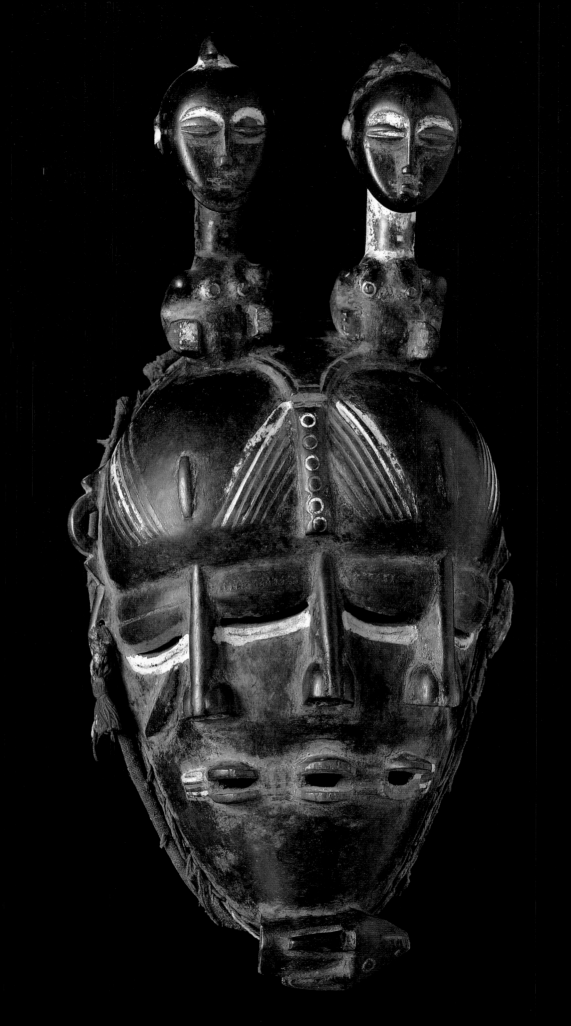

LIGBI MASK

I would say that this is visually a far more popular piece to Western viewers. It concerns multiple readings of part to overlapping part by means of exaggerated numbers: two figures above the mask's face are placed on the top of a head of a human being, which in turn has three noses, four eyes, and three mouths and is finally attached to a small sideways animal head. It's the placement of these incised and excised forms, the number and repetition of them, and the quality of the carving that interests me.

I think that if I had to live with this, I'd tire of it, because everything is revealed. If you look at it carefully after a while, you can pretty much memorize it. Yet the quality and the abstraction of the carving and its repeated forms is masterful.

I'd like to wear this mask to better understand its abstraction, to look through the eyes and see how space is distorted, to see perhaps how it functioned. Then too, I'm sure that if you put it on you'd have a different feeling about your own head in relation to your torso and legs.

MUMUYE FIGURE

This is marvelous. The sophisticated layers of abstraction are breathtaking! It has four distinct sides: seen frontally, the head doubles as a separate bird/man figure. The shoulder girdle is a collar, the arms are angular on the inside which forms a diamond shape. Each abstract form is monumental. At the same time, though, the profile of the outside of the arms forms a rectangle that emerges from the shoulder girdle and is rounded front to back. The stick-like torso is rounded, is elongated and is volumetric, with the navel projecting at ninety degrees. The pelvis looks like a log in cross section with the abstract male genitalia projecting. The

(continued on the next page)

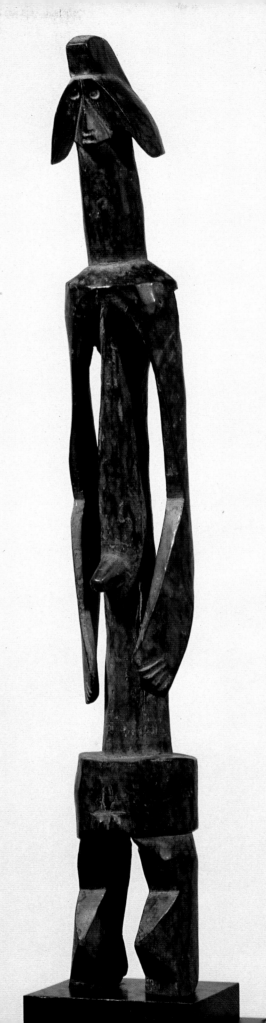

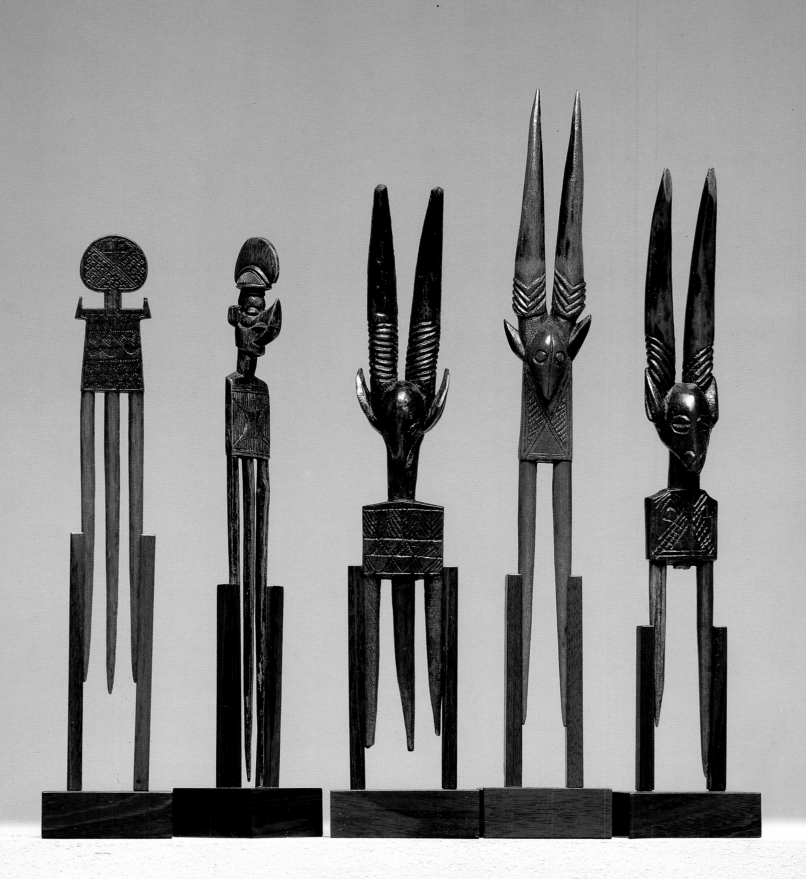

body is elongated: the neck is longer than the head, the torso is longer than the legs. Distortions enforce the abstraction of the figure. Even the details—the fingers, eyes, and ears—are abstract, highly selected forms.

The four-sided legs read as abstract zigzag relief shapes which double as front legs. This is further complicated, optically, by the rhythmic play of light and shadow on volume that interacts with the negative space between the forms. The feet are a negative space at the base of the legs—which recede because of the implied perspective in the diagonal relief planes, even as they *appear* to project frontally. Picasso's cubist pieces, as well as the fabricated sculptures of the 1960's, engaged in some of these visual sommersaults. The so-called negative spaces of Picasso's painting, drawing, and sculpture could simultaneoulsy become positive/negative shapes with multiple readings.

All these distortions cause a Westerner to think about the figure. While it's so figurative and so well defined in its details, it's also quite beautifully abstract.

YAKA COMBS

These combs are only eight to ten inches high, yet through the proportions and the detailing of the parts, they are monumental. With the teeth seen as legs, I relate the combs to the stick figures of Picasso and Giacometti—which are themselves said to come out of Assyrian or Etruscan bronze figures. The vertical horns of three of the animal heads read as an inversion of the comb's teeth, and in a way, become legs as well; the wood mass in between becomes a body.

The other two have very large prongs and proportionately tiny bodies. The top form in each reads as a human head. The head on the second from the left could also double as a human figure. It is three dimensional, quite abstract, and the smallest. Its head looks enormous though because of the contrasting size of the comb on which it sits. It's volumetric, while the other which has a human head form is flat and frontal, a silhouette.

The positioning of the five pieces (for display purposes) the two human figures and the way they stand with the tall antelope forms—reminds me of two museum presentations of far greater consequence:

the Sepik totems in the Rockefeller Wing at the Metropolitan Museum of Art in New York, and the South Pacific boats in the Dahlem Museum in West Berlin. In each case, a powerful display emerges as the result of the linear positioning of similar but varied forms taken out of their cultural context.

My large sculptures of 1970 and 1971— *Shaman* and *Variability and Repition of Variable Forms*—were influenced by photographs of a visually related, linear format within its cultural context. Carved wooden totem poles, two and three times taller than human scale and venerating the ancestors of the Pacific Northwest Indians were placed side by side in front of a pine forest and faced open sky and ocean.

So I have a problem here. These utilitarian objects, taken out of their cultural context, can only inform one another aesthetically. When that occurs, they are more readily cannibalized by Westerners. On the other hand, while I adhere to the theory that cultural information provides greater understanding of a work of art, I still believe that these pieces can be appreciated intuitively.

NANCY GRAVES

CAMEROON FOUR-FACED HEADDRESS

This is wood with a great deal of encrustation which I'm assuming has to do with some kind of handling and veneration. It's very volumetric; all the forms are bulbous. One could certainly read any one of these forms as abstractions: as a series of spheres or ball shapes, which then happen to be cheeks or eyes or eyelids. The mouth is the most emphatically emphasized, but then the teeth are also ball-like, small pellet shapes. The shape of each head is a distinct, imperfect sphere shape—an aberrant situation as if there really *was* a two-headed figure—which, of course, can happen in nature. The way in which the forms merge with one another, the twinness of it, and the idea of having four faces is, for me, very compelling. It reminds me of Olmec heads or Picasso's bulbous nudes of the late twenties and thirties.

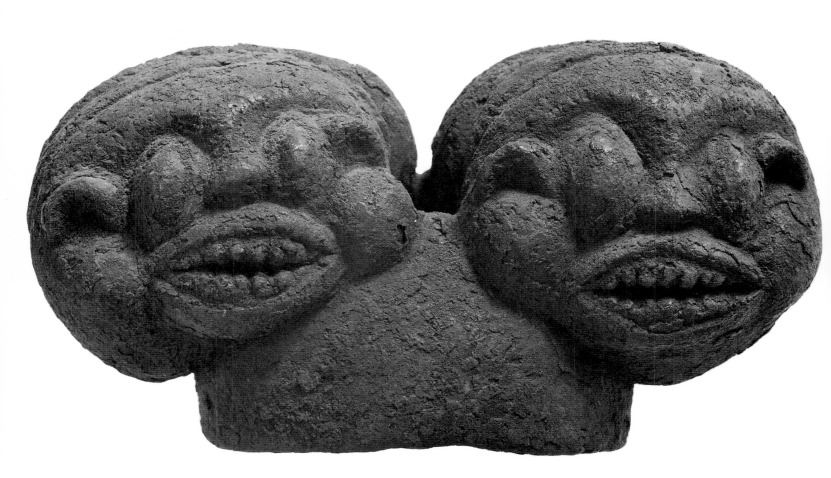

KONGO SEATED FIGURE

What interests me about this figure is the interplay between the "badly drawn" positive forms and the circular motion of the negative spaces that can read both positively and negatively. There are three of these negative spaces: the five-sided space of the hand holding the head; the profile of the neck to the shoulder; and the elongation of the figure's right arm (which extends from face to thigh) which makes a rectangular negative that is larger than that on the left side. The volume of the forms themselves, as in the crossed legs, for example, is defined by the play of light and shadow. The profile silhouette is striking.

It looks awkward, it looks wrong, it looks ignorant of anatomy. And yet it works. With its procelain eyes and bulbous stomach, it's very powerful. It does everything wrong, and yet it's extraordinarily successful on its own terms. It reminds me of a remark the sculptor David Smith once made: it had to do with the conviction of the artist's hand, no matter how unstyled or uneducated, eclipsing the standard qualities that we expect; that the very need and drive of the artist to express can be so strong that the drawing is its own reason for being.

*T*he American author, James Baldwin, is well-known as an essayist *(Notes of A Native Son; Nobody Knows My Name; The Fire Next Time)*, novelist *(Go Tell It on the Mountain, Giovanni's Room, Another Country)*, and playwright *(Blues For Mr. Charlie, The Amen Corner)*. Mr. Baldwin has devoted his life and art to probing the complexities of human relations, the experience of the black American family, what it means to be black and what it means to be a man. His writing has won numerous awards and prizes, among them, a Guggenheim Fellowship and a National Institute of Arts and Letters Award. Internationally prominent as a writer, intellectual, humanitarian, and spokesman for civil rights movements, Mr. Baldwin lives in southern France and is currently working on a novel.

"The paradox—and a fearful paradox it is—is that the American Negro can have no future anywhere, on any continent, as long as he's unwilling to accept his past. To accept one's past—one's history—is not the same as drowning in it; it is learning how to use it."
from *The Fire Next Time*, by James Baldwin

I feel reconciled to myself and my past; in fact to everything. This art speaks directly to me out of my maligned and dishonored past. I come more directly from this than from Rembrandt. Rembrandt means an awful lot to me too, and so does Picasso, to name but two. But this work has been buried, this has been destroyed. We are looking at remnants, fragments of civilization and of civilizations which have something to do with me, and also something to do with you. But you hide it. You historically have denied that; you've done everything in your power to destroy whatever civilization produced this work. Therefore I have to have another connection with it because what you do to them, you are trying to do to me. These are my children. How would I not know this is African! It says something directly to me because I am black. Because the world is composed of black people and white people. What does it mean to be black? It means that you're not white. It speaks to me more directly than other things might because the fact that **I'm** still here and that **it's** still here says things to me which it would not be able to say to you. People think that I am black, inferior to them. Black people live in white people's imagination, really. There's a great imbalance. Because I don't walk around—no black person I know walks around—with a white person trapped in his skull. But white people do. And it controls them. You see what I mean. White is a state of mind.

person I know walks around—with a white person trapped in his skull. But white people do. And it controls them. You see what I mean. White is a state of mind.

I've been aware of African art most of my life because of the Schomburg collection in Harlem. I've known it since I was nine or ten. I do remember that it made an impact on me. Pieces spoke to me. They spoke to me from a long way off. We recognized each other. Perhaps that's the best way to put it. It's not mysterious to me. Appealing is not a word that I would use. It's a similar connection that I have with Miles Davis or Leadbelly or Bessie Smith.

You don't realize that you're asking me very personal questions. You think you're talking about art. But you're not! You're talking about something else. You're talking about something which the West as a group has done its best to destroy. And it's still doing it's best to destroy. I'm talking about a kind of testimony to what a human being is or can be—which this mercantile civilization is determined to ignore. And to kill if it can. **I** know they cannot live without it. They don't yet. They'll find out. Every one of these things we've looked at - there have been thousands more that have been destroyed. And the people have been destroyed—or everything has been done by the Western powers to try to destroy them.

I know the things we looked at. It's forever, a criminal record. Much worse than criminal. And it is not in the past, it is in the present. The record is terrifying. And the attempt to destroy it is not in the past, it is in the present. I am talking about the rape of Africa. We are looking at the remnants of that rape. What's disturbing is not simply the artifacts which have remained; what is disturbing about it is the attempt to destroy its sensibility. It's the audacity of the idea of color. And it's the audacity too of the idea of profit! I was on the stock exchange; my children were on the stock exchange. The price of slaves, the price of rice—they were on the same board. People speculated on both.

The artist's work is his intention. There's this curious dichotomy in the West about form and content. The form is the content. I think the work of artists is to be useful. To have such works, to have them on the wall—you walk in and you are among friends. It's very different to me, and not at all real for the people who may be looking at these objects. They will not, in short, know what they are looking at. One way or another, they don't want to see it. They want to make it something extraneous, something exotic. But they know it contains their lives too. And I have other things to do than to try to translate anything for people who don't want to hear it. The mathematics of their lives, the algebra of their lives is built on not knowing it.

Then, maybe I'm tired of being a missionary. I'm talking in historical generalities. This is revealed in the choices—the social, political, and economic choices we make. In a way it's as though you're asking me to talk about Art Blakey. I'm not going to talk about Art Blakey. You want to find out? Go and expose yourself to him. You can't find out through a middleman anyway. You wanna play the blues, somebody said, go out and catch them. Then you'll know something I can't tell you. And if I tell you, what makes you think you should believe it?

MADAGASCAR MALE FEMALE PAIR

This is a mother and child, male and female figure. It's a curious combination, it's very ambiguous in a way. But let me find the words that I want. In other words, it's a combination of things. It's very, very gentle—the woman and the man. Though it appears that the man is more hopeless, despite the fact that he has a phallus. The way it's positioned is curious. It echoes his coming out of her womb and that she will be carrying his child. She's holding him and he's clinging to her. They're both indispensable. It echoes childbirth and it promises fertility. The craftsmanship is very economical. I'd like to write a novel like that. The key is somewhere in her face; the way she's looking out and the way he's looking—God knows what *he's* looking at. She's looking at the child she bore, the man she's bearing, and the child she will bear. She knows more about him than he knows about her, which is perfectly all right—that's part of their secret. Something about the arms and the breasts and his squatting and her standing suggests this to me. Is she standing or kneeling? No, it looks like she's kneeling. It's very beautiful.

It's hard to describe these things in a Western language. It speaks of a kind of union which is unimaginable in the West. Men and women distrust each other so profoundly that this piece would not be possible. No one on Madison Avenue could see that without being mad, without jumping off the roof. That's why we're called primitive. Primitive—what a curious word.

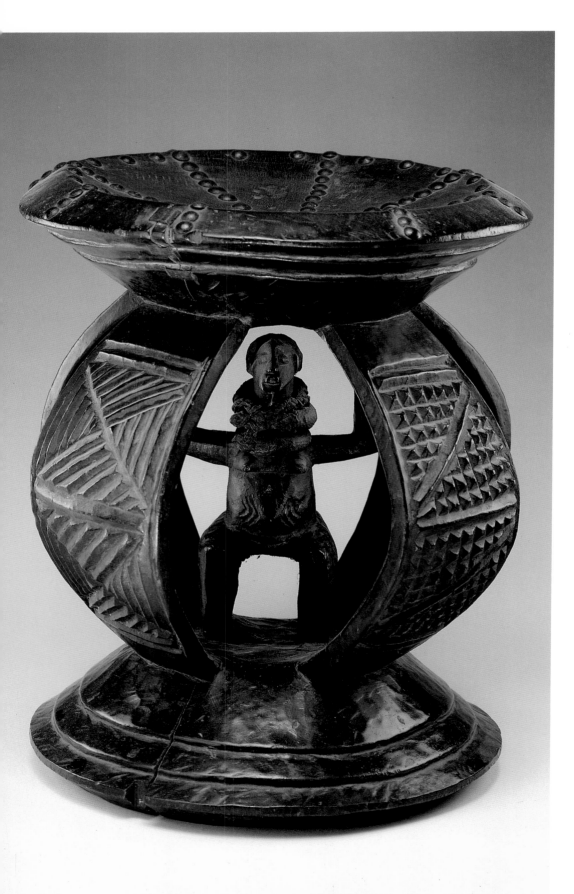

LUBA STOOL

It could be Samson. It's space that's something to be conquered. Not space in the American sense of Star Wars and all of that crap, but it's space of the world in which we live and the space of oneself. It's pushing back the boundaries, and it may turn you all around; it can be turned around and upside–down as well, but more difficult upside–down. Again, the form is the content, isn't it? She's outmatched by the weight around her, above her and below her—but she can change it. You can see this in the stance, in the arms, and the way she's looking out. She's not resisting; she's contesting. But the world is always, one way or another, the world she made. You have to assume that in order to change it.

The texture is very elegant. It's not a hollow space, it's an open-ended space: everything is possible. And everything is also impossible. It's very important. It's very passionate—in the best sense of the word. All the artists are anonymous. Which, as Auden said once, is the real desire of the artist—to become anonymous. No doubt though, in the village where he came from, people who knew him would know this from some other piece of work. I can't go there. I'm not equipped at all to discuss that.

LUBA STAFF

I recognize the women; I met them in Harlem. But it's another time and another space again. They're the women who live in Harlem. They are the women who raise—it's impossible to translate this. I shouldn't even have to. The women have been here for 400 years, and now you ask me who they are! Find out. You can't find out through me, that's not enough. I'm not sure I can articulate it. I'm also weary, weary, weary of trying to deal with this— you should know who they are.

It's a kind of celebration. It's also a challenge: if they are not mowed down by a machine gun, they will get to where they are going, out from wherever white people condemn them. Twenty-four hours in a black man's life, or a black woman's life—put them in the market or the subway, it doesn't make any difference. I would not know the details of the culture, but I see this on Lenox Avenue: the style, the determination.

There's nothing mysterious about the two ladies at all. They're on their way to a celebration, or to a funeral, or just to take a walk. There's a great deal between them that's unspoken: paying rent, cleaning the house, dealing with the children, dealing with their husbands. It's conceivable that they are married to the same man; it might be so, given the breasts. One is sagging and one is not. Like I told you hours ago, it's another time and another space. It's all done in another vocabulary which I am not equipped to try, and wouldn't even attempt to articulate.

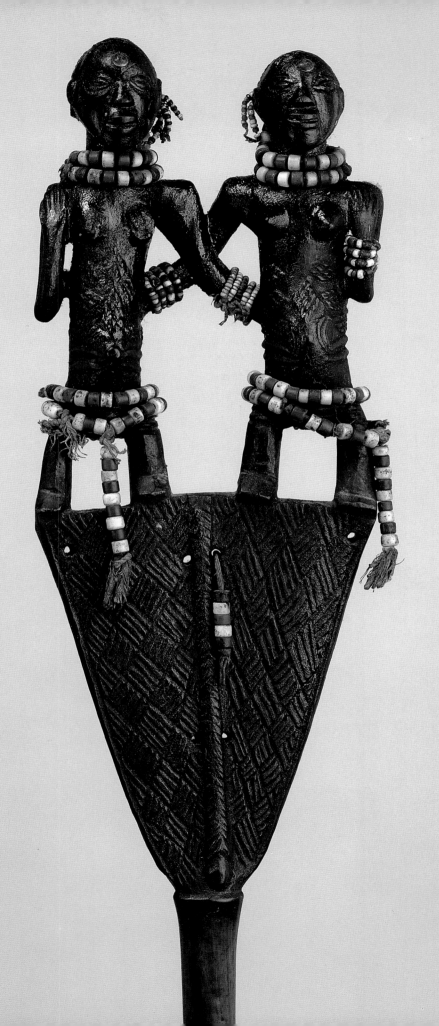

119

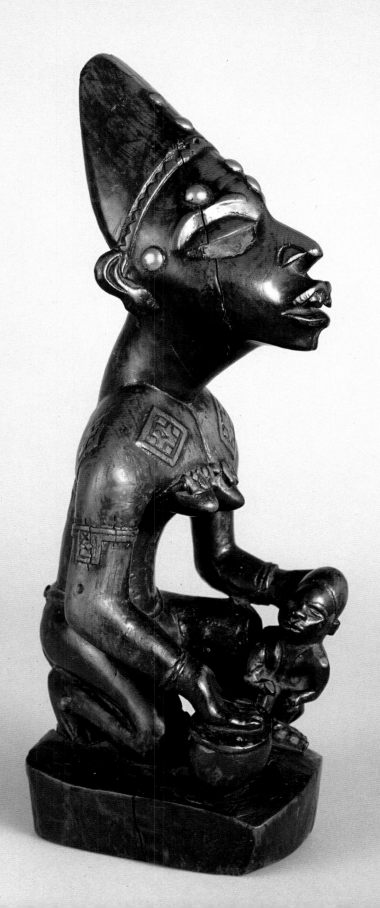

KONGO MOTHER AND CHILD

The key is her stance, the way she holds the baby in one hand; she's at once preparing the baby, and preparing to let him go. She sees what he's going to be facing and he doesn't see it yet. The baby is turned toward her. She has one hand protecting him, on his head. It may be that the baby is facing that way, but I think not. I think the baby is facing towards her. Her eyes look far seeing—into the baby's future. She might be anointing the baby. She's preparing him, in any case, for a journey. *She* knows about the journey—he doesn't yet. And she's also warning his enemies. Ah, but again, another time and space.

CHOKWE HERO CHIEF

There's a certain force in the body, in the shoulders especially. A certain eloquence and economy. But the force is what strikes you first. A very contained force, a very contained power. It doesn't feel malevolent at all. I suppose the word I'm looking for is authority. The whole thing—the hands and the feet; the neck and the shoulders, and the extraordinary headdress—are aspects that I like.

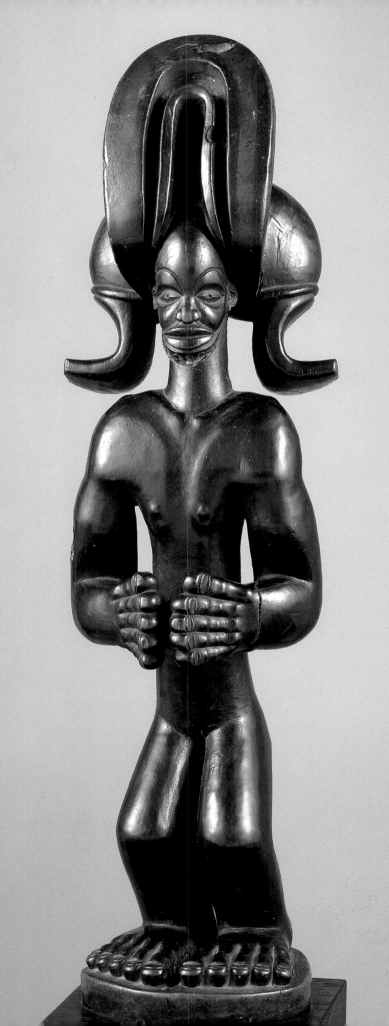

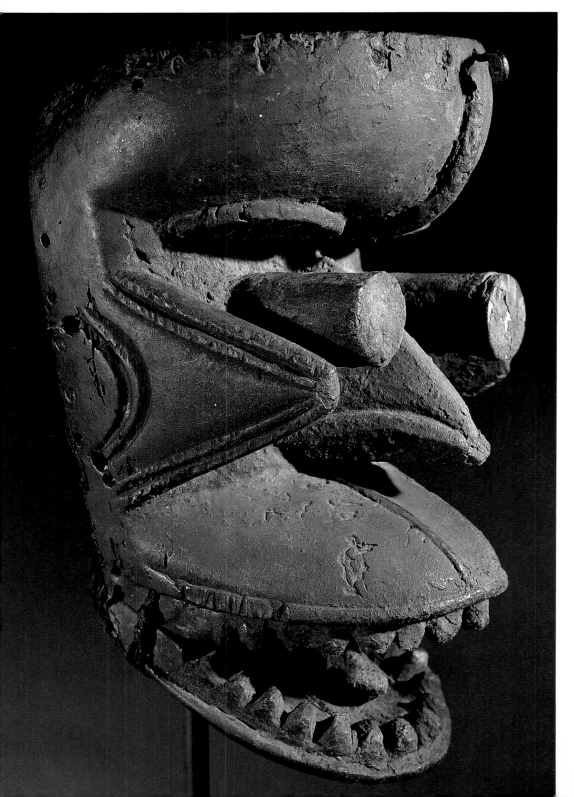

DAN MASK

You're asking me to be somewhat literal about it. I can't. I recognize it. I don't know how I recognize it. I don't know how to put it to you. I recognize a level of energy and passion which *this* time and space would like to kill—would like to obliterate that energy, that passion, and that perception. That's why it's called primitive.

It's extraordinary though, something between life and death, something from the skull. Something very—something clairvoyant, something fearless, perhaps. The clairvoyance is in the junction of the eyes and the eyebrow.

I don't think it's a question of preservation. I think it's a question of recognizing that this is eternal, that you can't kill it. In a curious way, you know, it's not as if we are seeing savagery; none of these images are hostile or frightening. They certainly aren't frightening to me. There's a reason Europe planned to destroy it.

DJENNE FIGURAL SCENE

I love it! What are they doing there? Everyone looks so calm. Even the animal. He looks tired, philosophical. Had a hard day, poor thing. He's leaning on one of the boys; he came there to rest. One of them is sitting under him—or her; you can't tell. They're all just taking a moment to rest. They're not strangers to each other; obviously he's not dangerous—he's brought his cup of cocoa. It reminds me of a song we used to sing in church called Peace In The Valley. But it would be hard to try and sing it. It's all the elements of the human being. Obviously they don't feel threatened by this, "the lion should lay down with the lamb." I grew up with that. But again, it's something impossible to discuss in the language of the West. It would require a language not yet forged. Or a language that's got to be excavated. The language in which somebody confronts and reveals

our connections, our *real connections;* a language which will attack our definitions. It's a language yet to be honored. It's obvious it exists. The artist always knows this language.

I love this. But I'd be afraid to have it; somebody might break it. In a sense, yes, it offers me a sense of serenity. The Western world is so completely fragmented—I don't see how anyone gets through the day.

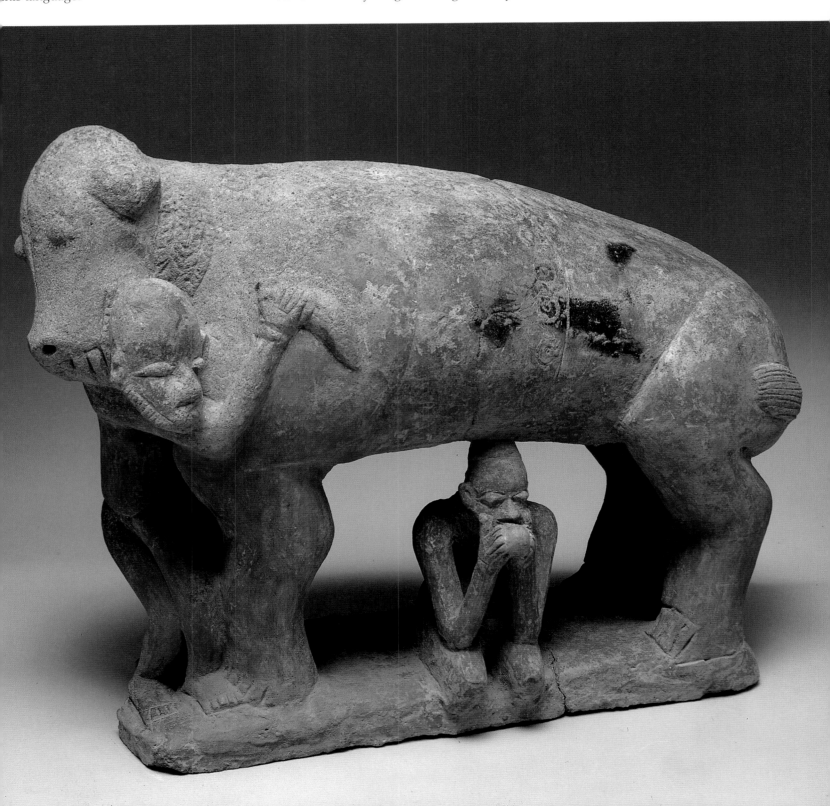

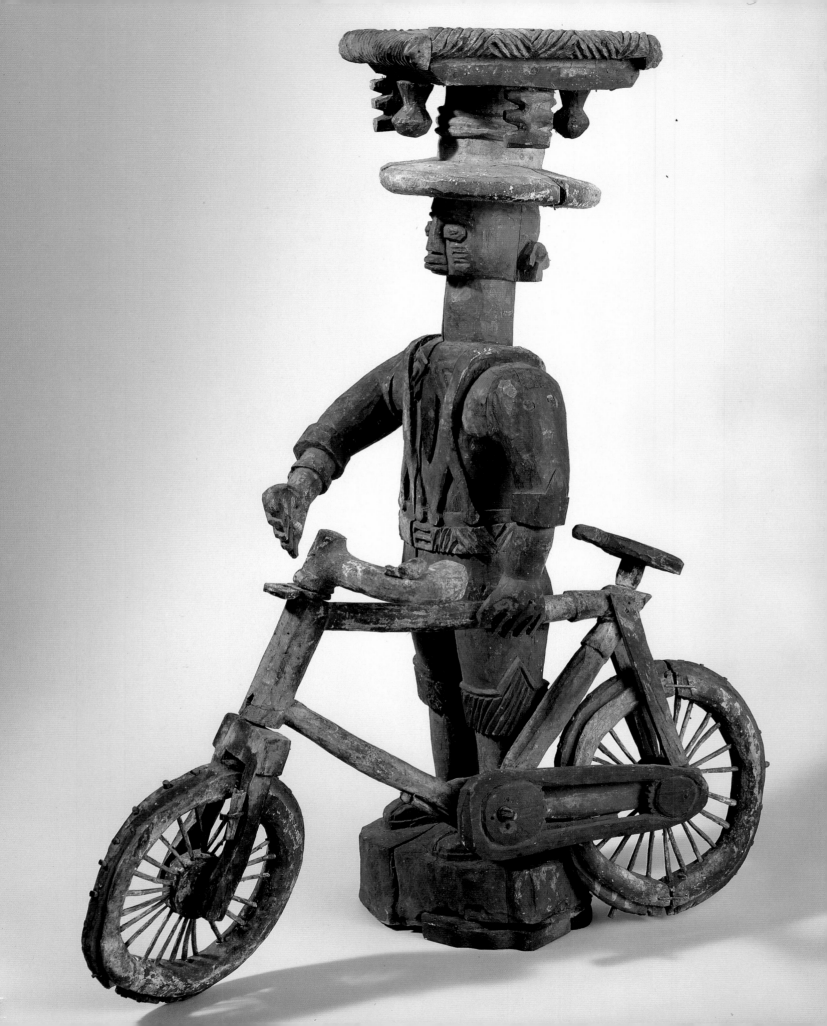

YORUBA MAN WITH A BICYCLE

This is something. This has got to be contemporary. He's really going to town! It's very jaunty, very authoritative. His errand might prove to be impossible, whatever it is. He's *one* place on his way to another place. He is challenging something—or something has challenged him. He's grounded in immediate reality by the bicycle. In other words, in another time. And therefore, in another space. The key to it, its tone, is confrontation. I imagine the confrontation is with the city. I didn't notice the crack at first. Was the crack deliberate, or did it happen over time? It adds a certain poignance, but it doesn't change my response. It seems to me distinctly different than the others; it's another time. It's much more literal. I imagine if I stopped him on the street, he'd ask me what I wanted—from a certain distance—but not with hostility. He's apparently a very proud and silent man. He's dressed sort of polyglot. Nothing looks like it fits him too well.

YORUBA MASK

There is something very peaceful about this. You get the feeling that whoever carved this looked around—and inside himself too. This strikes me as very—somehow very peaceful, very, very old. It's meant to portray someone very old—someone like my grandmother, someone who's been through everything. It's very tranquil. It lets you be assured, as if it's really been through it. It could be my grandfather, too; I don't see a physical resemblance at all, I mean metaphysical—something in the patience.

I find it very difficult to tell you what specifically attracted me. I feel I am being psychoanalyzed. It's probably something in my past. I've seen that somewhere—more than once. I've seen faces like that. I

(continued on the next page)

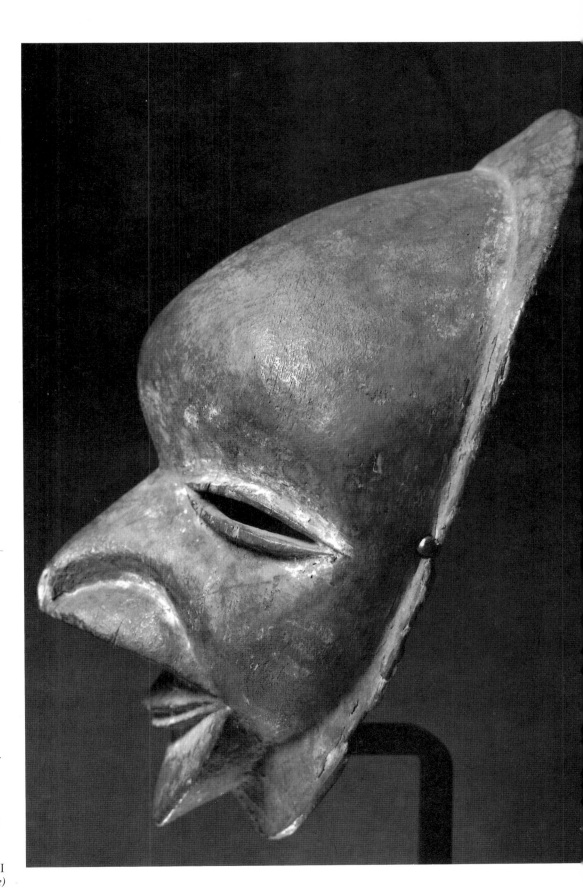

can't quite imagine what those eyes have seen, what's behind those eyes. I like the way the forehead has been rendered very much. It may be the key to it; I don't know. It's an indication of a certain wisdom, a quiet, and a certain patience. That smile is saying something. There's a smile in the eyes.

I wouldn't know enough about the circumstances or enough about the choices to write a story about that face, at least not on the spot. The language is not exactly mine, it's removed from me. It's not a Western face. One could say an African face, but it's something deeper than that. I can't find the word for it. *Africa,* for lack of a better term. *Time,* without thinking about it. But that's not geographical.

You need a whole set of options, choices, and battles—which would be very hard for me to imagine if that face had to be the key to the story. He's far beyond happiness, far beyond sorrow, too. Patience, wisdom, and grace. Kind of distilled. A reconciliation. It's a kind of union, a kind of tranquility—which is not Western.

CAMEROON STOOL

I love this. There is a sense of continuity—and not only between the figures. *Everything* is connected, holding up—it's being held *together* and also being held *up.* Again, it's another space and another time. It's not a Western idea. The whole thing is informed by the phallus. The faces of the children are really unreadable in some ways. From the Western point of view, it would be called grotesque. But it's very powerful. And finally, very true. I'm again talking about another space and time. This comes from a language which I'm still trying to excavate. I come from there too. It's an affirmation of the fact that the world is round and that we are all connected and that nothing ever dies.

The Western idea of childhood, or children, is not at all the same idea of childhood that produced me. To put it very brutally—to exaggerate it a little bit, but not much: white people think that childhood is a rehearsal for success. White people think of themselves as safe. But black people raise their children as a rehearsal for danger. In this piece, there's a connection between them—everyone of them is facing, they're turning around, they're all looking out. But they aren't protecting themselves; they protect each other. They're joined, but each one is alone too. They are all facing out differently. It's not like Mt. Rushmore—everybody looking either at the north or south. *They're* looking at the world. Each one sees a part of it depending on where he is. The world is round and everything is connected. They have a tremendous humility and a tremendous energy—they have that in common. It's very affirmative.

Mr. Rockefeller is currently active in numerous business and not-for-profit projects concerning a broad range of international, governmental, philanthropic, civic, and cultural affairs. Formerly chairman of the board and chief executive officer of the Chase Manhattan Bank (1969–1980), he has long been involved in culture, education, and public-private partnerships. He is a founder of the Business Committee for the Arts, serves as vice chairman, trustee, and member of the executive committee of the Museum of Modern Art, is chairman of the Americas Society, and is the past chairman of the Council on Foreign Relations. Mr. Rockefeller and his wife reside in New York City and Tarrytown, New York.

My first trip to Africa—south of the Sahara—was in 1958. I've probably been to at least twenty-five different African countries—some of them several times—on at least ten, and maybe more trips since then. Most of my trips to Africa have been banking trips for the Chase Manhattan Bank. But even on banking trips, usually, I try to take an hour or two here and there, by way of recreation, to see museums and do a little shopping. My collecting has been incidental to business trips. I don't claim any great expertise; some of the pieces I own, I merely picked up, and others have been given to me by African friends and officials. Most of them though I bought myself.

The only criterion in my purchases has been that I found them appealing from an artistic point of view. It was more an artistic sense than a scholarly one, and had no overall design. I wasn't trying to make a collection that was in-depth, or was with one tribe, or that tried to be totally comprehensive. As I traveled and had a chance to see things, I tried to buy things that I liked.

My brother Nelson, of course, was very interested in primitive art in general, and African art in particular. I was exposed to African art, to an extent, through him. He later formed the Michael Rockefeller Collection which is now at the Metropolitan. I think there you find that the quality of primitive art, for the first time, is recognized as having a comparable aesthetic to other forms of art.

Two of the countries that I visited a lot, and perhaps that's the principal reason why I have more things from these places—are Cameroon and the Ivory Coast. In the Ivory Coast there are some good shops that sell African art. I also have a personal relationship with the President of the Ivory Coast, Houphouet Boigny, as well as with other leaders, and that has given me some special insights.

Perhaps the insights are more political and economic than artistic or cultural. There is a lower standard of living, by and large, in Africa than in many parts of the world. I think they have a long way to go, and I think one of the questions that one has to ask is whether it's possible for African societies to transform themselves into what we like to think of as pluralistic democratic societies—in a meaningful sense—in a matter of decades. I think they haven't yet. We are sometimes critical of them for that; but then, why should they become that? I mean, they'd never heard of democracy. For that matter, they'd never heard of Marx—though they've heard about him now.

I'll never forget a dinner that we had with Samora Machel and Mobutu at Mobutu's guest house. It was very European style, a seven course dinner, three or four wines. During the meal Mobutu leaned across the table to me and said, ''Mr. Rockefeller, this is socialism.'' And I replied, ''Well, Mr. President, if this is socialism, maybe I'll have to revise my thoughts on socialism.'' Of course, he was smiling too. Still, in all my travels—which have included my being made an honorary Baule chief in the Ivory Coast—I have found people respectful of their traditions.

Concerning the market in African art, I think it's similar to the market for art in general. People are becoming much more discriminating, and the best pieces are going for very high prices. Generally speaking, the less good pieces in terms of quality are not going up in price. And that's a fine reason for picking the good ones rather than the bad. They have a way of becoming more valuable.

I look at African art as objects I find would be appealing to use in a home or an office—that I enjoy looking at in a setting that I have. I don't think it goes with everything, necessarily—although the very best perhaps does. But I think it goes quite well with contemporary architecture. I admittedly picked pieces because they appealed to me aesthetically and I thought that they would look good. And as you can see, I tend to mix things.

DAVID ROCKEFELLER

YORUBA GELEDE MASK

I guess that one reason I chose this is that I've always liked Benin bronzes very much, and this reminded me quite a bit of those—much more than any of the others. The design and composition of the head-dress evokes that memory; I wouldn't have been surprised had that been in bronze. The facial structure, as well, is quite similar to some of the Benin heads I've seen. I think it's quite strong. I found it appealing. When I first looked at the photograph, before I read the description, I wondered if it *was* bronze.

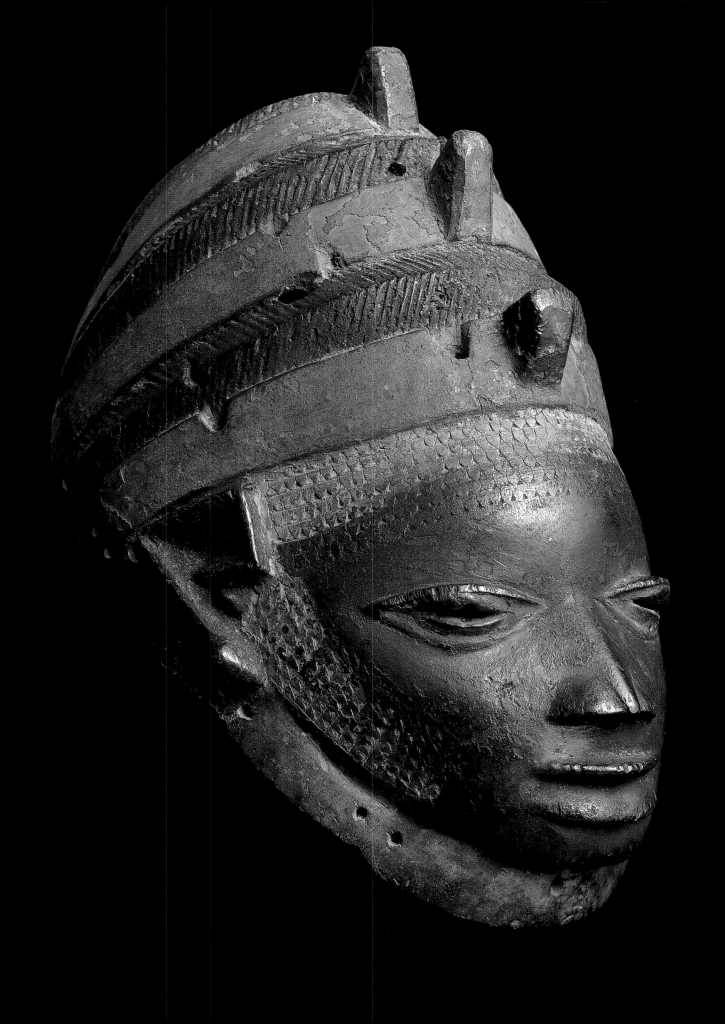

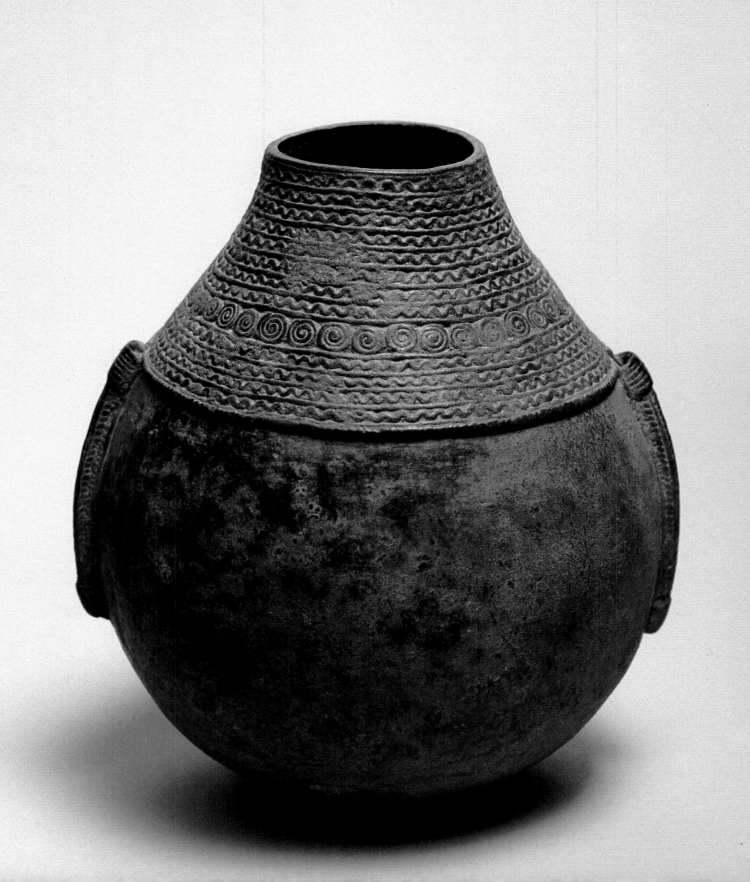

DAVID ROCKEFELLER

DJENNE BRONZE VESSEL

This is just very different from most of the others in the selection you've shown me. I thought that it was an unusual and a very beautiful shape. I am quite fascinated by the fact that in comparison with most African pieces that one sees, this is quite old. So much of the African art that one sees today is relatively contemporary—except for the Benin bronzes—which is the main reason I found this appealing. It's also a lovely shape and a lovely design. As I said before, I happen to like some of the Benin bronzes very much, but I had never seen one from Mali like this. I do have one Benin bronze, and I have a few Cameroon bronzes which I like, and I just thought this was a very pretty piece. So much of African tribal art is relatively recent, and it's nice to see—in a place other than Benin—some art that is this old and so sophisticated.

NOK ARM FROM A FIGURE

This I just thought was a very beautiful art form. Again, I was fascinated that it was as old as it was. But it certainly could also be a contemporary piece of sculpture that one would be happy to see done by Henry Moore or any number of other contemporary sculptors. I just thought it was a very beautiful piece. I think it's a hand, a fragment, and to me, it's a beautiful composition.

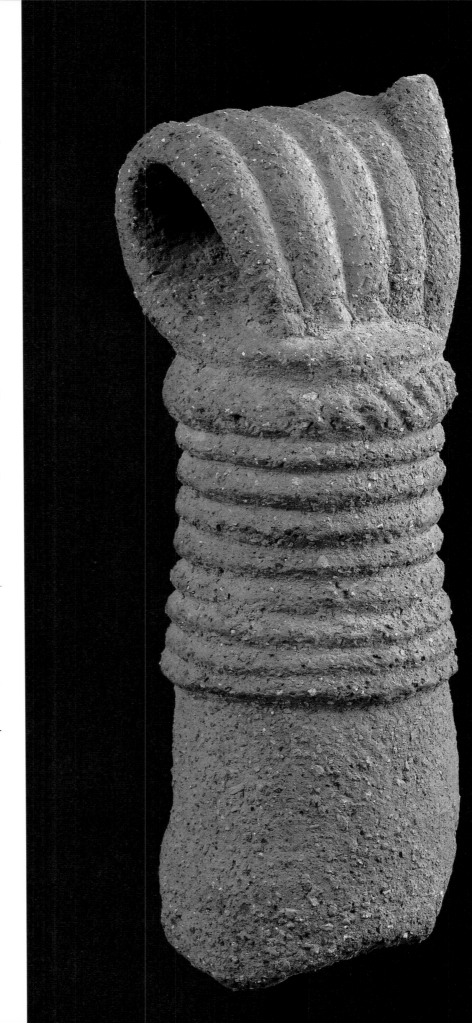

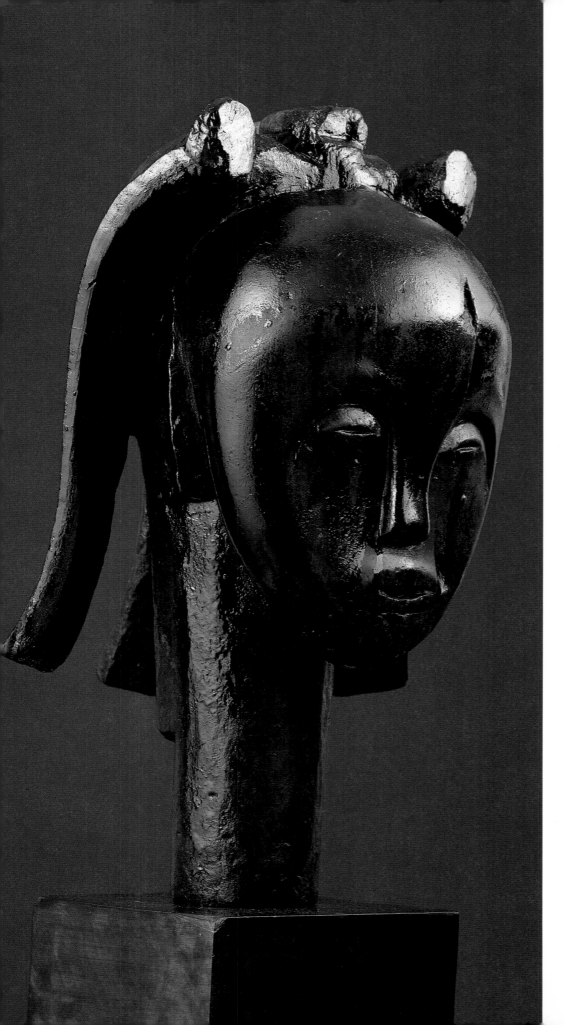

FANG RELIQUARY HEAD

I just thought this was artistically very attractive. These oval lines of the face—the eyes and the nose—I thought were quite beautiful. It's certainly an example of the type of sculpture that has had considerable influence on particular European painters and sculptors. I suppose that Picasso is the one whose work was very much influenced and whose work was best known. I can't think of a particular piece by Picasso that was exactly like this, but a lot of his pictures are similar. I was very fascinated by the marvelous show a couple of years ago at the Museum of Modern art on the influence of primitive art on contemporary art and sculpture. I have no reason to think that this particular piece was one, but to me it has a very contemporary feeling about it and would fit in very well with much contemporary art.

FANTI FEMALE FIGURE

I have bought and I own somewhat similar things to this, and I have always liked them. This is a rather more sophisticated version than the ones that I've seen, and I thought it was quite beautiful. This enjoys a little more elaborate design perhaps. I wonder: is that a snake going down the side, or just decoration? Again, the total composition has a very contemporary, very Western look to it. It's the kind of thing, I think, that goes very well with contemporary furniture or works of art. It's design is very harmonious with contemporary Western things. It would look very good in a modern apartment or house. The head and headdress are square, with this design around it; I've seen ones that are more round, so it's a little different because of that. And it's got altogether more ornamentation and delicate carving than many of the ones I've seen before. So it seems to me to be a very good example of this type of thing.

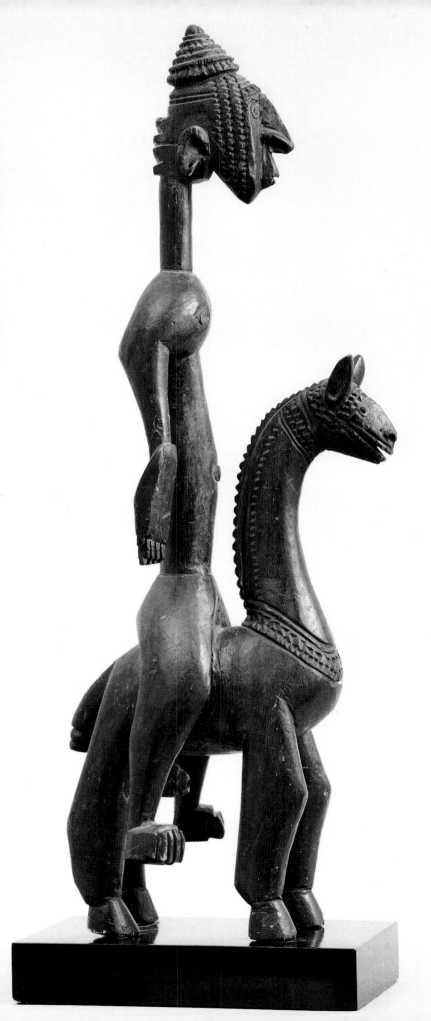

BAMANA HORSE AND RIDER

I just had never seen a figure quite like this before. I thought it was rather intriguing—the human figure riding on some kind of an animal, I'm not sure what—but I liked the form and found it appealing. It has somewhat more detail than some of the African wood sculptures I know, and I thought that the design was also an appealing one. I found the total composition attractive; I'm not sure that I can always recognize what is authentic and what isn't. But I've certainly never seen one like this one, and therefore, it looked to me as though it were an authentic tribal piece. I'd rather have a piece because it was done as part of the cultural and artistic expression of a tribe rather than something they simply thought would be appealing to a tourist. Even though I *am* a tourist, I'd prefer not to be categorized as such. I don't care so much about the age, because there are relatively few wooden pieces that are very old anyway due to the climate. So the only advantage of age is that one is more sure that it's authentic.

DAVID ROCKEFELLER

BAMANA ANTELOPE HEADDRESS

This piece is in my collection. I bought it about twenty-five years ago from Klaus Perls' Gallery. In fact, it's almost the only one that I think I bought in New York. They happened to have it there—I don't remember whether I bought a painting then—but I saw this and liked it. I chose it for the same reason I purchased it: because I think it's a very beautiful piece. I think that the overall design—the curve of the horns and the curve of the tail—and the composition to me is very beautiful. I've lived with this piece for a long time and liked it very much. I've had it at my office in the bank for twenty years.

NGUNIE RIVER MASK

This mask appealed to me for its artistic beauty and charm. It's also quite different—the headdress part and what look like horns are different from others I've seen. I think that the modeling of the face itself is very sensitive and delicate and it is rather different from any other masks I've seen. I find the craftsmanship finely and unusually done. It's not crude, but it also has very considerable strength. I think it is much the most sophisticated of the ones I've selected. I think that the Fang Reliquary Head, which I've also chosen—just in terms of design—is really quite beautiful, though it's not nearly as finely done.

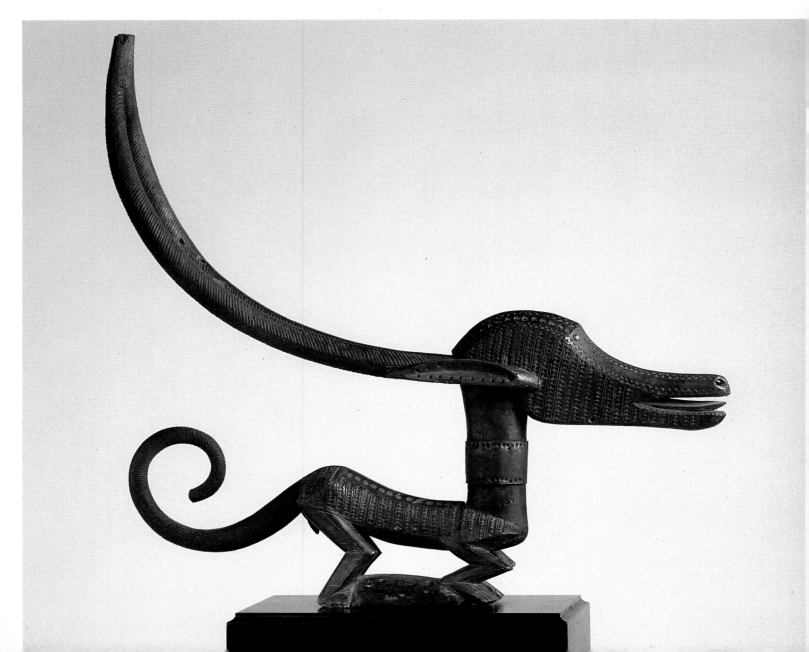

DAVID ROCKEFELLER

IDOMA SEATED FIGURE

This one, in many ways, is cruder than the others that I've chosen. But I think that, overall, it is quite an interesting, composition. I haven't seen one like it before. I am just intrigued by it. It seems to be a sort of freer design and less conventional posture. I don't remember seeing carved wooden figures that were seated with their hands stretched out and raised; I don't remember seeing anything like the cap this individual wears. I just find this quite appealing. I have no idea whether it's a particularly good piece, but I think it is fun.

SENUFO HELMET MASK

I have to say that I picked this because I own it. It was given to me by President Houphouet Boigny of the Ivory Coast. I think it's a very handsome piece. It's a mask, but it really is a piece of sculpture. It has great strength, and I just like it very much. I've lived with it for fifteen or twenty years and have always admired it.

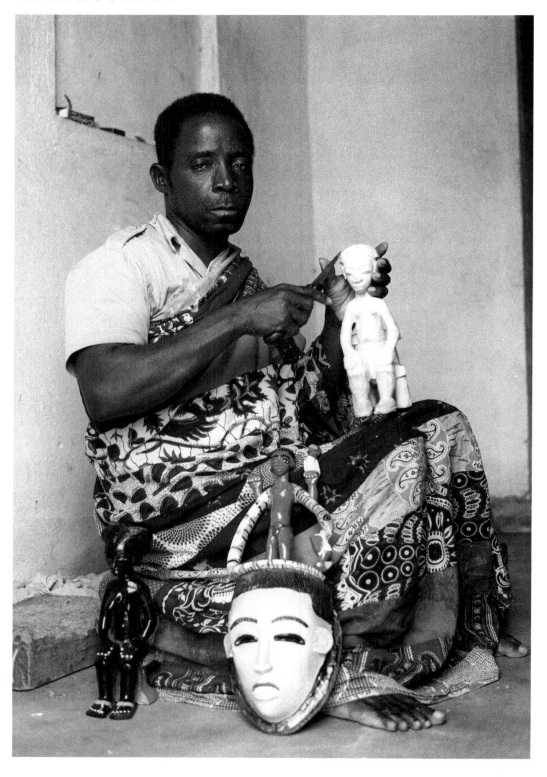

Mr. Lela is an artist living in a traditional Baule milieu in the Yamoussoukro area of the Ivory Coast. He comes from a family of sculptors, though neither his father nor his uncles carved. He began to carve as a young boy and taught himself, receiving inspiration from dreams. Even today, he often sees his finished works in his sleep before they are completed. Around the age of twenty, he had a polio attack which left him unable to walk or to do any farming. He then became a full time sculptor and diviner using the process of mouse divination. His sculpture clients are Baule (often those who have come to consult him as a diviner), and Moslem traders who purchase his masks and figures for eventual sale to foreigners.

Most Baule adults could not say when they first became aware of their art. Those who live in villages are exposed to it from their first months of life when they are likely to attend mask performances sleeping peacefully, tied to their mother's backs. If either parent has a spirit spouse (**blolo bla** or **blolo bian**) in sculptured form, it would be readily visible to the child in the parents' sleeping room. As the child grows older, other kinds of art gradually become available and the esoteric meanings expressed in art unfold progressively over a lifetime. The Baule have no formal initiation so individuals learn about art only as they are led to it by their personal curiosity, talent, spiritual needs, and life histories. Of the generations born before about 1945 almost everyone practiced a craft such as weaving and basket making for men, spinning, and pottery making for women. Baule art is inseparably woven into the fabric of Baule life.

The Baule language reveals ways the Baule conceptualize their art. Like most Africans, the Baule do not have a term that can be translated as "art" in the Western sense. They do, however, have many words and expressions that distinguish purposefully aesthetic creations from ordinary, serviceable versions of the same thing. A key word is **aguin,** meaning decorated or fancy. This word is used to describe artfully made objects (as opposed to plain ones), and to identify artists, **aguintifwe,** among the many men in Baule villages who carve hoe handles, simple stools and other utilitarian objects. Thus, a gong struck with a plain stick is called **kokowa,** while one paired with a beautifully carved gong striker, like the one illustrated here, is called **lawle.** Though many people casually refer to almost any kind of sculpture as **waka,** meaning "wood," they also use qualifying phrases to show that they mean the carved mask or figure.

When asked to discuss a work of art, most Baule will refer to its meaning and use rather than to its form; indeed Baule thinking about art tends to fuse the object and its role. Baule language makes few obligatory distinctions between works of art and their functions, between the mask, and the whole dance performance with its costumes, music and gestures, the persona represented and the spirit served by the event. For example, the Goli mask dance and the Goli cult itself are called simply Goli. The carved masks may be called Goli **waka** (literally Goli wood) or Goli **ba,** meaning Goli's little one (**ba** is the word for baby).

The Baule normally talk about different masks in a celebration Husing the personal name of each mask, discussing the whole performance without separating the experience of the costume, the dance movements, the carved mask, and the music, including the words of the songs and the rendition. Their integrated visual, aural, and intellectual aesthetic experience is profoundly different from our experience of African sculpture in isolation (closest perhaps to our experience of opera), and is antithetical to the dissecting analysis of art common in our culture.

The text published here is a composite of interviews conducted with Baule artists and art users. For use in this book and exhibition, photographs of Baule art were taken to the artist Kouakou Kouame, and his selection was recorded in an interview essentially similar to the others in this book. The remarks here about the selected objects, and some comments on their function and meaning come from his interview. Since that interview was very short, however, it has been amplified with material from other field interviews with Baule artists and art users. The portrait photo here is of another artist, Lela Kouakou, who provided information in the supplementary interviews.

Kouakou Kouame of Ouassou village is a self-taught artist born about 1943. He began carving as a young man, making a mask secretly in his father's fields. When it was seen by a woman, his work became known and caused him a great deal of trouble. (He had probably carved a men's sacred mask which women are forbidden to see.) After that he became a professional sculptor, making a wide range of objects such as masks, figures for nature spirits and spirit spouses, stools, chairs, spoons, and ointment pots. He still farms, as he does not have enough orders for sculpture. His clients are mostly from his village, but he carves for other Baule, and occasionally for Europeans.

S.V.

LELA KOUAKOU

SCULPTURE OF A MAN AND WOMAN

There is a man and a woman. I like it when I see the two together. Their faces and their heads go well together. Their hands are well carved. The man who carved it was a good sculptor. The grooving of the hair is very fine, very even. The scarification on the stomach is good. The skin is clean and healthy, and shining.

I do not know why the woman is bigger than the man, but it is certain that in the world there are women who have husbands of small physiques, and some men who have small wives. One doesn't take height or size into account to marry. There are certain women who are beautiful but who do not have handsome husbands. There are also some men who are handsome but who do not have pretty wives. Things in the world are not always equal.

This is for an *asie usu* [nature spirit]; they ask for many different things. I never saw a man and a woman carved out of one piece of wood before. Probably the spirit asked for it to be made that way. The spirit who follows you tells you how it wants to be carved. In a dream he will say: I want to be sculpted in this manner. It is he himself who determines his form before being sculpted by the carver. This would be a nature spirit and his wife—or maybe it is a female spirit and her husband. They are very dangerous. You must do exactly what they ask. If they ask for a statue in one piece like this, then you must do it exactly. Otherwise you might fall sick or some other misfortune will occur.

The *komien* [spirit medium] has to have many things in the house for the *asie usu* to rest on. Each spirit has its own thing. Usually they ask for a statue, but if the *komien* does not have enough money to get a statue, he can use a ball of kaolin, or a dish with things in it that the spirits ask for. Some *komien* just carve their own. I do not know much about that since you cannot see the place where the nature spirits stay in the house. You can hear the *komien* singing in there and chanting as he gets ready for a performance, but you cannot go in. When he is dancing, the spirits are on him. They fall on him. But normally, they sit on the statues and other things.

148

SPOON

There is an ancient spoon. Did you see this? Once before the white people came, spoons like this were used in the sacred forest to prepare sauces [for ritual feasts]. Even today we use them. An old person who had no teeth could take a spoon like this to eat with normally if they wanted to.

But I chose it because of the object sculpted over it. That is what I like. The sculptor has carved it well. It is a mask, a Kouassi Gblain mask he put on it. It is pleasing to look at, but spoons are not important.

SEATED MALE FIGURE

I like that one because of its scarifications and its hair and because of the stool on which he sits. The bowl he holds is also good. He resembles a man of the village. His beard is good. In the old days men wore beards like that, and had braided hair. Now only women braid their hair. I like it because of the scarifications on the neck.

During a divination dance, this would be taken from its hiding place and put in public with the other objects of the divinity. Since I like that, I chose this figure. I could carve one like this. Just yesterday, I was carving a statue with hair braids like this. The bowl he is holding is made from a coconut shell. We take them for drinking wine. Maybe the carver put it here to remind us that when we drink we always pour the wine that remains last in the cup onto the earth for the ancestors. They enjoy palm wine.

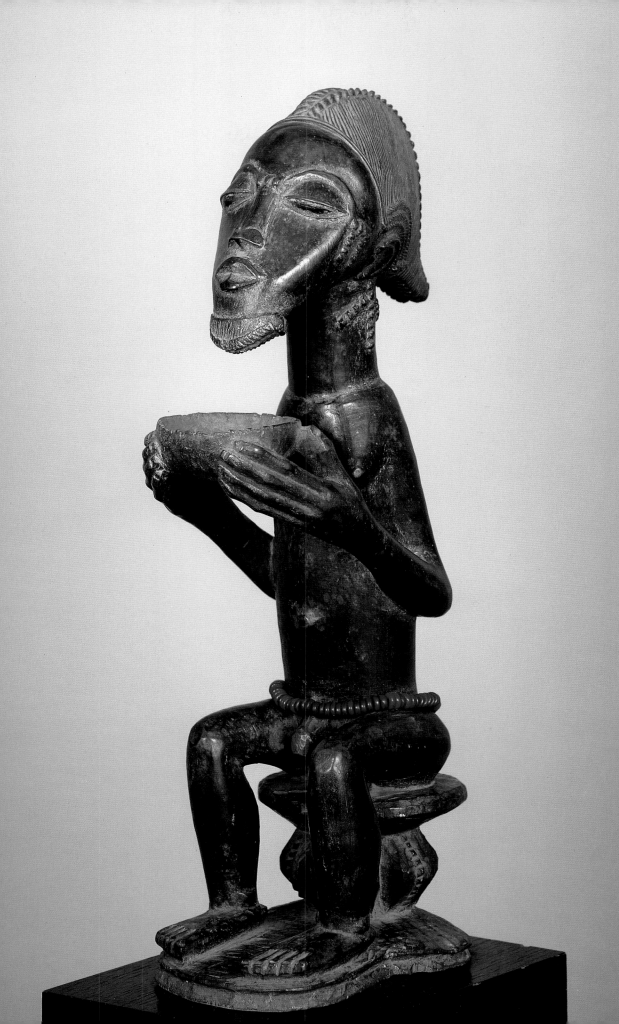

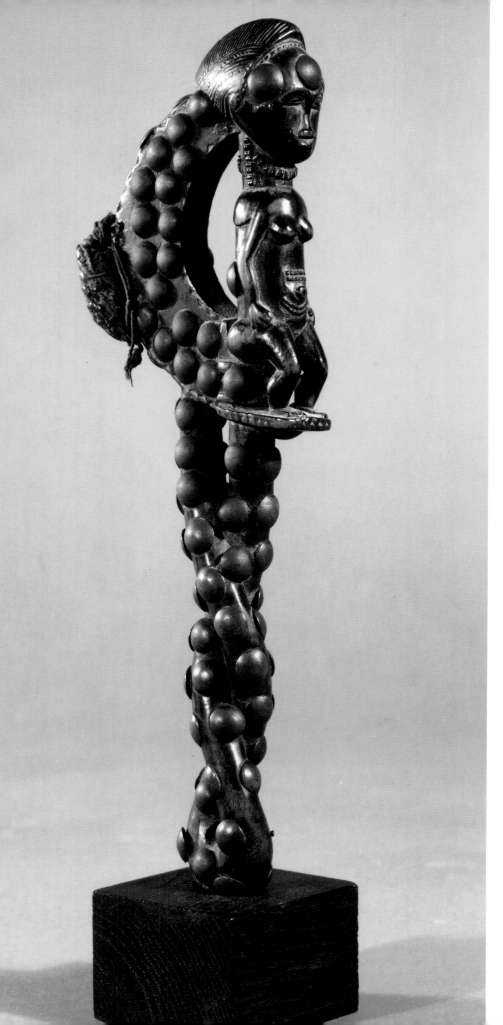

LELA KOUAKOU

GONG STRIKER, *LAWLE*

I chose this one because I like it. The
sculptor knew how to carve. And what
gives even more beauty is the person
carved on the side, the tacks, and the
twisted handle. It is all that which I like.
When I say it is well carved, it is to com-
ment on the serious work that the sculp-
tor has done. I observe his work in order
to do as much as he. The twisted handle,
that is difficult. All the marks he made on
the object please me. This is a *lawle* that
komien [spirit mediums] use. They strike
the small iron gong when they are alone
in their rooms and go into a trance. They
are trained to do that. You could not do
it. It does not happen to me when I hear
the steady beat on the gong, but *komien*
hear it and immediately they are pos-
sessed by their *asie usu* [nature spirits].
Then the voice the people hear is the spir-
it's voice. Haven't you noticed, when they
dance, that they dance with different
steps? Some slow and graceful like a
woman's, some hard like a man's. Those
are the different spirits, male and female,
that fall on the *komien* one at a time. You
can recognize their different voices when
they answer questions.

 When *komien* dance they always carry
the *lawle* and the gong with them. That is
so that they can strike it again if the spir-
its start to leave them in the middle of the
session. Sometimes the spirits just leave
in the middle, and the *komien* is humiliat-
ed. Or they can make him tell lies, can
keep him from seeing the reality and he is
humiliated. That is what can happen if he
does not observe the prohibitions and the
requirements they have revealed to him.
Usually the *komien* does not know what
he said while the spirits were on him. Af-
terwards he will ask people what hap-
pened.

STANDING FEMALE FIGURE

I choose this because I like it. Here are the reasons. The sculptor carved it well. He placed the arms well and the stance is also good. The hands and the feet, and the hair are well carved. I like the way she holds her breasts in her hands. The skin is well smoothed. As I have already said, it is because of all those traits that I was moved to choose this one.

Probably this is a man's spirit wife, *(blolo bla)* but it is not from this village so I cannot say definitely. Some people left a husband or a wife behind in the other world *(blolo)* when they were born. Later they have lots of troubles and a diviner will tell them that it is because their spirit wife or husband is angry. Maybe this figure was carved for that. You can see that he has given her white beads to wear on her ankle. She is young and beautiful.

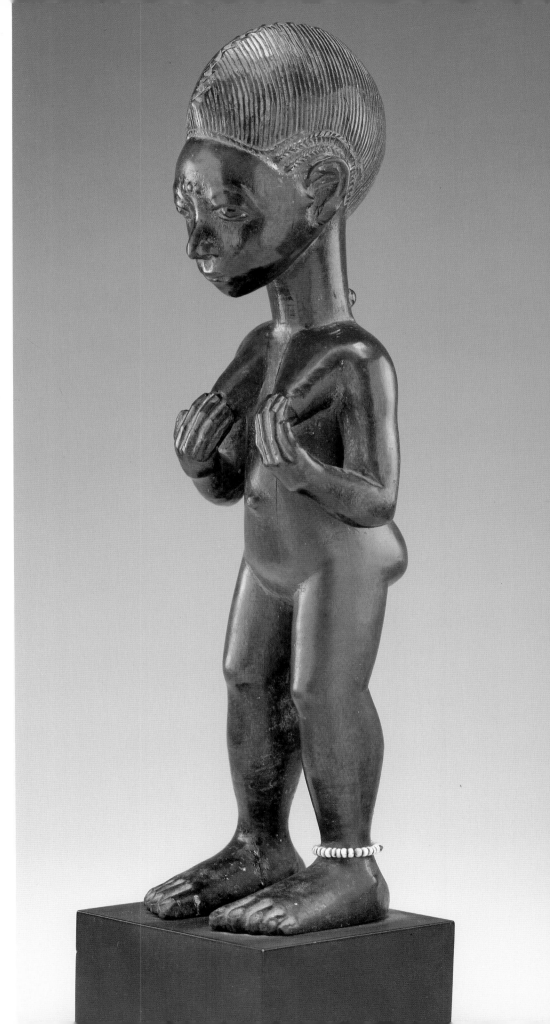

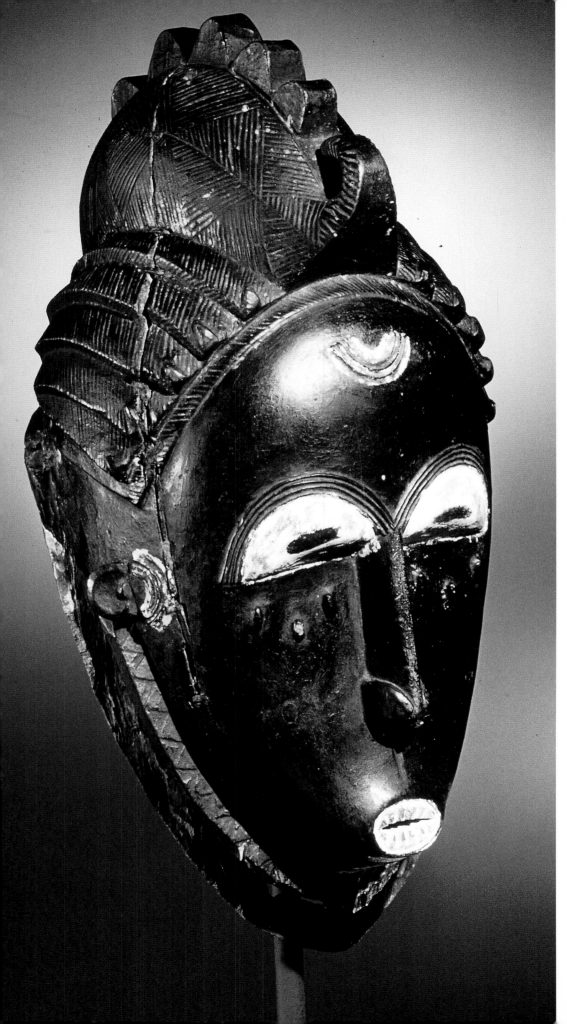

LELA KOUAKOU

PAIR OF FACE MASKS

This one is Kpan. The Goli Kpan mask. We don't have that dance here in our village. It is danced in a village near us named W—. That is our chief's original village. The day when they dance Goli we go to the performance. There are two Kpans who come out at a time, male and female, red and black. You could say that they are like man and wife. They dance first one, then the other, then the first again. Their dance is very interesting. You know, this mask comes out dressed in raffia and wearing a leopard skin on his back. This is the last mask that dances in Goli and it is the most beautiful and important.

There are two Kpan masks but I choose this black one and not the other. The male is the black one, which is better than the red one. Each person has his own taste and manner of liking. That is why I chose this one. Not because the other one is not good. It's this one that I like. I sincerely like the sculpture. I very much like the placement of the eyes and its two scarifications.

Even though we do not have Goli here in our village, I know how to carve the masks. It is like all other work, you use intelligence to carve. I observe the masks attentively when they dance in another village, and I say to myself, I know how to carve them. Thus from that moment on, I keep all the essential points in my memory. I don't make any drawings but I keep it all well in my mind because I am a trained sculptor. Back in the village, when someone comes to ask me to make him this mask, right away I remember and begin to work by placing its coiffure and other parts in the same manner as the other one. It is enough for us sculptors to see the mask. The simple act of seeing is a drawing for us, and we are able to reproduce exactly the same thing.

At W— village where I saw the mask dance, the people held up cloths and prevented the public from seeing the mask as he approached, and it was at the moment when he arrived before us that they dropped the cloths and allowed the peo-

ple to see it. It is a moment of glory for him. It's because he is very beautiful that he is hidden when he makes his entrance into the village. Once arrived there where the dance takes place, the cloths are taken away and immediately he begins to dance very gracefully. All this is for a glorification, a way to make life beautiful.

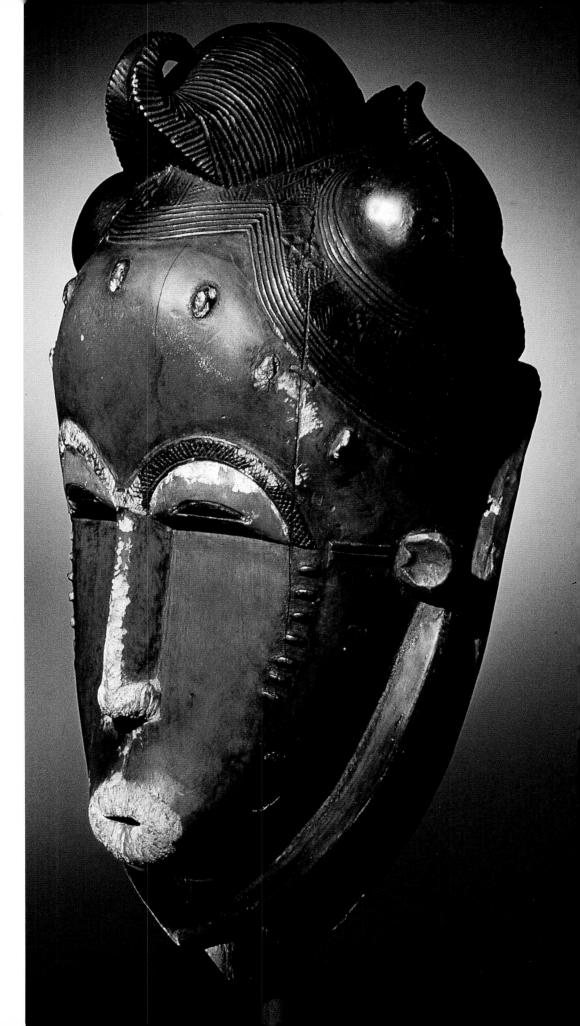

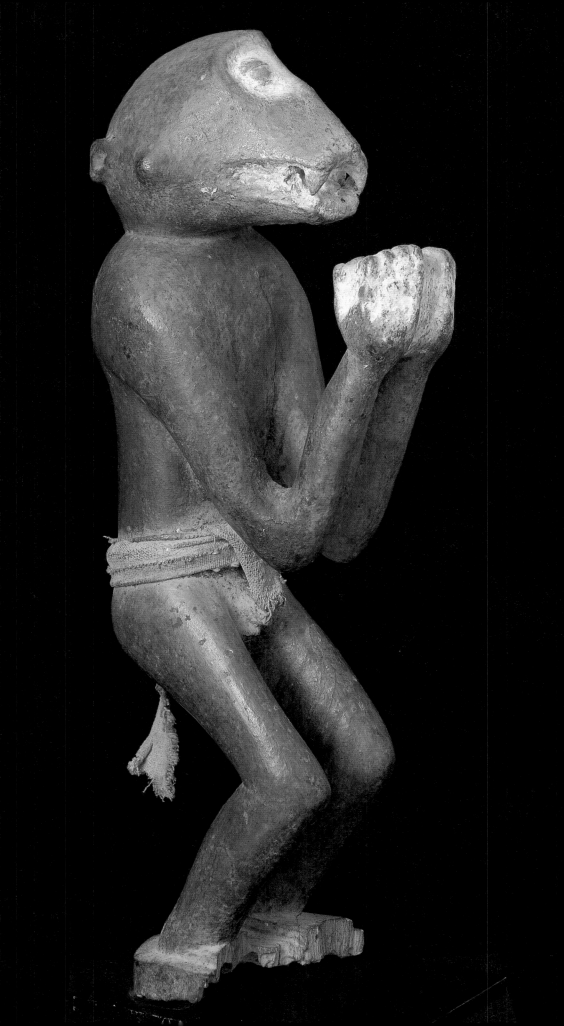

LELA KOUAKOU

MONKEY FIGURE

This is an Asri Kofi figure. In this village we call it Asri Kofi. His head looks like a chimpanzee or a monkey. He holds an egg in his hand, and he receives blood offerings. Yes! His body is covered with sacrificial blood. He is very agitated as you see him. You know it is an Asri Kofi from the hands, the head, and the loincloth.

It is for the male god Mbra. During the course of divination dances, this spirit comes and performs wild dance steps and then leaves. Both men and women can practice Mbra divination. They are called *komien* [spirit mediums]. When Mbra comes, one sees nothing but sparks everywhere. If there is fire in the hearth, he takes the burning wood and throws it here and there. During the dance if the Mbra spirit possesses the *komien*, some people in the audience may flee if they are not brave. After performing these extraordinary feats, the Mbra spirit leaves, and the more serious spirits return and dance normally. When he comes he makes revelations like the other [nature] spirits. This spirit is different from the others. When he possesses the *komien*, the other spirits move away and later, when he leaves, the others return and dance suitably. Mbra is very interesting.

OINTMENT JAR

This one here is a *kwle* [ointment jar]. I like it because of the head he put on top of it. The lines on the bottom are well done. We have a relative here who carves them, his name is papa Kouassi Brou. He is dead now. He is the father of young Kouakou. Their household is over there. He is the brother of my grandmother. No one else in this village carves in the same manner as he does. I do not think he carved this one. These are used by old women. They put shea butter in them

(continued on the next page)

157

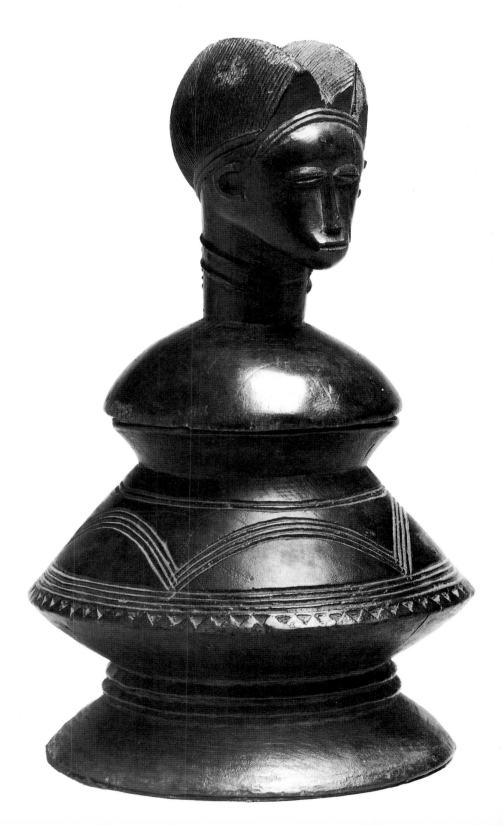

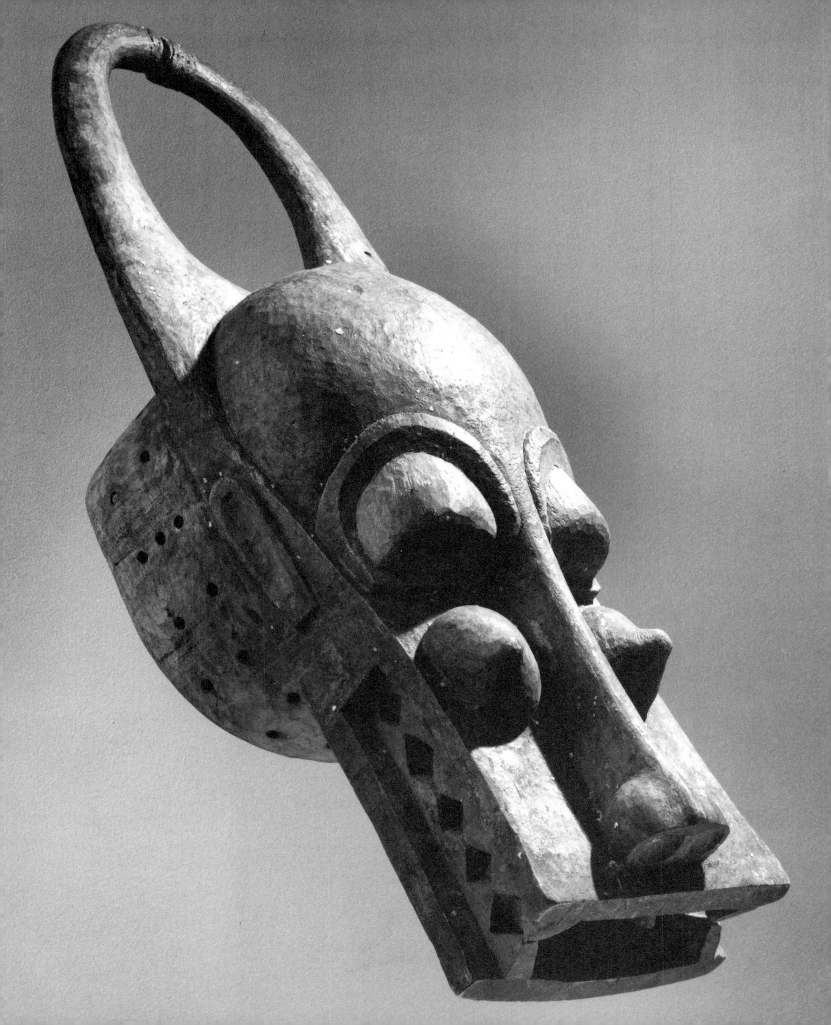

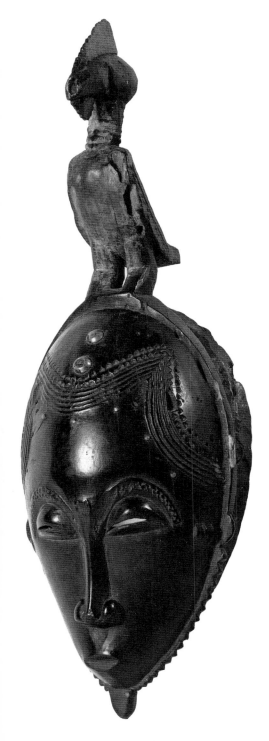

which they use as a pomade after the bath. It smells fine and makes your body beautiful and shining. But young women are modern now and use lotion they buy in the market that already comes in a jar.

MEN'S HELMET MASK

This is the Dye sacred mask. The Dye god is a dance of rejoicing for us men. So when I see the mask, my heart is filled with joy. I like it because of the horns and the eyes. The horns curve nicely, and I like the placement of the eyes and ears. In addition, it executes very interesting and graceful dance steps. I never saw one with those things beside the nose.

This is a sacred mask danced in our village. It makes us happy when we see it. There are days when we want to look at it. At that time, we take it out and contemplate it a while. Women are forbidden to see the Dye mask, so when we dance it, they must all leave the village or stay in their houses. If a woman saw it she would fall sick, she would swell up and eventually die if she did not confess and make proper sacrifices. There is one and only one woman among the men. This woman has reached menopause, thus, she is considered as a man. But look out! The day on which she reveals the secrets of the mask to the other women, she can die. This is a very powerful mask for men.

Dye has a strong way of dancing, fast and hard and interesting to see. Two men who are very good dancers each take a mask and begin to dance one after the other [wearing the masks], and each dancer has his group of supporters. When a dancer finishes dancing, he goes over to stand among his supporters.

This kind of [helmet] mask is difficult to make. The exact hollowing of the inside must be done very carefully. Often with inexperienced carvers the wood will split before they finish or they will make a hole in the outside by accident and then have to throw it away.

FACE MASK

This mask is very beautiful! The sculptor did his work well and placed a rooster above it. I must choose this one because of the scarification, the shape of the head, and all the geometric decoration around the edge. The hair is beautiful, the eyes are beautiful, and the mouth is too. The whole face and mask are very even and fine. This is a man's face, but some are women.

This is an *ngblo* mask. When this type of mask comes out, all the women come to dance. A particular woman can even be used for inspiration to sculpt the mask, and then the mask resembles her like a photo. And when this mask comes out, the woman who is its namesake follows it and begins to dance. They do a graceful dance like a woman's dance. When they come out it is at the end of all the *ngblo* masks. The last one is the most handsome, as soon as he appears at the entrance of the sacred forest, the people see him and cry out "Eh! there he is!" Immediately he returns back into the sacred forest. Finally he comes up to the crowd and makes himself seen. He is hidden with cloths and goes back to the sacred forest. For the seventh and last time he comes, all the cloths are taken away and he presents himself to the crowd in sight of everyone, and sits down. He doesn't stay even five minutes. He goes back to the sacred forest. In this manner the funerary ceremony comes to an end. He doesn't come out during the funerals of people who aren't important. Only at the funeral of an important person, one who has no equal on earth.

*B*orn in 1928, in St. Louis, Senegal on the Atlantic coast of Africa, Mr. N'Diaye has, since 1967, been permanently based in Paris where he devotes himself to painting, drawing, and the study of ethnography. From 1949 through 1959 he studied both architecture and art in France after which he returned to Dakar. There he created the Department of Visual Arts of Senegal's National School of the Arts, and remained its director until 1967. Upon his return to Paris, he assumed responsibilities for the non-photographic iconography at the Musée de L'Homme. Mr. N'Diaye's art has appeared in one-man shows in Dakar, Abidjan, Paris, New York, and Stockholm. He is married to the ethnologist, Francine N'Diaye.

Africa is an immense continent whose peoples and cultures I am far from knowing. I was brought up in Saint Louis, Senegal, a small port city, open to all the influences from beyond the seas. The African knowledge of my ancestors was passed on to me not by the intermediary of ritual masks and statues, but by means of stories, fables, proverbs, and tales told in the evenings. I've preserved the flavor of the metaphorical expression and that of the parable. That's why the "reading", the interpreting of my painted or drawn works, can be done on several levels.

As for the formal relationships which may exist between my art and the visual arts of the African continent, I didn't research them in a systematic manner. I studied African sculpture just as I did ancient Roman and Gothic and European sculpture: by drawing it when I saw it in museums. I've never borrowed directly and if certain forms of African sculpture frequently appear in my graphic studies, it's because they offer me a solution to the problem of depicting volume in space, the proportions, and the meaningful details of form.

As I've often said, I discovered African sculptures in European museums. As a child, the only museum in Senegal where I could have seen any sculpture, was in Dakar. There, the IFAN (French Institute for Black Africa) had gathered a collection of masks and statues collected in all the French colonies of West Africa, but I didn't know of its existence.

It wasn't until my return to Senegal in 1959—after ten years of study in France—that I began to buy the objects that make up my modest collection. These are objects that I learned to see by drawing them. Also, as head of the sculptural arts section of the School of the Arts of Dakar (which opened in 1959), I created the first courses in African art history.

But unlike some artists of the period between the world wars who refer to "primitivism", I did not collect those objects because I felt that they had a certain resemblance to my work. Having lived so many years surrounded by statues and masks, and having drawn them so many times, I have without a doubt—in ways unknown to myself—submitted to their influence. Maybe one day an art critic will venture to describe the things in my works which owe a debt to the influence of African sculpture.

Though as a painter, I consider myself to be self-taught, I must give credit to the sculptor Coutin, in whose workshop I really became aware that the profession of artist is essential. He was a great admirer of Focillon, whose "Eulogy of The Hand" is one of my favorite readings. I still think that one doesn't become a painter in school, but I know also that like musicians, painters, and other visual artists, we must all pass through an apprenticeship of techniques. These techniques alone give us the know-how which later will serve as a foundation for our audacious creations.

Painting is my means of expression. I hope that it allows for many different interpretations, leaving those who look on it the possibility of imagining a personal reading through their background and their preoccupations.

IBA N'DIAYE

SUDAN DOLL

I believe that what attracts me is its coincidence with all my own pictorial research. In my compositions on jazz, there is often a singer who presents herself in this manner. I could even borrow from some of the materials. I cannot say that it's a great sculpture, but what I like is the kind of gracefulness of the singer who presents herself here, with her preoccupations. She seems to have the preoccupations of a singer who is standing before the public, after having sung, and has only to bow. In the costume, all these fabrics, there is something that may seem artificial; it is in fact a triumphant garment.

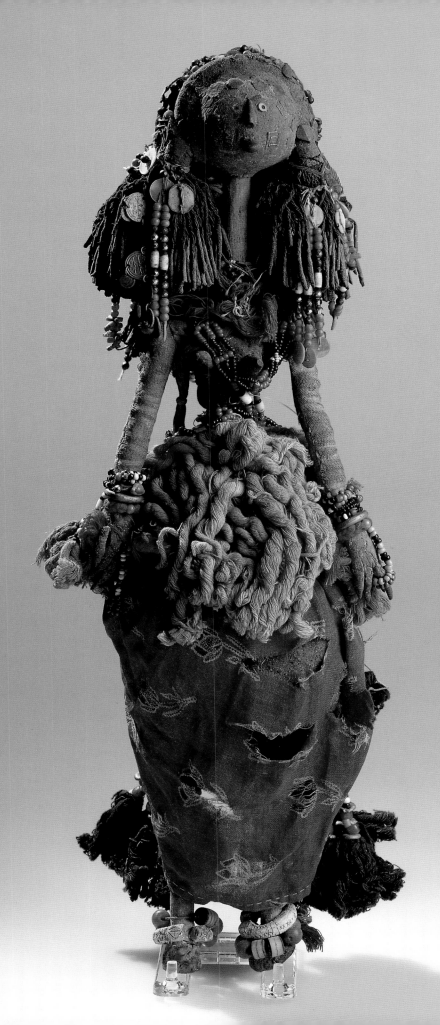

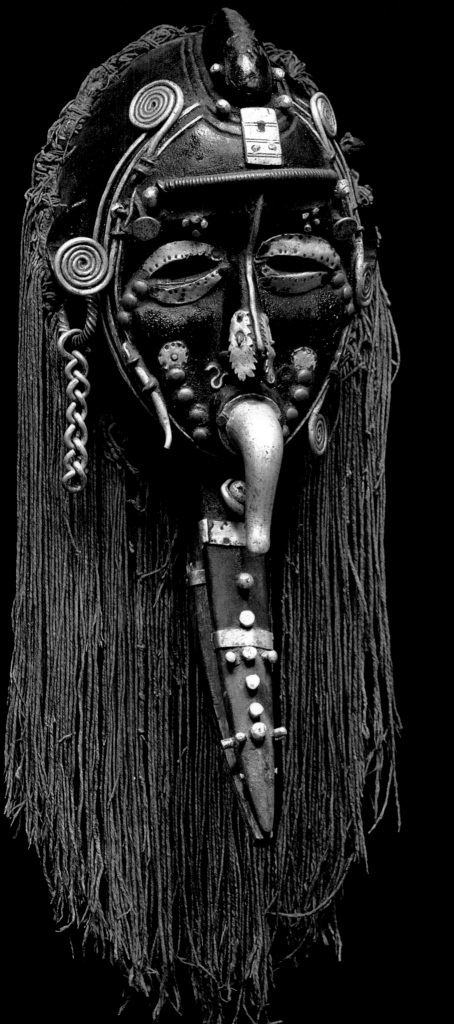

MAO MASK

When I look at this, I think: what more have modern artists created? I believe that present here are all the forms that can be inscribed in space and volume, all the possibilities of additions and collage. Here, really, everything has been attempted, whether it be the effect of the eyes, or the jewelry, or this horn. Of the horn, it seems that one could say that it's a mouth, and also that it's a handle. But there is more. The additions of string for hair—it's an African hairstyle—make the sculpture a testimony to its culture. It's an object that's at once terrifying and significant. It seems to be the work of a sculptor who is partially joined to nature and at the same time, he transforms it. I am also attracted to the additions of makeup, or what evokes the makeup of a woman— with the blue under the eyes and the other additions. You know, one can meet a woman like this! I like her! Everything is here—even the eyelashes. This is the creation of a veritable artist.

BWA MASK

I think that this mask is interesting on many levels. As a painter, what I am first of all attracted to is the polychrome that underlines the basic geometric forms—in particular, the circle. In this mask, it is the eye which is repeated, and not merely for decorative effect. The importance of the central face, the one that has four eyes, is emphasized by this device. In this photograph that you have shown me, I am also struck by the monumentality of the mask—the contrast with the modesty of the architecture that I can see in the background, that shows this mask worn by a dancer in repose. Once he gets up and dances, the disproportion will be even more noticeable. There is a dimension to objects that I have difficulty imagining if I do not know the space in which—and for which—they were conceived.

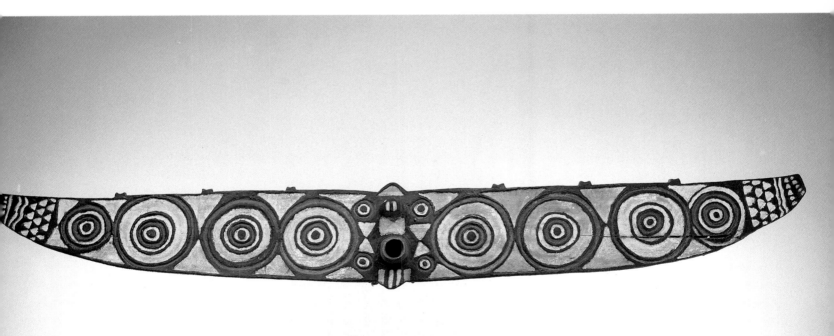

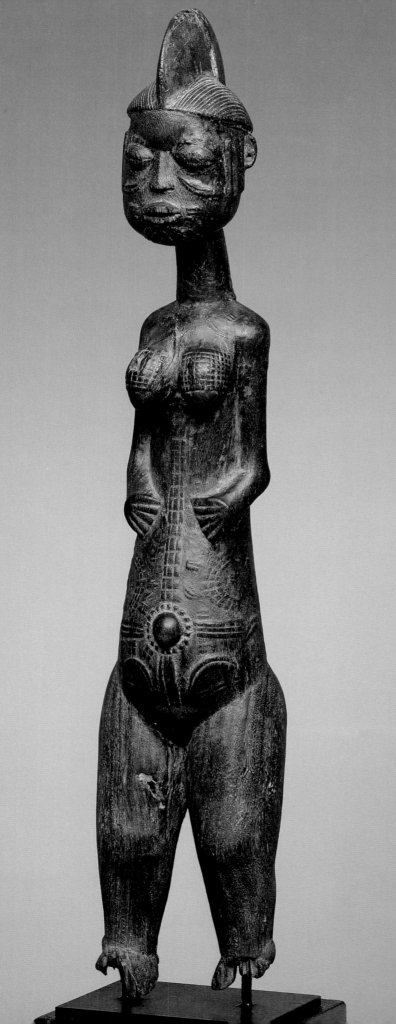

KULANGO FIGURE

What I like most about this statue is the elegance and the simplicity of the lines. It is an elegance due to the economy in the resolution of the forms. I love it. I do love it. This term ''elegance'', when one uses it, can give the impression of an artificial aspect. But here we are dealing with a natural elegance—what is present or isn't present, without the aid of any artifice whatsoever. The hands, placed in this manner, can be read as two eyes, with a nose which comes down to the navel. I see the whole torso, now that I look closely, as a face. But perhaps I am mistaken.

When we create forms, we collide with nature. In creating, we must strive for the purity of crystal.

LULUA FEMALE FIGURE

This object, for me, is once again the representation of what I mean by purity. It has been carved, like the Kulango Figure, to receive ornamentation. The decorations are different, but one nonetheless has the impression of a great similarity. There are also different facial forms. But it is much more descriptive than the other. They both proceed practically from the same conception of sculpture, even though the decoration may be subtly different. Here there is a great purity in the neck, but in the Kulango, the decoration in the neck is much more elaborate, even *recherché.* One can speak here of a sort of baroque which doesn't take anything away from the value of the object. What strikes me also is how many of the statues are carved with their own solid base. The feet are really rooted in the ground. It is imposing, representing characters who are, we might say, well-rooted.

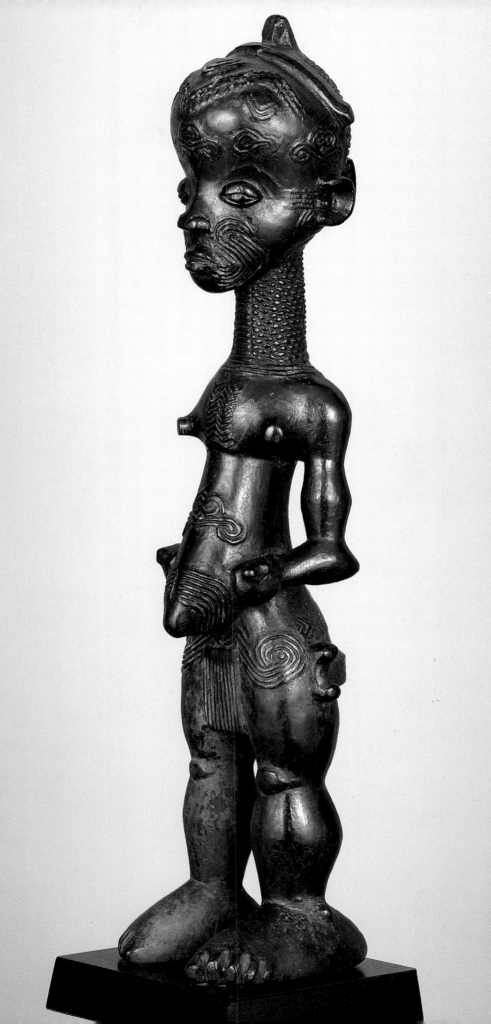

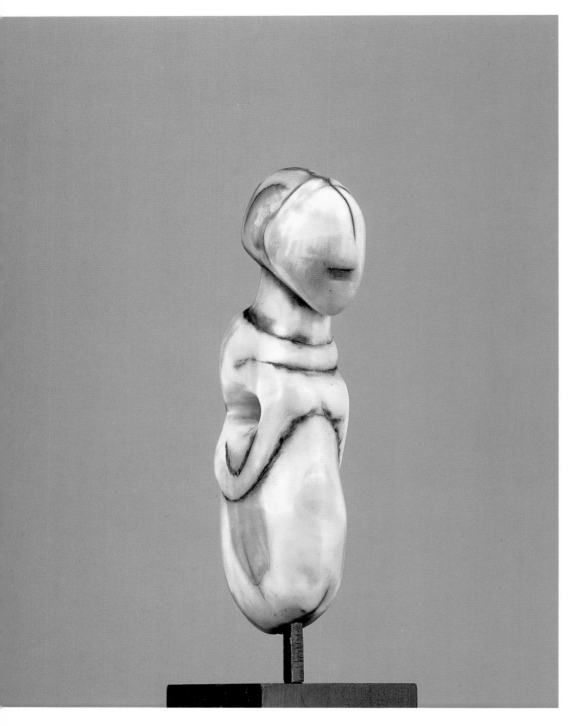

LUBA IVORY PENDANT

Here again, it's the simplicity that attracts me. It's the separation of the forms in the treatment of the volumes. One finds these same qualities in a statue of European origin—a certain prehistoric "Venus", the "Venus Lespugue", which I believe is in St. Germain en Laye. She also has this kind of humility in her posture, and I believe it too is of ivory. I imagine it in my hand, I imagine touching it. To caress it would give me an almost sensual knowledge of it. I would thus better understand and appreciate the work and the emotion of the sculptor.

SHONA STAFF

The line is beautiful. I like this object very much. The space is described by a graphism which imposes itself by extremely pure lines. In my opinion, one finds here practically all the geometric forms which comprise the concerns of all visual artists. The straight line almost curved inward; the two triangles—which could be a woman's breasts. This is a geometry which could be called both abstract and anthropomorphic. There are all the creative forms of geometry here, except the scroll.

We are looking at a description of space which has been created by the sculpture, of course, and yet, at the same time, it could be a mobile by Calder—something which in its movement takes possession of space.

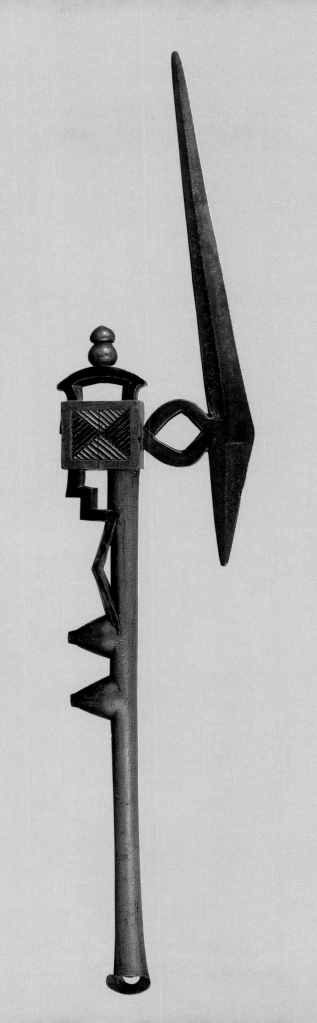

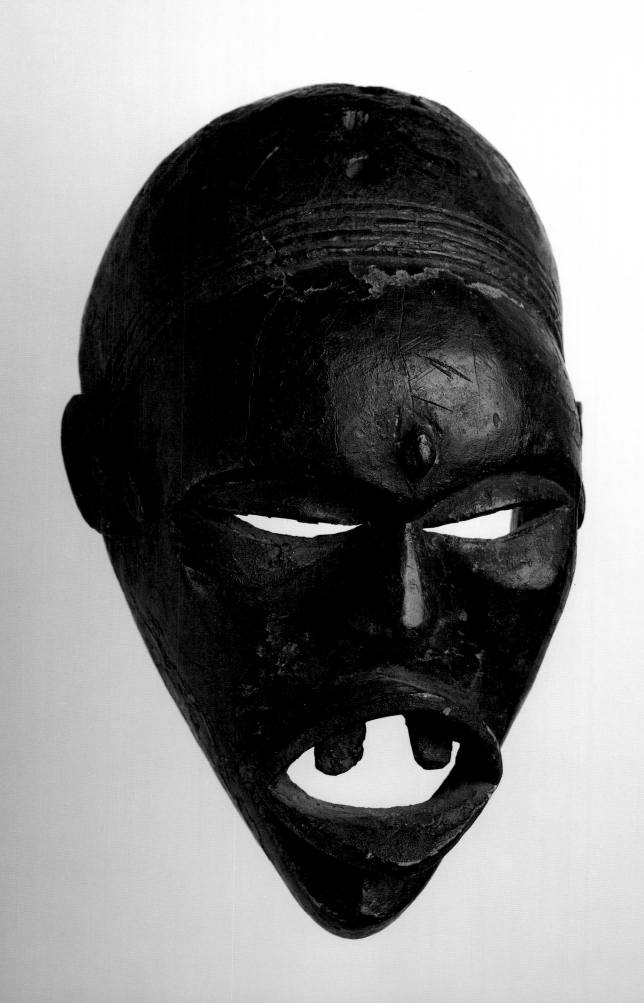

IBA N'DIAYE

KONGO MASK

It's amazing, almost to the extreme of
what is possible in the domain of creativi-
ty. I think it is also the composition of the
forms, those of the inwardly curved eyes
and the swollen eye-lids, of the mouth
which gives the impression of opening it-
self to a scream. A scream that is like a
strangled cry. This is what, for me, makes
such a strong impression. A mask like
this on a wall—it would be impossible to
live with! And yet, there are real faces
which are exactly the same image as this.
It is a very realistic mask in this sense.

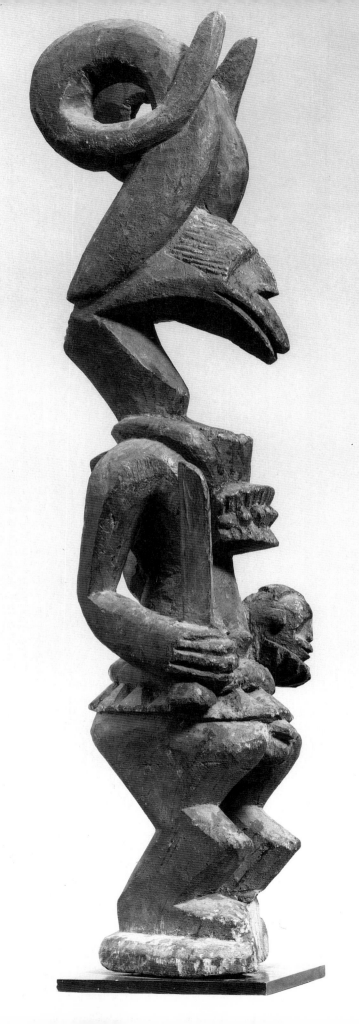

IBA N'DIAYE

IGBO IKENGA

This is really a matter of sculpture-sculptor—of an example of what one can do when limiting oneself to the geometric forms which butt against each other to create a composition. It is truly an architectural composition. And here again, we see the monumental scale of African sculpture. If I had to do a veranda pillar—that is, if I had to create one—I would be inspired, perhaps, by this.

SONINKE BRONZE STAFF

These four heads are an ingenious invention. It is surprising that it has not been thought of before. What symbolism in this triumphant head of the individual who holds his genitals! He holds them in his left hand. In a way, he's there to address himself to everyone, brandishing his sex like a sword. I could keep this; this is really sculpture. It is quasi-surrealistic. I think that an artist such as Giacometti would have loved its elegance and elongation and also its fragility. Does not the space that encircles it menace it with dissolution?

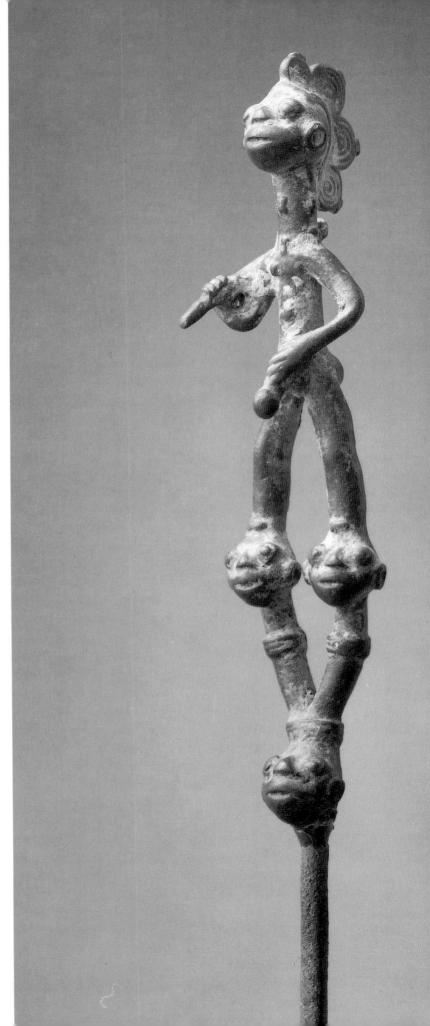

*R*obert Farris Thompson is Professor of African and Afro-American art history at Yale University, and Master of Timothy Dwight College at the same institution. He has devoted his professional life to the study of African and Afro-American art and music, and has published—among many articles and monographs—four books: *Black Gods and Kings, African Art in Motion, The Four Moments of the Sun: Kongo Art in Two Worlds,* and *Flash of the Spirit: African and Afro-American Art and Philosophy.* These works reveal the richness of traditional arts among Yoruba, Kongo, Dahomean, and Ejagham peoples. He has curated four major art exhibitions for the National Gallery of Art and the Museum of Primitive Art, among others. He is currently at work on three books, each outlining a different aspect of the moral impact of classical African peoples on the modern world.

I became involved with African art through a passion for African music. The first 'take' was Afro-Cuban music in Mexico, the mambo period of the early 1950's. In Cuba, I ran full-tilt into four African-influenced traditions: Yoruba, Dahomean, Ejagham and Kongo. And before I knew it, I was completely swept into Afro-Atlantic art history. I went to western Cuba several times on field trips. I participated in an Ejagham-influenced ceremony in Cuba, in the spring of 1960, nine years before I actually got to Ejagham country in southwestern Cameroon. By the end of the 1950's I was totally committed to Afro-Cuban artistic culture. In my doctorate I fused two loves—art and music—by studying the music/dance coordinates that Yoruba sculpture was put into. A lot of traditional African art emerges from the moving coordinates of the dance. It's a way of adding life and spirit to stasis.

I came in contact with African art **per se** by reading about it. Once I became motivated by the power of Afro-Cuban art, I became motivated by anything that inspired the rise of Afro-Cuban art. That essentially meant

Yoruba and Kongo sculpture in 1957. By 1959 my taste was fixed: an abiding passion for African traditional art.

All of which linked up to an alternative tradition that I found gave meaning to my own life. But there was something else, something in the air. I can "describe" it by turning on the nearest radio: rock, hip-hop, mambo, salsa, reggae, ska, rocksteady, at least seven major black Afro-beats in the city, all pointing in the direction of that alternative tradition and affirming it. It's a kind of steady-as-you-go moral source. If you get discouraged, turn on the radio. It's there. Your colleagues are with you.

Cuba was my entrée. Cuba gave me a kind of intellectual head start in Kongo, Yoruba, Dahomean and especially Cross River—Ejagham—art. The Ejagham are noted for their ideographic writing, glyphs and ciphers. Ejagham intense artistic realism, particularly in certain of the skin-covered heads goes, I think, with their mastery of ideography. I'm following here what Lévi-Strauss suggests: namely, that realism and writing go together. With writing you can seize a person's name and age and availability for taxation. Writing is a grasping device. If you have writing, Lévi-Strauss suggests, art can 'grasp' you, too, in realism. There are literate qualities to the accuracy of capture of cheekbones, nose shape, hair, and other elements.

Similarly, many West and Central African initiatory societies seem time-resistant. They seem resistant to mercantile and missionary effort because the last thing you want to give up, under modern pressures, is the aspect of your heritage that secures your transformation from child to man or woman. In addition, like the signs and symbols of Ifá in Afro-Cuban-influenced sectors of Hispanic Miami and New York City, like the crucifix among Christians, and the menorah among Jews, there are certain inalienable symbols that, if given up, mean that you are no longer what you are.

It is precisely in the spirit of that richness of exegetical activity, that makes the iconology of Christian and Jewish art perennially rewarding, that I am led into my selection of objects. What draws me into the study of African traditional art is **meaning,** more than anything else. Aesthetics are equally important. I started with aesthetic studies. I will end with them. But attractive to me at this point in my career is African iconology, the study of world view through formal assertions, and iconography, the part-by-part analysis of represenation.

ROBERT FARRIS THOMPSON

KONGO POWER FIGURE

This is a standing image of what might be called a lord of jurisprudence. He is a spirit so strong he can wear upon his stalwart chest the painful, intricate issues of his peoples symbolized by inserted blades. The issues symbolically hammered into this image were 'heavy'; they had to do with the swearing-in of members of important societies, the termination of law suits, and the ending of skirmishes between villages.

This is one of the mightiest of the examples of the *nkondi*. Note a classical *nkondi* attack gesture: arms akimbo. This is a wrestler's pose, meaning "I'm ready to attack, to knock all evil off balance, on behalf of the community." Note the gesture of the eyes, the way the pupils deliberately are pinpoints: it's been explained to me in northern Kongo that *nkondi* see so far into the conceptual distance studying major issues of life and death, that their eyes mirror the distance bridged by their penetrating gaze. The deeper the issue, the farther away the gaze, the more the eyes narrow and dwindle into tiny points of black (or sometimes red). An ocular gesture of clairvoyance.

A whole legal process goes with the driving-in of the blades. Saliva on blades functions as a kind of formalizing signature tying the vow or admonition to the blade and hence to the inner *nkondi* spirit in perpetuity. In effect, a vow has been programmed in iron and sealed in saliva. If anyone breaks a vow hammered-in, the saliva tells the spirit in the figure exactly who to destroy. Each *nkondi* operator must memorize the vows and admonitions connected with each blade. To jog his memory, he might code a blade by tying on special visual signs or reminders or he might dot a blade with camwood impasto or kaolin. It's critical that by whatever mnemonic means, he know the meaning of every single legal vow that was hammered into the figure. There are nails, blades, screws. If we try to put this in Western terms, this awesome image is no more strange than walking into a lawyer's office and seeing his walls drip with legal erudition—all those books were meant to impress you that the lawyer will know just the right precedent. Similarly, all the legal admonitions coded here seal a wealth of mystic, practical erudition in this mighty image. There is a protocol for the nailing process. Nails should be driven in only halfway. Otherwise, you could not read the issues coded in their size and shape or any dotted signs written on them with camwood paste or kaolin.

You don't have to be a Christian to appreciate medieval art and architecture; neither do you have to be Chinese to revel in the glorious experiments in spontaneous ink drawing by Southern Sung Zen masters. And you don't have to be Mu-Kongo to appreciate a sense of overwhelming power embedded in certain of the large *nkondi* figures. However, we don't insult the reliquaries of the medieval period by labeling them fetishes. Indeed, we see them as part of a complex of ideal moral gestures. And so we are coming to view *nkondi*. We see them not as "exotic" (a bourgeois term for the culturally complex and strange). We see them ringing with elements from a parallel language of moral vision. We sense in myriad embedded blades ideographic equivalents to Old Testament-like punishments in fires, floods, and pestilence. These forces can be stilled by righteousness. They can be activated by falling into evil. To paraphrase *Job* only slightly, fear of the lordly *nkondi* releases wisdom. To be frightened from evil—by its blades, and war-like pose, and the curving terror of its tongue—is understanding.

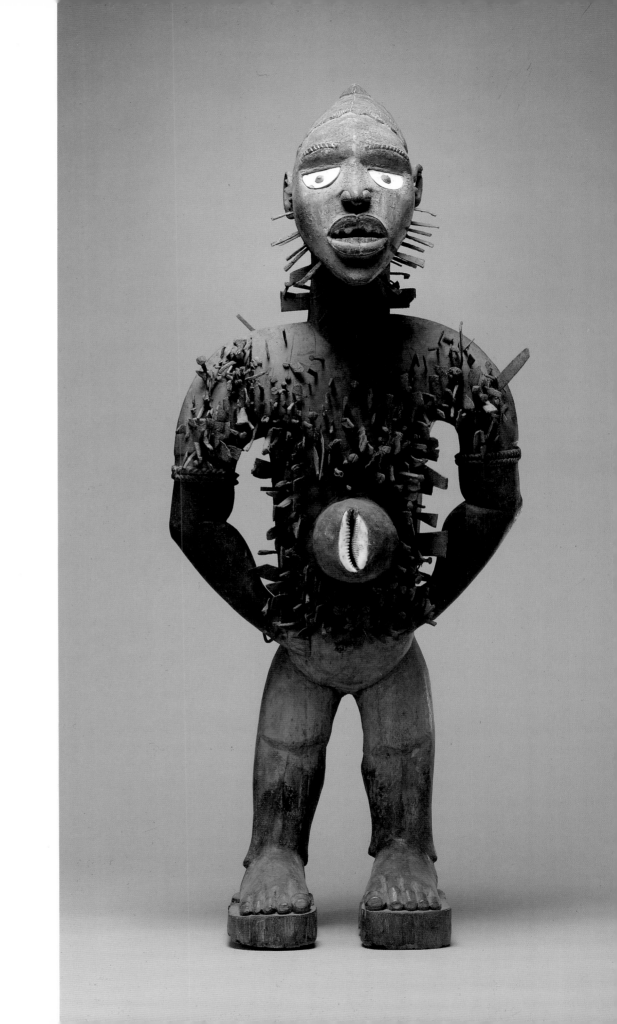

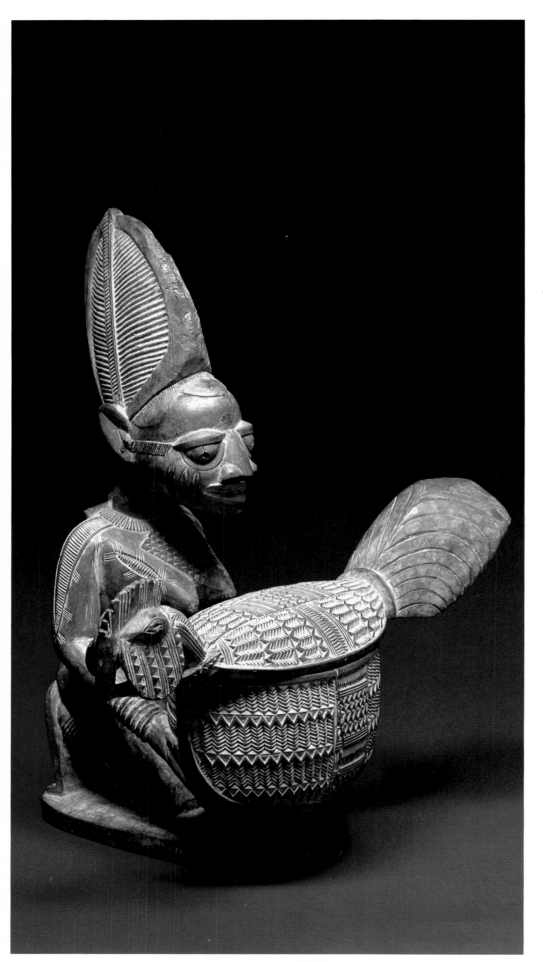

ROBERT FARRIS THOMPSON

YORUBA FEMALE FIGURE WITH LIDDED BOWL

This appears to be a Yoruba master work by a very famous sculptor who has many praise names, but the one I've heard frequently in the field is Obembe Alaiye (a master carver of Efon-Alaiye, east of Ilesha). What he's given us here is one of the essences, one of the ideals of Yoruba culture: to assuage through generosity, to "cool" through giving. This sculpture radiates the special elegance of the style range of Efon-Alaiye, the marvelously rimmed eye, full, flat lips, rendered almost like metal, the chin sharply facetted. At a conceptual level, what makes this sculpture marvelous is the purity of her rendered act, how she makes a step towards the divine in the act of offering something to higher authority. The nobility of her act relates her to kingship and to the gods. It scintillates in the mind, like certain phrases in Yoruba praise poetry.

KONGO MOTHER AND CHILD

We are looking at, in English, Mother and Child. But are we really looking at something we can translate as *maternité?* That is the convention. But does "maternity" fully translate the phenomenon? Let's imagine that we are watching Humphrey Bogart kiss Lauren Bacall in a film and she says "you'll never know what that kiss meant to me" and the Spanish subtitle is, simply, *"gracias."* Wouldn't you feel a sense of loss? Well, one of the reasons I am passionately concerned with the problem of cultural nuance in African art is to make sure that the subtitles, as it were, are appropriate and full.

You can relate to this image, simply as the smoothly carved depiction of a mother. But if it simply means "mother", just that, everywhere, at all times, then it really has no meaning. Why not immediately substitute a porcelain mother-and-child

from Sweden for this image, then? There is something unique to the meaning of this form which only is released by careful cultural translation. It's more than "mother-and-child." It's mother as embodiment of *mooyo*, life, spirit, soul. *Mooyo* is the core word. It means vitality itself. It is one of those Ki-Kongo terms carried into the North American linguistic bloodstream by blacks in the deep South where it re-emerged, in creole form, in the blues, notably as the concept, *mojo*, meaning spirit, vitality, charm, mystic force, potentiality. Even if you know nothing of Kongo, if you know the blues, you've heard the word "mojo," —"my mojo working", "my soul," "my life-enhancing power working."

This mother is an icon of *mooyo* because with her gesture and her accoutrements she tells us how life is completed. With dignity and the rules of good government. How so? First, she wears an *mpú* cap, the prerogative of a ruler; she also wears the teeth of a leopard, sign of sovereignty and seriousness. Her eyes are blank—she deals with a spiritual domain reflected in the unbroken purity of the whiteness which forms her eyes. And this detail, blank white eyes, qualifies the meaning of the baby in her lap as a being which cannot yet speak.

Every bit of this woman symbolically resonates. Her legs are crossed; a triple pun on three terms: *nkata*, crossed legs; *nkata*, circle of life; *nkata*, lap, as seat of competence and bearing. In other words, she crosses her legs to form a lap, bulwark of competence and security for her child, and to register that she understands the circle of life, why we're here and where we're going. Finally, as hinted at by the flash of porcelain white in her eyes, and the funerary decoration which bounds the stand upon which she rests, she exists between two worlds. In other words, her mind is alive to perceptions of "the double issue," life over death.

What I also find appealing about this image is the rounding of all traits, the perfection of them. The fact that every civilizing grace has been so crisply carved. Even if you don't know the meaning behind the details you can sense their importance in the care by which they have been realized. You feel moral authority in the chiefly bracelet, the pattern-of-two-worlds carved upon the stand which elevates the figure. The beauty of a work like this pulls you into its iconography.

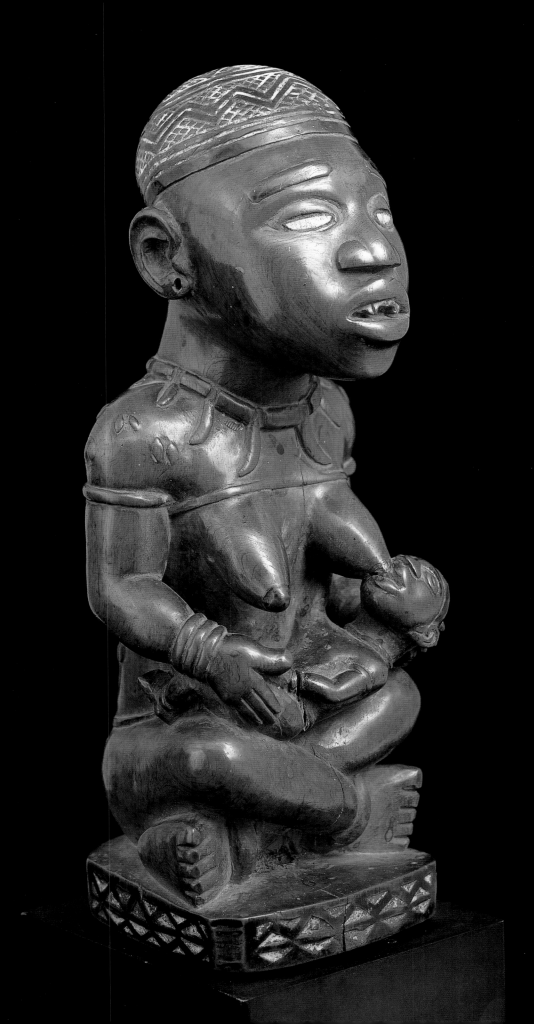

ROBERT FARRIS THOMPSON

YOMBE SCEPTER

I chose this *mwvala*, scepter, because it is aesthetically splendid. I need to work on the Loango coast, however, to find out what the signs mean. I suggest the bird standing on what seems to be an elephant is not decoration but, most likely, a representation of a proverb. In fact, it may not even be a bird—it could be a powerful person whose talent for mystic transformation and flight and clairvoyance are rendered metaphorically as a bird. That person is so supreme in his powers that he can stand on an elephant, stand on something really powerful and lordly. The staff is surmounted by a seated dignitary who is activating a medicine, apparently, by chewing on a root. He seems to be holding a medicine-horn in his left hand. His power, both to invoke blessing or to curse on behalf of a client or his people, would be immediately enhanced by horn and root. But there is a lot more going on here. It pains any scholar to invoke the words "I do not know" but there are definitely further to-be-discovered issues locked into this configuration which I'd like to investigate in the field to see if I can come up with fresh vernacular rationales for these apparent proverbs.

One thing seems clear: the small bosses, maybe cowrie shells, are speaking of a process. Process in a general sense, process in the sense of the law. This might well have been a scepter held by what we might call a dialectician or barrister in traditional Kongo culture, i.e. someone skilled in legal disputation. Or, it could have belonged to someone really important in traditional medicine or government. Whoever it belonged to was clearly flattered by all the symbolic allusions to deepness of power. I'll just salute it. I think the reason I chose this piece is that it is something I want to work on in the field.

KONGO POWER FIGURE

It's a power figure because it's standing in the power pose. This pose means many things: that while this medicine is working on your behalf it will neutralize your enemies. Left hand on hip to neutralize evil at the region of evil—down there in the waist; right hand up, to release some sort of positive assertion. Crisscrossed across her breasts are beads in different colors that may well encode vows or admonitions like the different coded vows and admonitions that go into the "nail" and blade images. The beads are crisscrossed, and this wards off evil doubly. The crisscross emblem is ancient and bears a special name relating to the building of a mystic palisade about the person, like crossing one's arms, before the heart, to ward off cold.

The mirror is embedded in the swelling *kundu* gland, the "capital of all evil" in Kongo traditionalist terms, invisible, but not to initiated men and women involved in healing. It is made visible here to indicate that this figurated medicine, this *nkisi,* moves at the level of the jealous and the felonious, and the sorcerous.

This image would be commissioned by someone who needed special protection. It would be carved by a sculptor and it would be mystically "charged" or armed by a specialist. Enabling medicines involved here always include two types which fuse to make it act: spirit-embedding earths—earth is believed at one with the spirit, especially soil taken from a graveyard—and spirit-admonishing substances and objects—a seed for mystic increase, a claw for spiritual grasp, and so forth. The gesture made by the image is itself a medicine because it tells the embedded spirit to attack.

I chose this image for the elegance of the face and further pleasing aesthetic qualities, the curve of the eyebrows, the smartness of the lips, the well-shaped breasts.

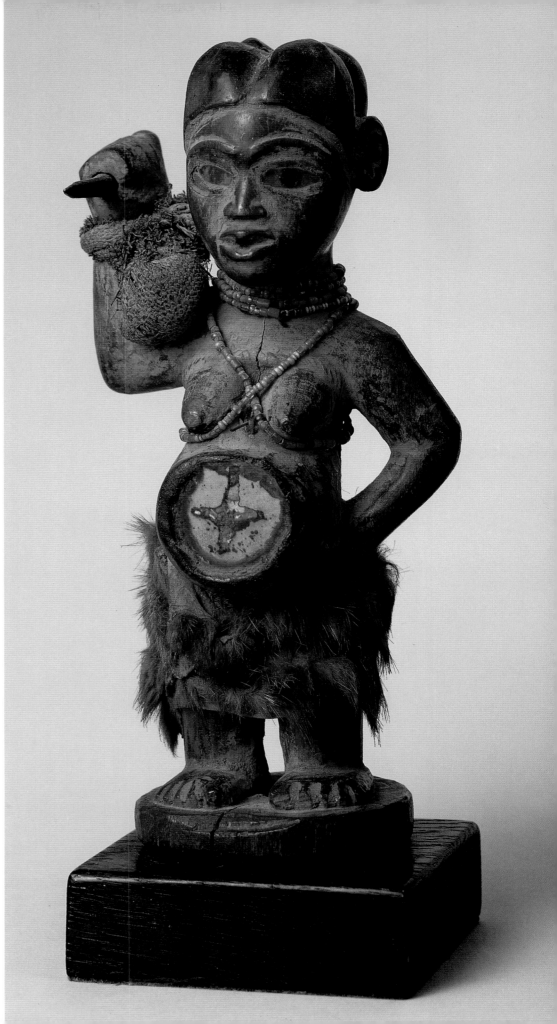

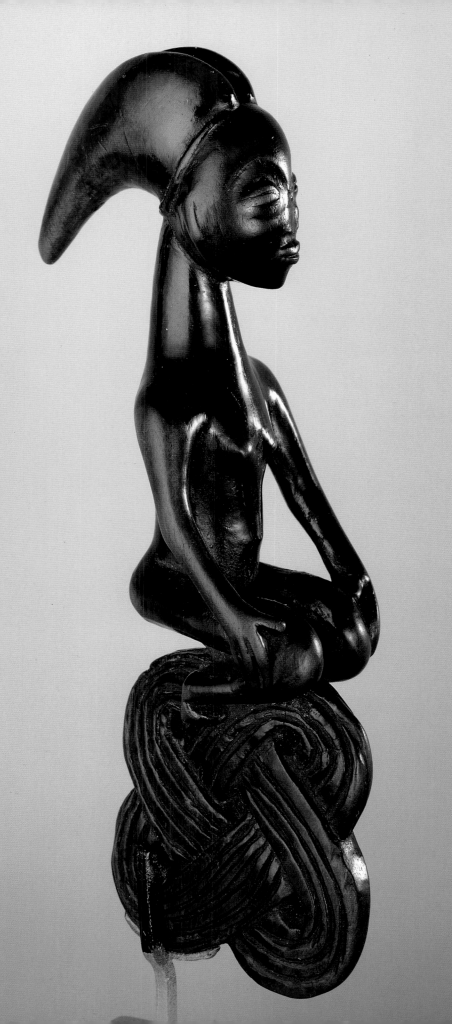

ROBERT FARRIS
THOMPSON

LUMBO HOOK FIGURE

A striking element of this marvelous little figure is the long-tailed hairdress, a style which northern Bakongo call *tuumba,* long hair that can operate miracles. Kongo traditionalists draw a comparison between *tuumba* (long hair) and *fuuka* (aura, foliage). A man with long hair has an aura; a star with long, trailing streamers, a meteor, also has an aura. People call on such stars to fall on them and bring their aura, their flashing gifts of plenty.

Long hair and streaming stars announce the birth or death of most important persons, who lived so powerfully that they became immortal *bisimbi,* living forever in ultimate brilliance, the glitter of a waterfall, a piece of quartz with sunlight shining in it, the wind-ruffled Atlantic Ocean.

Note that the woman is seated in such a way as to display the elegance of her arms. A similar image in the field was compared to a water spirit. You can well imagine why these potent associations of streaming radiance, long hair, feminine beauty, and the water prepared the Bakongo in Brazil to accept immediately the Western mythic image of the mermaid. There is a lot of oral literature being cited in the vernacular reasoning of this image. There is a lot of lore about long cascading hair preparing Jamaica, perhaps, (to which many Bakongo were brought in the slave trade), for the ultimate world-famous rise of dreadlocks, the sign of the Rastaman and an important sign of black identity discussed in certain reggae songs.

I have heard a Kongo legend about a man with extremely long hair, a man with *tuumba.* It is believed that he can sing a plateau right out of the water, that he can sing a forest right into a plateau, that he can sing skyscrapers onto a plain or remove them, purely by his song. But the secret behind these extraordinary powers is his long hair.

So, clearly, this is no ordinary woman. She is a *simbi* woman, seated on interlace. The word for interlace is *nkata,* instantly conjuring associations of the circle of life, mystic support, and the lap as foundation of instruction and human competence.

186

She kneels upon a mystic lap. We in turn can rest upon her lap for aid or psychic sustenance. She is elegant but her hair and the knotted emblem upon which she kneels tell us that she is connected with something beyond our knowledge, as if a meteor in miniature had come to rest upon a sacred emblem. The craftsmanship, the polish, the sveltness all are appropriate to the central tenets. Phrasing the *simbi* in elegant miniature is like summing up the crucifix with onyx and with gold; it's like illuminating a passage of the Torah with letters in gold outlined in bright crimson. The text is intact. But it's so much more beautiful when bathed in conceptual gold. If I were to choose one of these objects to own, this would be the one, this incredible mermaid-like figure with her smooth breasts, flashing hair, displayed arms, kneeling on the earth as lap of all mankind. I'd choose it for all the elegance and good works that stand behind it, deftly symbolized. I'd want her as my Cleo, hopefully to clarify my soul, make me a better person, challenge me.

KONGO SEATED FEMALE FIGURE

This one is a problem. I showed a copy of something similar to informants and they were troubled by the head. They said that this might have been carved with the outside world in mind, but no upstanding MuKongo would cut off the head and reset it. There are hints that this has to do with mourning—the gesture of the arms crossed and folded on bent knees is called *Toolawa,* to form an enclosure around yourself. It's a gesture that generally means "I'm cold." It can also mean the ultimate chill, the big chill. If there was medicine in this image, which I cannot tell from seeing just the front of it, perhaps it was protecting someone from the effects of death, or being in a state that would lead you to mourning.

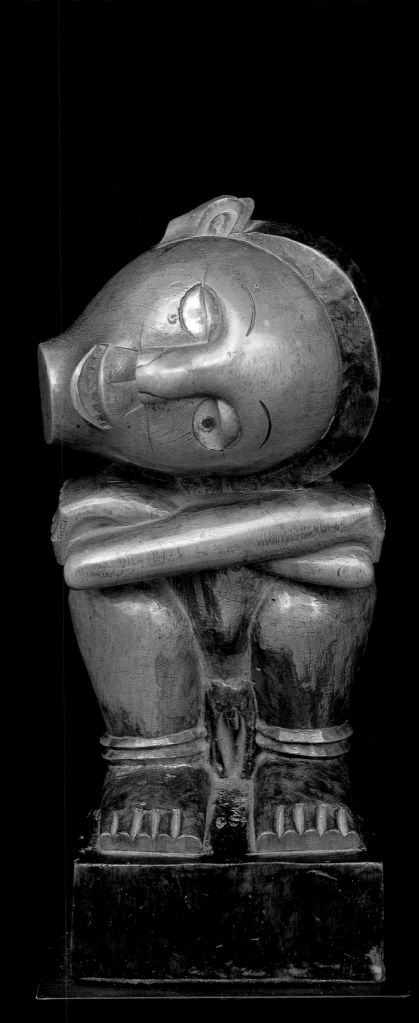

**ROBERT FARRIS
THOMPSON**

YORUBA PILLAR

This is an autograph piece by Olowe of
Ise in southeastern Yorubaland. It repre-
sents a seated king with (probably) a
standing senior wife and children or at-
tendants. The looming figure behind the
king is clearly royal because of the multi-
ple strands of beads around her waist.
The contribution of the senior wife to the
well-being of the ruler is powerful and ex-
plicit. His success, his victory, will de-
pend on the special medicines that she
prepares as his bulwark. If the pair of
standing figures flanking the senior wife
represent her twins, they will bring luck to
the palace. In Yorubaland today, if you
want to impart luck—say to a team of soc-
cer players—get a pair of twins and let
them perambulate at the head of the line;
twins are very lucky and they will irra-
diate the whole team with luck. The
kneeling figure can represent a supplicant
before the king or a member of the royal
family in a posture of respect. All three
small figures wear royal hair styles.

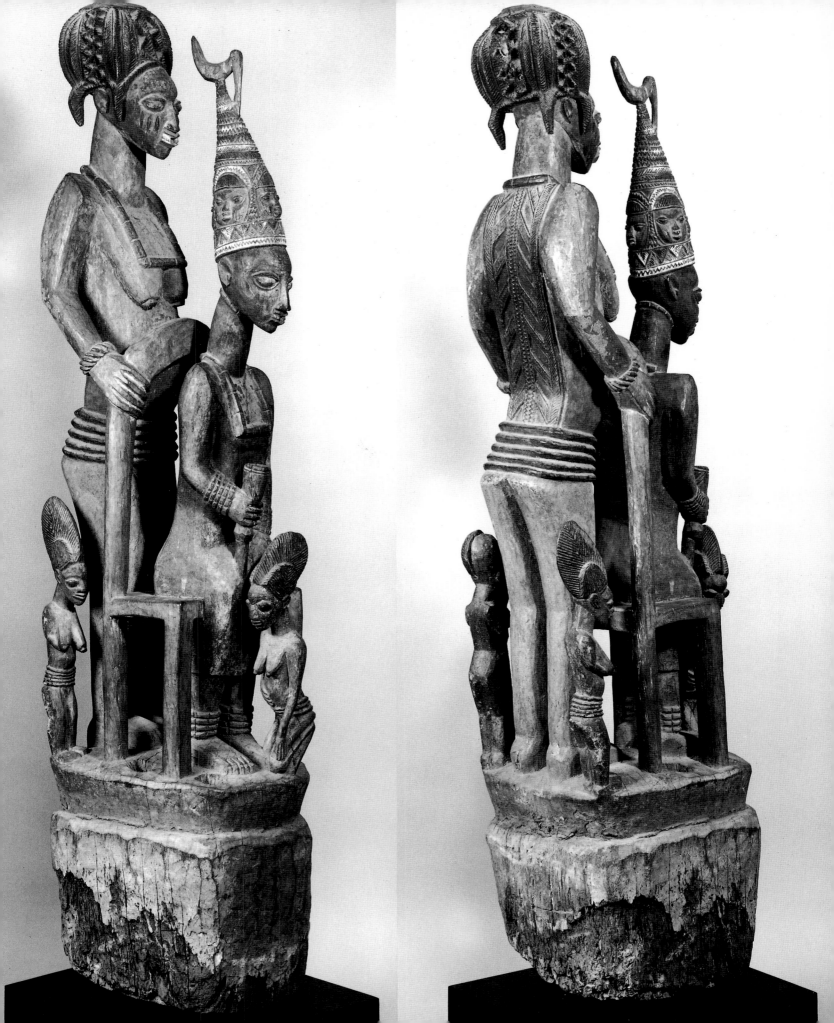

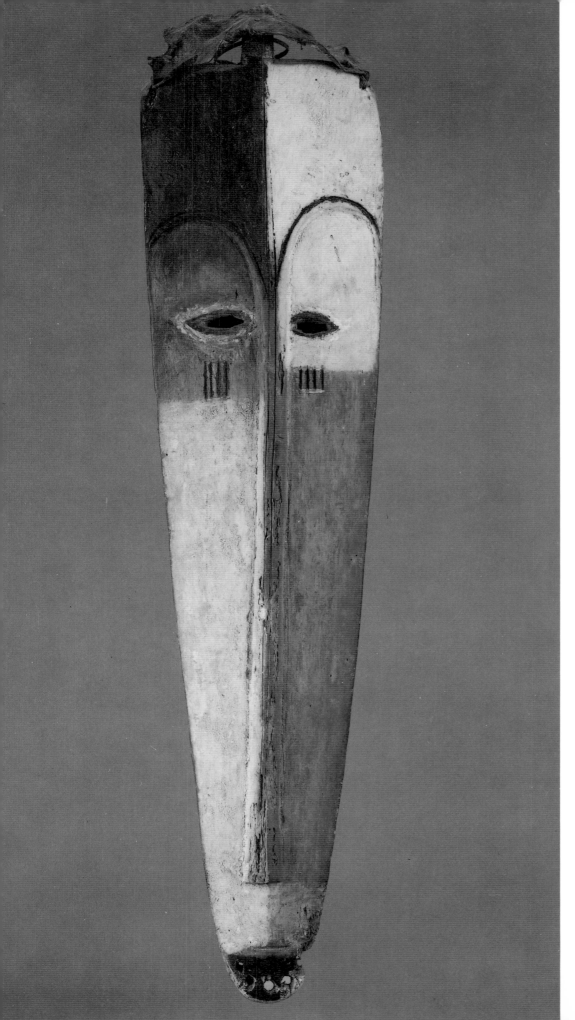

ROBERT FARRIS
THOMPSON

FANG MASK

This piece is out of my field. But I want to talk about it. I chose it for the same reasons I selected the Kongo scepter, as a challenge for the future, a goad towards future fieldwork. And that challenge is: what are the indigenous *African* definitions of the impact of African art forms on the artists of the cities of Europe (like Fang masks in Paris) at the beginning of this century? What do the traditional opinion leaders of *Africa* (as opposed to Western scholars) think about the redistillation of certain of their forms, about the clear impact of their plastic elongations, their strongly indented body forms, their dazzling usages of "high-affect" coloration and so forth, in so-called modernist primitivism of the 20th century? Savor the arrogance of the Western art historians, never once considering that African priests and traditional leaders might have something of intellectual substance to contribute to this most important argument.

Now it is said, in northern Kongo, that a mask with an incredibly elongated facial trait (in this case the nose) mirrors, in its very elongation, the seriousness, the elongation, of the issues activated or discussed in the presence of such a mask. They would have warned Modigliani that you don't play with forms like this out of sacralized contexts. A man who takes on a priestly role before such forms must be strong in order to withstand the vibrations. Told Modigliani died before his time, they would have smiled a knowing smile.

In any event, the final definition of the impact of Africa and Oceania upon modern art remains incomplete until we take large photographs of the Africanizing works of Picasso, Braque, *et al* to traditional Africa, take Gauguin's play with Marquesan design to the Marquesas, and so forth and listen to indigenous comment and critical reaction. And thus I paused to consider this Fang mask not in terms of its great expressive power or its ethnographic background but as a note towards a future project of mine, the revision of so–called modernist primitivism .

190

KONGO POWER FIGURE

Now this is a splendid thing. This is an *nkisi*, figurated in the shape of a woman. A medicated charm of the *kundu* (sorcerous gland represented in this case by a swelling at the belly) category which presents a head-on collision between evil (the *kundu*) and good (pregnancy). A glorious "obstetric line", to borrow from the elegant phrasing of Djuna Barnes in her novel, *Nightwood*, has been complicated and worked over by the addition of gritty medicines. A pregnancy-implying swelling has become a *kundu*, the centering of evil and jealousy right in the middle of *mooyo* (life), i.e. the sign of pregnancy. That awesome juxtaposition of life and medicine warns us that this image must have been used to protect not just a single person but a community. If it *was* commissioned for a single person, then it was in relation to one hell of a critical issue, perhaps a clan problem. One of the fascinating things going on in this case is the fact that the *kundu*, glandular protuberance, has been circled with a string of beads. Whatever the swelling danger was, it was broken down into various comprehensible admonitions and solutions, color-coded by the encircling beads. People with their legal or spiritual problems, together with their culturally appropriate solutions—that's what is very nicely suggested by this image. The image itself is strongly carved, very crisp, great ears, strong eyes, and it includes an ideograph of life, bent knees. It is easy to overlook the importance of that convention. There is a semantic difference between knees which are rendered straight, like lumber, and knees which are gently bent and are a sign of life. This is one of the ways of telling whether a child represented in a Kongo *maternité* is supposed to be viewed as dead or alive—take a look at the child's legs. When the child is depicted dead, legs straight, we are looking at a sculpture of moral allusion that warns women an immoral mother may lose her child.

AFRICA

Morocco
Tunisia
Western Sahara
Algeria
Libya
Egypt
Nile River
Mauritania
Mali
Niger
34
12
Niger River
4
8
Chad
Sudan
Senegal
Djibouti
Gambia
Burkina Faso
Guinea-Bissau
Nigeria
Somalia
3
Guinea
33 32
22
Ghana
9
30
Ethiopia
Sierra Leone
29
24
2
39 20 18 35
Central African
7
17
5
15
19 13
Republic
11
Cameroon
Liberia
16 36
Togo Benin
Ivory Coast
Equatorial Guinea
14
27
Congo
Uganda
Kenya
Gabon
1
26
Congo River
Rwanda
38
6
37
40
Burundi
21
Zaire
23
Tanzania
31
10
25
Malawi
28
Mozambique
Angola
Zambia
Zimbabwe
Namibia
Madagascar
Botswana
Swaziland
South Africa
Lesotho

1. Aduma
2. Akan
3. Baga
4. Bamana
5. Baule
6. Bembe
7. Bongo
8. Bwa
9. Chamba
10. Chokwe
11. Dan
12. Dogon
13. Ejagham
14. Fang
15. Fanti
16. Grebo
17. Guro
18. Idoma
19. Igbo
20. Ishan

21. Kongo
22. Kulango
23. Kusu
24. Ligbi
25. Luba
26. Lumbo
27. Mahongwe
28. Makonde
29. Mao
30. Mumuye
31. Pende
32. Senufo
33. Soninke
34. Tellem
35. Tiv
36. We
37. Yaka
38. Yombe
39. Yoruba
40. Lulua

INDEX